PEACE,
WAR,
AND
COMPUTERS

PEACE, WAR, AND COMPUTERS

Chris Hables Gray

Routledge New York • London

Published in 2005 by
Routledge
270 Madison Avenue
New York, NY 10016

Published in Great Britain by
Routledge
2 Park Square
Milton Park, Abingdon,
Oxon OX14 4RN

Copyright © 2005 by Routledge

Routledge is an imprint of the Taylor & Francis Group.

Printed in the United States of America on acid-free paper.

Library of Congress Cataloging-in-Publication Data

Gray, Chris Hables.
 Peace, war, and computers / Chris Hables Gray.
 p. cm.
 Includes bibliographical references and index.
 ISBN 0-415-92885-0 (hb : alk. paper)—ISBN 0-415-92886-9 (pb : alk. paper)
 1. War. 2. Information warfare. 3. World politics—21st century. 4. Globalization.
5. Peace. I. Title.
 U21.2.G669 2004
 303.6'6—dc22
 2004021543

For Jane Lovett Wilson. When the horrors of September 11 started, I was sitting next to her on our couch in Great Falls, Montana, watching Katie, Matt, Al, and Ann. As life has continued to unfold we have often talked about how current events are shaping the chances for the real peace that we have both been working for since long before we met. Many of the ideas in this book have been influenced by her wisdom. Our first encounter, in 1980 when I went to New England to protest against the Seabrook Nuclear Power Plant, did not begin well. There was the matter of Jane's dead parakeet, victim of an unfortunate late-night misunderstanding. But since then she has forgiven me my role in that small tragedy, and for many other things large and small. We have continued to work for peace and justice and have been involved in many difficult radical projects together, most notably raising our two sons Corey and Zack. Thank you, my love.

—C

contents

acknowledgments

This book, more than any of my others, is based on the sum of my political experiences and thinking. So I must thank my parents, Gonzalo Martin-Villigran, Mr. Beck, Col. Daly, the Stanford Rehabilitation Movement, Columbae House, the VVAW, SEIU, ARC, SCRIP, the South Africa Catalyst Project, Black Rose, RANE, AC/DC, Wandering Star, Love and Rage, CDAS, the Abalone Alliance, LAG, VAC, CPSR, UAW, the History of Consciousness Board of Studies, the Postmod Squad, and many others for sharing their political wisdom and energy with me. In the actual writing of this, my colleagues, students, and learners from the University of Great Falls, Goddard College, and the Union Institute and University have been very, very helpful. Some are cited in the text who I drew on specifically; the others have my thanks here.

Matt Byrnie, who did a great edit, Bill Germano, and the rest of the Routledge staff have been very helpful and particularly understanding to an author who decides he must totally rewrite his manuscript a few weeks before it is due. I hope the wait has been worth it.

I thank the following publications that printed or posted the academic and other articles that I wrote during the research on this book. Parts of these earlier texts are folded into many of the chapters here: Interview with Shimon Gelbetz in *Haayal*, November 2001; "September 11," in *Teleopolis*, Internet; "In Defense of Prefigurative Art: The Aesthetics and Ethics of Orlan and Stelarc" in *Orlan Meets Stelarc*, Joanna Zylinska, ed., London: Continuum/Althone, 2001; "Art and the Future of War" in *N: The Gruinard Installation*, Mark Little and Lloyd Gibson, ed., London: Locus-plus, pp. 38–43, 2001; "Posthuman Soldiers in Postmodern War" for a special issue ed. by John Armitage on "The Militarized Body & Society" for *Body & Society*, 2004; "Cyborgs, Attention, and Aesthetics" in

Issues in Contemporary Culture and Aesthetics, Jan van Eyck Akademie, Maastrict, Netherlands, 2001; "Star Wars 2001" in the *CPSR Newsletter,* vol. 19, no. 2, Spring, Internet; "Real War 2000: The Crisis of Postmodern War" in *Strategy and Tactics* (English, in press), *Teleopolis* (Internet— German), and also in Turkish as the forward to *Postmodern Savas,* 2000; "Real War and Postmodern Illusions" in *Globalize Liberation,* David Solnit, ed., City Lights, 2004; "The Second Cold War and Postmodern Terrorism" for *Nationalism and Terror After 9-11: Global and Local Discourses,* Begoña Aretxaga, Joseba Gabilondo, and Joseba Zulaika, ed., Routledge, 2004; "Agency, Technology, and Peace" for *War, Violence and Agency,* Michael Flynn, ed., Rowan & Littlefield, 2005; "New Information Technology and Warfare" for *Global Communication and Global Change,* Peter Wilken, ed., Manchester University Press, 2004; "The Perpetual Revolution in Military Affairs" in *Information Technology and International Security,* Robert Latham, ed., The New Press, pp. 199–214, 2003; "Empire in the 21st Century" for *Peace News,* December, 2003; "The Future of War" for the *At War* Catalog, Antonio Monegal and Francesc Torres, ed., Center of Contemporary Culture of Barcelona and Diputacio de Barcelona, pp. 358–369, 2004; "Cyborgs, Aufmerkamkeit und Aesthetik" in *Kunstforum.,* Dec.–Jan., pp. 131–135, 2000; and various versions of "The Cyborg Body Politic," co-authored with Steven Mentor. Much of this last piece is folded into various sections of this book, in particular Chapter 7, and I must thank Steve for most of the good ideas it contributed.

introduction

TERRORWAR IN THE TWENTY-FIRST CENTURY

Terror is a relationship.
> —Diane Nelson (2002, p. 199)

War is a relationship, one of humankind's most intimate. The outlines of the grotesque intimacy of terror and war in the twenty-first century are becoming starkly clear. The conquest of Iraq is over; a deceptively easy victory. The subjugation of Iraq may never happen. In the long run, despite thousands of civilian dead, the Iraqis could end up better off when the Americans leave, perhaps not. But the United States and the world will pay a high price—the perpetual Cold War of terror will continue. For the United States this means the occupation troops in Iraq and elsewhere will be attacked but the "homeland" will remain the highest priority target. And it won't just be a wounded Al Qaeda seeking to strike the American heartland; they have new allies now across the Moslem world and even beyond. The enemies of the United States are increasing and they are increasingly united, both as a direct result of the policies that are exemplified by the invasion of Iraq.

Fighting will also continue in Afghanistan, U.S. troops will still operate in Colombia and the Philippines, and U.S. security forces will conduct raids in countries such as Pakistan, Yemen, Somalia, and the Sudan with regularity. The world system of nation-states will balance constantly on the brink of terror. Just as dangerous as the nonstate actors who relentlessly seek weapons of mass destruction (WMD) are such flash points as Korea, Israel-Palestine, and India-Pakistan.

The proliferation of WMD will increase. They are now the only guarantee of safety from U.S. preemptive war, as North Korea has proved. Each new WMD program spawns responses in neighbors and other potential enemies. At the United Nations (UN) and in other international bodies consensus, or even clarity, on most matters of substance will be nearly impossible to achieve. Some of these bodies don't even include the United States (Kyoto Accords, the International Court), others are collapsing or becoming superfluous (Nonproliferation Treaty, North Atlantic Treaty Organization), and still others are disempowered by U.S. actions (UN).

There will almost always be opposition to U.S. initiatives and it will be substantial, especially from the new "superpower" of global public opinion, or as the Zapatistas called it in the 1980s, International Civil Society. The worldwide protests before the Iraq War were the largest in history, and the network that produced them continues to spread and evolve, focusing much of its energy on ending war.

War is always a struggle for meaning. Today, the most important contested meaning of all is that of war itself. This book is an intervention into this "battle." One could accuse it of being a netcentric war for the hearts and minds of the readers and be only half wrong. For shaping how people think and feel isn't just war's purview, it is what culture itself is about. War just happens to be one of the most frightening and obvious ways of bringing about cultural (including economic, political, and social) changes. It is also obsolete, we just won't admit it. This irony produces Cold Wars.

Today's international system of ongoing fear and tension is the second Cold War. It grew directly out of the first Cold War between state communism and neoliberal capitalism, but it most certainly has its own particularities. It is part of the same postmodern war system that has been in effect since 1945 (Gray 1997). Since then it has become obvious that today war (and the threat of war) is terror and terror is war. There is no real difference between the two. TerrorWar must end; it cannot be used to produce real peace.

This has all been true for quite some time, but it took 9/11 and the U.S. response to make it crystal clear.

POLITICS AND SEPTEMBER 11[1]

Man is by nature a political animal.
—Aristotle (Rawson and Miner 1986, p. 272)

Politics is the art of the possible.
—Otto von Bismarck (Rawson and Miner 1986, p. 273)

Aristotle is wrong. Men and women are not political animals and that is to our credit. We are social, and there is a difference. Otto von Bismarck may have been right in the past when humans didn't have apocalyptic weapons, but now he is very wrong. Politics must now be the art of the necessary, not the possible. Technology has raised the stakes. So a large part of this book is about how technology, especially computer and telecommunications technology, underlies the current world crisis and its effect on attempts to create a peaceful international system. But this book was also profoundly shaped by two important events. A few weeks before the first draft was due, two commandeered commercial airliners were flown into the World Trade Center in New York City, killing almost 3,000 people. A third was crashed into the Pentagon and a fourth went down in a field in Pennsylvania. As the final draft was being finished, the United States invaded Iraq in the face of international law and opinion.

Any discussion of the prospects for peace in the twenty-first century has to take these horrors into account. The people of Oklahoma City refer to their postbombing lives as the "new normal" (Linenthal 2001). There is a new normal for the whole world now, and the scary thing is that it doesn't feel new at all because the new normal is much like the old "normal" of the first Cold War. We have been in a "new" Cold War for a number of years now, we just did not realize it. To understand it we must study history, of course, especially the first Cold War and the long story of war itself.

What particularly marks these times as unique is the incredible power of modern technology. It makes globalization possible, it makes the weapons we use to threaten and kill more powerful and easier to attain, and it allows billions of humans to occupy the planet at once. The most important of these technologies process information; they undergird all the others, from biotechnology to structural engineering to weapons production. So we must pay particular attention to information technology's direct influence on international relations and, just as important, its indirect effect on the very way we conceive and consume information.

I won't start with information theory, as interesting as it is, although I do comment on it briefly later. After this introduction, the first half of the main narrative (our current situation) begins in Chapter 1 with a discussion of the meaning of terror and how war has become terror and terror

has become war. This is followed by a close analysis of the U.S. invasion of Iraq, Islamist[2] terrorist attacks, and what they reveal about possible futures. Chapters 2, 3, and 4 are also about today's international system—Chapter 2 on contemporary war, Chapter 3 on the political struggle over the organization of the world economically and otherwise, and Chapter 4 on globalizing technologies and their politics, including contemporary information theory and its political implications.

The second half of the book, focuses on peace: Chapter 5 on contemporary peace movements and theories, Chapter 6 on what could be called the semiotic struggle (or *kulturkampf*) over the very assumptions of society, which is known on the street as culture jamming or even art. Here I apply the political idea of prefiguration to art and other cultural processes. Chapter 7 explores the implications of our intimate relationship to technology in terms of subjectivity, character, and citizenship. Finally, Chapter 8 searches for reasons for hope.

These are new times and words are particularly slippery at such junctures, so let us take a moment here to define a few especially important terms.

KEYWORDS[3]

The following keywords are not presented in alphabetical order but rather as they seem to lead one to another. These definitions are not definitive, and all of these terms are explored at greater length later.[4]

Information

Information is intangible.

—Paul Levinson 1997, p. xi

To lead them to the light by a faithful information of their Judgments.

—J. Spencer 1665

The first meaning of *information* in the *Oxford English Dictionary* (OED) is "the formation or molding of the mind or character." We don't just *use* information; information forms us culturally and psychologically. On a deeper level even our corporal selves are shaped through information. As the dictionaries also say about the root word form: "(in)form" in English was first "to put into material shape." In 1590 the poet Edmund Spenser

said in *The Faerie Queene*, "Infinite shapes of creatures' Informed in the mud, on which the Sunne hath shynd."

Information can also be thought of as one of the key building blocks of reality along with energy and matter. Although this definition isn't in many dictionaries, it is in common use within academia and the computer industry: information as pattern, as plan, as specificity. It is this sense of information that is meant in this book.

The mushroom cloud of a nuclear explosion is proof positive that matter can be turned into energy and we have often turned energy into matter in our gardens, but information is much harder to think through because we have to use it to think about it.

So, our understanding of information is very uneven. Certain aspects, such as its transmission and the subcategory of mathematics and other formal information systems, are pretty well advanced. But our set of accurate rules and effective metaphors for information remains rudimentary. These issues are expanded on in the second part of Chapter 4, but there is one particular point that needs to be emphasized here. The most important thing that we do know about information is that our knowledge of it, or of anything else of consequence, can never be perfect. The details of this will be filled in later, as well as some of the positive things we know about information. But for now, just remember that we can't know it all. Ever. Finally, information is about relationships and the rules and metarules that govern them. It is no accident that so is power. "Information wants to be free," cyberactivists proclaim, and "Information wants to be alive" (Thomas Ray, quoted in Maret 2002, p. 68), but actually information wants nothing. It can, however, serve human desires, particularly in the quest for power.

Power

The meaning "to be able" comes first. This says much of what we need to know about power. It is not just about power "over" someone or something, it is creative as well. At the end of the *Oxford English Dictionary* definition there is a quotation from 1325 "And Shaf to man fre power to chese." Power to choose. That says most of the rest. But it turns out it is the details that are important if we are to understand and use power.

For example, agency is there besides, animal at the least, often human, sometime our own. Sure, the dams of the Great Falls on the Missouri produce hydropower in the form of electricity, but the power is real only because humans built the dams and the generators and we use the

resulting electricity to power our lives. Nature is nature and running water is running water. It becomes a home when the beavers build their dams; it becomes a power source when humans build ours.

Power is a relationship (and therefore part of information theory). Usually the relationship is complex; it is made up of other relationships. The relations can be physical (energy/matter) or of meaning (information) or a combination. In any event, there is always causality (with no apologies to David Hume[5]). Power is the ability to do something. Power cannot exist in and of itself or in a vacuum. It has to be useful. Things do act on each other; that is what a relationship is—even if it can't be proven to the satisfaction of certain logics. That shows their limits, not the absence of causality. This is important. One's view of causality is a position on power, and it reveals one's guiding assumptions about human nature and epistemology.

All power does not corrupt. Certain kinds of authoritarian coercive power are horrible, and Lord Acton's maxim certainly applies to them. And as absolute coercive power becomes technologically possible, we face the danger of absolute authority and corruption (see *Cyborg Citizen*, Gray 2001). But much power is constructive and some power is delightful, even edifying. Consider child rearing. Having (modeling) loving relationships is a powerful act that changes the children one is responsible for. But it is also positive, even wonderful, for the parent.

Power can be constructive, not just destructive. Power can be subtle; it need not be obvious. Yet power is mostly thought of as destructive and crude. Perhaps this is one of our key political problems. Most types of power that have been well analyzed are violent and unsubtle, such as military action. For analysis that pays attention to subtle and constructive as well as destructive power, no military theorist has surpassed *The Art of War*, which is thousands of years old. This tells us something about military thinking.

The Greek historian Herodotus said that "Power is precarious" almost 2500 years ago (Rawson and Miner 1986, p. 280). This is just as true today. Power comes out of dynamic and complex relationships. It is always shifting, collapsing, reorganizing.

Real peace depends upon a radical redefinition of power in international politics and all other human relations. Exciting as bombs and guns are, *the greatest power is in defining what is power*. That's what real peace will be: a radical redefinition of power.

Peace

Peace, like power, has been oversimplified. "Freedom from, or cessation of, war or hostilities" is the common first definition, but that can be the "peace of the battlefield," a field of dead, or the victory of dictatorship. Those "in power" are always willing to sacrifice the freedom (power) of the rest of us to save us from war or the threat of war, leaving us with the false peace of tyranny. A later meaning, "relation of . . . concord and amity," has more to offer. There needs to be a feeling of peace between people for there to be real peace and a feeling of peace inside each of us. This is made clear in still later definitions, "reconciliation" and "friendly relations."

On first glance it might seem that "terror or peace" is an easy choice. But if war is terror and peace is complex and difficult, many will choose the bloody security of war over real peace, as humans have been doing for thousands of years. It is time to put peace into action.

Peace has long been a noun, as well it should be. As a verb its first uses were, appropriately enough, imperative, as used by Chaucer's pilgrims back in 1386: "Peace!" In those days there could only be limited, temporary, peace. Now, with the collapse of modern war and modernism things may, indeed they must, be different. That is the hope in postmodernism.

Postmodernity

The term *postmodernity* is widely accepted now, but there are still people who rail against it. Even most of these critics would agree that the times we live in are new, they just don't like the term postmodernity. Fine, as long as one recognizes just how our age is unique.[6]

Part of it is quantitative, of course, but with qualitative implications: six billion humans, fewer species, jet planes, Mars probes, and incredibly powerful munitions. We can kill everyone on the planet; that's new. We can feed everyone; that is new as well. The qualitative differences are harder to notice, but they are just as important. The widespread acceptance of the idea that every human has inherent rights—not just my nation, my gender, my religion, my tribe, my family, myself—is new. The project to seize our evolutionary destiny and create posthumans is quite strange and it is very new.

Call it what you will, just note that postmodernity is used here in reference to these "interesting times."

Cyborg

One of the most interesting and important things to appear out of post-modernity is the cyborg. A cyborg, or cybernetic organism, is a self-regulating system that includes working elements from two very different domains. These domains have many names: born/made, living/dead, animate/inanimate, natural/artificial, and organic/machinic among them. But the crucial point is that the cyborg idea both strengthens and explodes these binary concepts at the same time. They are strengthened because the cyborg exists only as this union of supposed opposites and, in naming the cyborg as such, they are preserved and clarified. But on the other hand, the very existence of the cyborg reveals that these elements are just co-operating subcategories of larger systems and so are not really opposites at all.

For humans, the use of prosthetic and other technosciences in modifying ourselves is the primary focus of our political concerns about cyborgs. Cyborgization represents the culmination of the long human relationship to tools and machines, which means that it includes profoundly militarized aspects as well as more sweeping implications for us that range from the epistemological to the futurological. But it shouldn't be forgotten that the idea of the cyborg extends down to the micro level of artificial life and nanotechnology and up to the realm of the global, where Gaia itself has been called cyborg (Haraway 1995).

Globalization

Today it is impossible to deny the importance of globalization. Although the world has always been a single ecological system, it has also included subregions that had a great deal of autonomy because of the difficulty in spreading life forms from one bioregion to another and because of the differences in climate. Now, with human civilization ubiquitous, which includes the conscious and accidental propagation of other life forms, the world is more of a single ecosystem then ever before.

Important as all this is, in many ways globalization is a shift in human consciousness more than it is a new ecological, economic, or technological relationships. The realization that Earth is one system has had profound impacts on how we see ourselves. This is especially true for those "outside" the West, who have experienced globalization as Westernization. Yosef Bodansky wrote in 1999:

The Islamists' growing hostility toward the West—fueled by the seemingly unstoppable spread of Westernization through the electronic media—motivates the terrorists, such as bin Laden, to commit more horrendous, more spectacular strikes if only to demonstrate the viability of radical Islam and its rage. Their individual struggles are the essence of the Islamist movement against Westernization. (pp. xvii–xviii)

So it is personal *and* political. The question of our age seems to be "Who will rule the World?" and until we find an answer, we won't have a truly peaceful world. If the answer is truly "the people," us, that means anarchism: self-rule.

Anarchism

It is often claimed that anarchy means "without government" (and the resulting chaos) and that the anarchist program is about just that, when in actuality what we could have without governments is a healthy complexity, not chaos, if we work for it. Besides, anarchism is not an ideology; it is an ideal, and as such it isn't just about the absence of government or even of all oppressive and dangerous hierarchies, it is fundamentally the principle of liberty, the belief that freedom is the first value.

It doesn't necessarily focus on total freedom, now. Most anarchists, surprisingly enough, are practical, pragmatic people. Thomas Jefferson and many of his allies were pragmatic anarchists, believing in the principle that "the less government, the more freedom."[7]

However, the idea of freedom bothers some people. They fear their own desires and those of their neighbors. For some, liberty is even licentious; perhaps that is what they fear in themselves. Taverner in 1539 whines, "This unleful lyberty or lycence of the multytude is called an Anarchie." More accurately, Blount in 1656 wrote that anarchism was "The Doctrine, Positions, or Art of those who teach anarchy; also the being itself of the people themselves without a Prince or Ruler." This is not so much the absence of government, really, but of rulers and ruled; it is "the being itself of the people themselves." In a crisis people fend well for themselves, organizing rescues and other help without the prodding of centralized authority. This was seen on September 11, 2001, as it is in every disaster. If we can manage our lives in times of terror, there is hope that we can manage our lives in times of peace.

Hope

> Terror struck into the hearts of the enemies is not only a means, it is the end in itself. Once a condition of terror into the opponent's heart is obtained hardly anything is left to be achieved. It is the point where the means and the end meet and merge. Terror is not a means of imposing decision upon the enemy; it is the decision we wish to impose.
>
> —S.K. Malik (quoted in Bodansky 1999, p. xv)

S.K. Malik was an Islamist and a brigadier in the Pakistan military who wrote *The Quranic Concept of War* in 1979. In it, he argues that this Islamist (Koranic) approach to war is superior to all others because it is "fought for the cause of Allah," which meant that all acts are justified.

In Caleb Carr's novel *Killing Time*, many of his protagonists are convinced that *mundus vult decipi*, the world wants to be deceived. This is how they explain humanity's acquiescence to war, injustice, environmental degradation, and the commodification of their very desires. I deeply hope that most people do not want to be deceived; we want to know. But what is the attraction of fooling ourselves as S.K. Malik does? Fear.

Should we hope? On the one hand we have people like Malik, whose sweeping and simplistic epistemology is designed to ratify their deepest hopes and fears. We hear Jerry Falwell and Pat Robertson pontificating on the causes of 9/11 in comments that Falwell later called "ill timed" but never retracted. This transcript is from Lisa de Moraes' *Washington Post* column (2001):

> Falwell: What we saw on Tuesday, as terrible as it is, could be miniscule if, in fact—if, in fact—God continues to lift the curtain and allow the enemies of America to give us probably what we deserve.
>
> Robertson: Jerry, that's my feeling. I think we've just seen the antechamber to terror. We haven't even begun to see what they can do to the major population.
>
> Falwell: The ACLU's got to take a lot of blame for this.
>
> Robertson: Well, yes.
>
> Falwell: "And—I know that I'll hear from them for this, but—throwing God out successfully with the help of the federal court system, throwing God out of the public square, out of the schools. The abortionists have to bear some burden for this, because God will not be mocked. And when we destroy 40 million little innocent babies, we make God mad. I really believe that the pagans and the abortionists and the feminists and the gays and the lesbians who are actively trying to make that

an alternative lifestyle, the ACLU, People for the American Way—all of them who have tried to secularize America—I point the finger in their face and say, 'You helped this happen.'

Clearly, Jerry Falwell is a world-class hater, much like Osama bin Laden. They hope for death and destruction to validate their own demons, as do many others. In a world with such as these, and our incredible technologies, how can we hope to survive?

What is the minimum we need? Tolerance, pluralism, acceptance, love? How are these manifested in life? Acts of empathy and friendship, nurturing, creating. Starhawk, the well-known anarchist witch, explains that the goal of terrorists, state or freelance, is

> to fill all our mental and emotional space with fear, rage, powerlessness, and despair, to cut us off from the sources of life and hope. Violence and fear can make us shut down to the things and beings that we love. When we do, we wither and die. When we consciously open ourselves to the beauty of the world, when we choose to love another tenuous and fragile being, we commit an act of liberation as courageous and radical as any foray into the tear gas. (November 5, 2001)

On September 29, 2001, the first big antiwar rally of the new millennium, in Washington, D.C., was on C-SPAN2. They had a chant there that I had a complex reaction to. It went: "Another World is Possible! Another World is Possible!" My first response was, "Yes, that's right. This world is not inevitable." Having been an organizer for many years, I know how hard it is to help people believe that we can indeed change the world. But then I thought, "Lots of other worlds are possible, and most of them are even worse than this one." That set me back a bit. So I thought a bit more about it and decided that, if I was into chanting (which I generally loathe, except for my old favorite "More mindless chants!"), it would have to be "A better world is possible." Not easy, I grant you, but I do know a better world is indeed possible. Even more, I know it is necessary.

the situation

the new normal isn't

ON TERROR

Virtue without limits becomes terror.
> —Jean Bethke Elshtain (quoted in Der Derian 2001, p. 202)

War is cruelty, and you cannot refine it.
> —William Tescumseh Sherman, 1864

Terrorism discourse must be disenchanted.
> —Joseba Zulaika and William Douglass (1997, p. 239)

War has become indistinguishable from terror. To have real peace, Terror-War must be ended. This has to be the last war. But the causes of this synthesis of terror and war are complicated, and moving beyond its grip on human politics will certainly be difficult. Our situation is shaped by two key 21st-century realities: information (and its technologies) and globalization. Our future will be determined by power: what it is, who uses it, and for what—terror or peace? We cannot have both. So this book begins with terror, as so much of our political thinking must these days. We have to understand the TerrorWar system if we are to have any chance of surviving it.

Terror is fear, great fear—all the dictionaries say so. From the *Barnhart Dictionary of Etymology* (1988, pp. 1127–1128) we learn that in 1375 *terroure*, meaning "great fear," was the old French, and earlier the Latin terror meant "great fear, dread." The words come from the Sanskrit *trasat*, "he trembles." The *Oxford English Dictionary* makes it clear that many of the earlier uses were to describe the terror of damnation or of death by nature. But war was a part of nature, as "terrror breathing warre" by Drayton, circa 1598 makes clear (OED, p. 3268).

In 1795 "terrorism" came to mean "government by intimidation," thanks to the French Revolution with its busy guillotine. Since then the word has been used more often to describe violence by those opposed to states rather than the violence states perpetuate (OED, p. 3268). The very act of labeling terrorists has become one of intimidation, aimed at provoking fear and disillusionment, while it opens the terrorists themselves to be met with sudden violence and the fear of it—counterterror.

Two anthropologists, Joseba Zulaika and William Douglass, have done the best job of explaining how deadly the term *terrorism* can be. They studied and lived with the Basques and so heard much about terrorism, met many so-called terrorists from all sides, and even felt terror on occasion. They were deeply troubled by the "referential invalidity" and "rhetorical circularity" of the uses of terrorism; the term seemed useless and dangerous. "It is the reality-making power of the discourse itself that most concerns—its capacity to blend the media's sensational stories, old mythical stereotypes, and a burning sense of moral wrath," (1997, p. ix) which leads inevitably to counterterrorism—terrorism that is to counter earlier labeled terrorism—because it is "seemingly the only prudent course of action" (p. ix).

In *Terror and Taboo* they pointed out that terrorism was "becoming a functional reality of American politics." It had "been 'naturalized' into a constant risk that is omnipresent." Their conclusion is chilling: "Now that it has become a prime raison d'étre, its perpetuation seems guaranteed" (1997, p. 238).

Today, terror is a political perpetual-motion machine, a form of violent discourse that isn't supposed to be won. As Grenville Byford points out,

> Wars have typically been fought against proper nouns (Germany, say) for the good reason that proper nouns can surrender and promise not to do it again. Wars against common nouns (poverty, crime, drugs) have

4

been less successful. Such opponents never give up. The war on terrorism, unfortunately, falls into the second category. (2002, p. 34)

Helpful as this is, it still begs the question, "What is terrorism?" This has been a matter of great debate for quite some time. In the United States alone there are dozens of "official" definitions from the Central Intelligence Agency (CIA), Department of Defense (DoD), Federal Bureau of Investigation (FBI), State Department, and many smaller units. One college textbook unselfconsciously entitled *The Terrorism Reader* and apparently aimed at undergraduates begins with nine different definitions from various institutions and individuals. The definitions are mutually contradictory and deeply unsatisfying. Almost all of them could apply to any war (Whittaker 2001, p. 3). This word terrorism is constantly, perhaps always, being misused. As Zulaika and Douglass wryly observe, we are indeed "dealing as much with who has the power to *label* as much as *level* their adversaries" (1997, p. 81, original emphasis).

Implicitly agreeing with this logic, a *Los Angeles Times* article headline cynically proclaims, "Political manuals more useful than dictionary in defining 'terrorism'" (2002). The article ends with three different definitions, by the FBI, the Israeli government, and the U.S. State Department. The FBI definition (unlawful use of force) and the Israeli definition ("killing and making attempts . . . on citizens") so clearly apply to many of their own actions one almost suspects governmental irony. The State Department, on the other hand, avoids this problem by simply restricting terrorism to "subnational groups or clandestine agents."

But we know the word originally meant something quite different, if not actually opposite: governments terrorizing their citizens. So it has been with a long history of red terrors, fascist Black Hands, vigilante committees and outright governmental repression in the form of counterterror, bombings, beatings, street fighting, assassinations, and most of all war. It has been an unequal struggle, physically and even rhetorically.

Back in 1982 Edward Herman made a distinction between "retail" and "wholesale" terror. As he rightly pointed out, most terror was (and is) perpetuated by nation-states. Herman characterized the greatest body counts as wholesale terror, as opposed to the retail terror of nonstate actors. There are two problems with this distinction. First, many of us would condemn all terror, from the beating of one child to the bombing of a city, so morally we may not see a difference between wholesale and retail terror. Second, the increasing technological complexity of our society has made

it possible for a handful of nonstate terrorists to kill thousands, granting them the same degree of killing power as nation-states. The gap is closing between these different types of terrorism, thanks to information technology and the technosciences it fosters. A network such as Al Qaeda could not threaten the United States without the sophisticated technologies it appropriates for communication, targeting, and destruction. Even though it is a network, not a state, Al Qaeda can kill thousands with major international effects, thanks to the existence of global communications, commercial airliners, and skyscrapers.

Still, Herman's main point remains; the system of terror includes nation-states, and states still have the resources to do the most damage. The West is particularly hypocritical about terrorism in this regard, justifying the massive destruction caused by various U.S. bombings and Israeli raids as collateral damage, although the numerous civilian deaths are absolutely predictable, while condemning every nonstate action, although many kill far fewer innocents. Besides, governments such as the United States often use proxy terrorists.

So what is terror? The answer is at once simple and terrible: Terror is war. All war is terrorism. Startling as this first seems, in retrospect it was inevitable. War has always been about terror, often mainly about terror. Joseba Zulaika and William A. Douglass could not have been more prescient when they said:

> The concept of "war" itself is no longer the same when deprived of the goal of military victory: the traditional meaning of war is being replaced by *terrorism* (defined as "surrogate war") and *deterrence* (defined as "mutual balance of terror"). (1997, p. 82, original emphasis)

War has always evoked terror; now war has become terror. War was seldom noble, but the slaughter usually followed certain rules and was confined to combatants. Sometimes prisoners were even taken and the wounded mended. Sometimes when cities were sacked only a few women were raped and none even sold into slavery. But as weapons were developed that could kill at great and indiscriminate distances, all war became terror. The terror of the front lines was moved to the shelled cities (Atlanta, Paris) and then the bombed ones (Shanghai, Guernica, Barcelona).

In World Wars I and II all sides worked hard at developing "strategic" ("terror") bombing. Although the Italians (in Libya before the war) and the Germans (zeppelin raids on London in WWI, rockets in WWII) were pioneers in indiscriminate aerial attacks on civilians, the Allies perfected

them. In his brilliant history of U.S. strategic bombing, *The Rise of American Air Power: The Creation of Armageddon,* Michael Sherry argues that the political fanaticism of the Axis powers was matched by the technological fanaticism of the Allies. For the Germans, Italians, and Japanese, nationalistic or racist politics justified the exterminations (of Gypsies, Jews, Slavs, Chinese, Koreans) and war on civilians. For the Allies, the existence of the technologies of strategic bombing and nuclear weapons justified the extermination of cities. Sherry explains that it was the product

> of two distinct but related phenomena: one—the will to destroy—ancient and recurrent, the other—the technical means of destruction—modern. Their convergence resulted in the evil of American bombing. But it was a sin of a peculiarly modern kind because it seemed so inadvertent, seemed to involve so little choice. Illusions about modern technology had made aerial holocaust seem unthinkable before it occurred and simply imperative once it began. It was the product of a slow accretion of large fears, thoughtless assumptions, and at best discrete decisions. (1987, p. 137)

It led to atomic bombs and then hydrogen weapons, primary symptoms (but certainly not the cause) of postmodern war. These incredible weapons and other new technologies produced the structure of the first Cold War: a balance of terror. The current crisis, this second Cold War, is caused by the collapse of that balance. The United States is hegemonic now, and the "enemies" are ideas and networks more than nations or civilizations.

But terror didn't just determine nuclear strategy in the first Cold War, it was integral to low-intensity conflict, and the details should prove instructive because the central conflicts of the second Cold War are squarely within the low-intensity definitions, as the occupation of Iraq revealed. Because nuclear weapons are too horrible to use, all postmodern wars have to be managed. This is called crisis management, but often it looks more like the harshest of coercions: torture.

Daniel Ellsberg recalls that it was his wife who, after reading the Pentagon Papers, pointed out "in horror" that the U.S. Vietnam War strategy was described by its architects in "the language of torturers." He gives numerous examples ("'water-drip' technique," "fast/full squeeze," "the 'hot-cold' treatment," "ratchet," "one more turn of the screw") by such luminaries as William P. Bundy, Robert S. McNamara, John T. McNaughton, and Richard Helms (1972, pp. 304–305).

The other side certainly thought the same, and they had a fine pedigree for the idea that terror was justified. Trotsky wrote an essay called "On Terror" when he was commander of the Red Army. In it, he noted approvingly (and mistakenly) that even when you terrorize and kill the innocent your enemy's will grows weaker. Communist theory and practice certainly followed Trotsky's reasoning. But approving terror isn't limited to Communists. Since 9/11 the legal use of "hard" torture has actually become a matter of serious debate in the United States, and so-called soft torture or torture "lite" (sleep deprivation, constant extreme noise, isolation) is policy.

The language of torturers is the language of nonstate terrorists as well, the language of pure coercive violence as Al Qaeda and other suicide bombers have made clear. The conflict doesn't have to be between states for it to be horrible. The long, drawn-out blockade and bombing of Iraq after the first Gulf War seem remarkably similar to many Vietnam War operations, even to the extent that they were both ineffectual and murderous to women, children and the elderly, hundreds of thousands of whom died. The blockade was followed by the invasion, which has now turned into a low-intensity conflict. This last step wasn't part of the U.S. strategy. It actually puts a bit of a crimp in the plan for "the U.S. to rule the world" (Armstrong 2002, p. 76).

A series of official reports by the former Secretary of Defense Dick Cheney (1992, 1993), the latest secretary, Donald Rumsfeld (2002), and key staff members Paul Wolfowitz and Colin Powell lay out the current grand strategy for the United States to be the "biggest bully on the block," in Powell's phrase (Armstrong, p. 78). The strategy involves developing tactical nuclear weapons as bunker busters, new computerized systems (including autonomous kill platforms), new doctrines such as preemptive war, and dominance of space under the pretense of ballistic missile defense. U.S. planners envision having the ability to threaten and kill everywhere. It is a policy of terror using nuclear, conventional, and special forces.

Colin Gray (no relation) has put it quite clearly in the theoretical journal of the U.S. military, *Parameters*: "For example, special forces can be unleashed to operate as 'terrorists in uniform.' Unconventional warfare of all kinds, including terrorism (and guerrilla operations, is a politically neutral technique" (2002, p. 6). He goes on to complain that "The U.S. armed forces have handfuls (no more) of people amongst their substantial special operations forces who truly can think 'outside the box" and who can reason and, if need be, behave like 'terrorists in uniform'" (p. 11).

Is it a coincidence that Saddam's Iraq was the Republic of Terror par excellence? Fear ruled. "Since 1991, the tyrant has remained in power not because he is loved (never the case in Iraq), nor because he exerts genuine authority . . . but out of fear of what lies in store in the future" explains Kanan Mariya in *Republic of Fear* (1998, p. xxxi). This is how the United States rules in Iraq and, in all likelihood, how the U.S. successor there will be chosen. In the strange real-world logic of cold war, you often become like your enemies, as they become like you.

Fear now rules the United States, also. The fear is everyone's now, not just the soldiers'. Yes, the soldiers have fear. Terror is with them always. Even with the aid of coercive discipline, camaraderie, nationalism, drugs, rage, and ideology, many soldiers desert and, eventually, most burn out. Killing and dying are two of the most frightening things humans do. Studies of U.S. troops after World War II revealed that in the case of an Army division fighting in France in 1944, a time of heavy combat, 65 percent admitted that fear severely affected them. In a division fighting in the Pacific almost all of the soldiers reported such symptoms of fear as "violent pounding of the heart" (84%), shaking or trembling (over 60%), vomiting (over 25%), and diarrhea (21%). Before recounting these statistics, Gwynne Dyer reminds us that "Fear is not just a state of mind; it is a physical thing" (1985, pp. 141–142).

Isaac Rosenberg wrote a poem in 1916 called "Break of Day in the Trenches" while serving on the Western Front, not far from where he would be killed two years later. The poem ends with the narrator speculating on what a "queer sardonic" rat's-eye view of the trenches would be.

What do you see in our eyes
At the shrieking iron and flame
Hurled through still heavens?
What quaver—what heart aghast?
Poppies whose roots are in man's veins
Drop, and are ever dropping.
(Quoted in Featherstone 1995, p. 144)

In the balance of terrors of the second Cold War, the fear is all we have now and it is just as real, even if we do inhabit strange "trenches." The nation was once reassured that it had nothing to fear "but fear itself," but now President Bush says everything is about fear. Bob Dylan sang, "Terror is my constant emotion. I deal in terror. I buy it, sell it, and make a profit"

(quoted in Zulaika and Douglass 1997, p. 117). A future where this is true of most of us would be the victory of terror.

The systematic torture of prisoners in Iraq and Guantanamo Bay by U.S. and British troops shows how pertinent this question is. It is clear that the Bush doctrine is really "Terror Firma," in Grenville Byford's phrase.

The problem of terror is the problem of war and peace itself. To end terror is to end war, which means bringing an end to postmodern (cold) war and fundamentally transforming the international system.

THE SECOND COLD WAR

Despite television network logos ("America's New War"—CNN) and the protestations of President George W. Bush otherwise, September 11, 2001, was not the beginning of a new war. At most, it marked a new stage of what should be called the "second Cold War" because in many ways it is a continuation of that conflict.[1] There are two ostensibly different world views colliding around the globe, but always below the threshold of total war. The vast range of the conflict, from the "shock and awe" lightning war that overran Afghanistan and Iraq twice, to the proliferation of weapons of mass destruction (WMD), to the suicide bombers of New York and Israel, to the hacking of Web sites and the freezing of bank accounts is just like the bricolage of the old Cold War. That mosaic included the set battles of Korea, the sending of poisoned cigars to Fidel Castro, death in the jungles of Vietnam, and the gigantic nuclear arsenals. The centrality of information (as myth, metaphor, and machine), the intense mediation and mediazation of conflict, the explosion of technological options are all the same. This new Cold War is a postmodern war, just as the first one was (Gray 1997).

Justice is the ostensible issue of this worldwide struggle.[2] It is a word that has been used often. Just as the first Cold War opposed two supposedly different visions of justice against each other, so does the second. Cold War I pitted communism (as it labeled itself) against capitalism (although really a mixed economy dominated by corporate interests), and Cold War II, the sequel, has pitted fundamentalism against the same capitalism (also known as secularism).

Hindu and Christian fundamentalists hate Islamist extremists, as Chinese Communists hated Soviets, but all sides share a totalitarian worldview that is as closed intellectually as it is culturally. Different as they

are, the fundamentalists often find common cause. For example, Hamas and other Islamists share with some fundamentalist (extreme orthodox or even hyper-Zionist) Jews an aversion to peace in Israel, a view also shared by some North American Christian fundamentalists who see Armageddon in the Middle East as a necessary precondition for the Rapture. So fundamentalist Jews set up settlements on captured Palestinian land with Christian fundamentalist backing while Muslim fundamentalists use the settlements as the pretext for more suicide bombings in Israel itself. More moderate believers find themselves either supporting "their" fundamentalists or allying with the secular-capitalist coalition, just as Social Democrats and other leftists found themselves strange, reluctant bedfellows either with communist totalitarianism or with the semicapitalist system they were trying to transform.

The first Cold War can be seen as a struggle between those who claimed to prioritize economic justice and those who professed to value political justice (often called freedom or democracy) more. In actuality, both systems produced super-rich elites and lesser classes, both savaged the environment, both relegated the rest of the world to bit players in their Cold War drama, and both did great violence to their own principles with this desire to frame the whole world around their conflict. The West often chose right-wing dictatorships and immoral wars abroad while curtailing liberties at home as a strategy for saving democracy. The Communists, for all their talk of economic justice, not only ended up with an elite new class much more closed and limited even than the West's upper classes but in the long run failed to produce enough economically for their systems even to survive, let alone establish economic justice.

Both systems claimed that their primary "justice" (economic or political) would lead to the other. At least the "capitalist" system generated great wealth that trickled down to a high percentage of the middle and working classes in the First World, although it left millions brutally poor in the West's own heartlands and produced more millions of starving people in the Third World.[3] The Communists, far from proving that their version of economic justice would lead to political justice, actually set up totalitarian and imperialistic regimes that were more like fascism than anything else.

Notice how similar the two Cold Wars are militarily: worldwide terrorism supported secretly by states, an ongoing spy-versus-spy dance, outbreaks of large-scale battle, uprisings galore, and all conflicts subsumed under the larger struggle, good versus evil. Technology keeps changing the rules of war, offering glimmers of hope for easy victories and bloodless

conflicts while in reality constantly raising the number of civilian casualties and the stakes, toward Armageddon it seems. The feeling is the same. Where once we feared every day that some accident or demagogue would plunge us into nuclear war, now we fear that some terrorist will plunge our mundane life into terror. The fear of nuclear and biological war haunts us still.

The similarities between the first Cold War and the second were not clear until recently because the second Cold War developed slowly within the first. Just as with Cold War I, Cold War II is hardly cold, but it is very diffuse and it pretends to explain almost all world conflict when it actually disguises the four major overlapping fault lines in human culture:

1. The gap between humans and the nature that sustains us
2. The growing chasm between the rich and the rest of us
3. The divide between the "true believers" who will kill rather than doubt themselves and who will die rather than learn tolerance and the rest of us
4. The gap between those who can get justice (economic and political) and those who cannot[4]

It is not a pretty picture, and thanks to ever-improving military technology it is one that directly threatens everything. It is postmodern war, the system we've lived with since 1945.

NOT A NEW WAR

Why are they calling it a new war[5] or even, in President George W. Bush's words, the "first war of the twenty-first century"? Doing so is a fine rationale for taking the national security state of the first Cold War to a whole new level. Not only has the horror in New York mobilized the populations of the West to support military interventions, and military casualties at heretofore unacceptable levels, but also it has given political muscle to those who have long wanted to expand domestic police powers. Naomi Klein points out that "Terrorism doesn't just blow up buildings; it blasts every other issue off the political map" (2003, p. 1). This is particularly true of civil liberties.

The first major victory for the second Cold War security state was the so-called Patriot Act, which greatly expanded search (physical, wiretap, and

Internet) and detaining powers. Soon after, the Bush administration instituted procedures for secret military trials for presumed foreign terrorists, and it has tried to seize for the executive branch the power to declare U.S. citizens noncitizens and detain them in perpetual secret, although the Supreme Court rejected this. Despite promises not to use the Patriot Act for nonterrorist crimes, ambitious prosecutors are doing just that, even declaring methamphetamine a "chemical weapon" and a pipe bomb a WMD (Associated Press 2003).

The militarization of policing is getting much worse, especially against political protests. It is now "standard procedure to erect a miniature police state around globalization summits" creating "rights-free zones" that the writer Rebecca Solnit warns could be "prefigurations of what full-blown corporate globalization might bring" (2003, p. 3). Chillingly, the head of the U.S. Northern Command (which oversees operations in North America), Air Force General Ralph E. "Ed" Eberhart, says the military needs to focus more on "the home game," meaning the United States (Engelhardt 2003, p. 1).

Sacrificing human rights on the altar of security isn't limited to the United States; it is the policy in Europe and the rest of the world as well (Pitts 2003). Naomi Klein notes that the threat of terrorism is a "shield of impunity, protecting governments around the world from scrutiny for their human rights abuses" (2003, p. 1). As with the first Cold War, she argues that today's

> War on Terror never was a war in the traditional sense. It is, instead, a kind of brand, an idea that can be easily franchised by the government in the market for an all-purpose opposition cleanser. (2003, p. 1)

In the first Cold War the brand was anticommunism and it justified, for example, the disappearance of 30,000 Argentineans (officially to combat terrorism) and the massacre of hundreds of thousands of Indonesians along with many other cleansings, coups, and wars. Now a senior Indonesian official, Rizal Mallarangeng, can talk openly of the "blessing of September 11" as human rights are curtailed there. Klein's conclusion about the Argentinean "dirty war" from 1976 to 1982 applies today: "As with all wars on terror, terrorism wasn't the target, it was the excuse to wage real war on people who dared to dissent" (2003, pp. 2–3).

It should be no surprise that Defense Secretary Donald Rumsfeld said in his major press conference on September 13, 2001, that there are no

models for the current conflict, but that is just not true.[6] He didn't want to draw attention to the best model, the first Cold War, from which the current situation evolved and which it closely resembles.

We have other examples of diffuse, globe-spanning, and complicated conflicts,[7] but the best model we have other than the first Cold War itself is Israel's long war against its cousins, the Palestinians, and this is not a coincidence. There are many different beginnings for this Cold War, but one of them is clearly the Six-Day War (June 1967) when Israel occupied Gaza, Golan, the West Bank, and the Sinai. Until then, the Israel-Arab conflict was basically one of states, despite some Palestinian attacks, and the conflict was integrated into Cold War I. But with Israel's sweeping victory the conditions were set for negotiating peace with some of the main state opponents of Israel's existence and, once this was done (most notably when Egypt made peace through the Camp David Accords), the conflict became mainly one between Israel and the Palestinians.

Back when this second Cold War was just a subset of the first Cold War system, the Israeli-Palestinian conflict still produced a great deal of the violence of those days, including hijacked planes, airport massacres, and the murders at the Olympics, as well as wars (Yom Kippur, the Invasion of Lebanon) and raids. As the first Cold War faded it was replaced by the second, most clearly in 1991 when Saddam Hussein's naked grab for more oil was slapped down by an allied coalition that restored the Emir of Kuwait. But in many respects it is the war in Afghanistan that represents the most crucial turning point. It started as a conflict of the first Cold War but it is now clearly a part of the second.

This Cold War analogy is not the only interesting theory about what is going on in the world today, and two of the other prominent models seem particularly relevant in light of the claim that we are in the midst of a second Cold War: Samuel Huntington's "Clash of Civilizations" (1993) schema and Benjamin Barber's *Jihad vs. McWorld* (1995) thesis.

The "Clash of Civilizations" is, not to put too fine a point on it, wrong. It is as bad as "strategic hamlets," one of Huntington's contributions to the Vietnam War. Huntington posits that future conflicts will be between nine great civilizations: Western, Confucian, Japanese, Islamic, Hindu, Slavic, Christian Orthodox, Latin American, and African. His descriptions of all of the civilizations are simplistic and, in particular, the West is unrecognizable. Apparently, it monopolizes most virtue and certainly the majority of democratic values. All the other cultures are defined as inferior inversions or pale imitations of the West. In actuality, as we see

with the second Cold War, the real conflicts that concern us cut across these civilizations more than between them. Bin Laden hates the Saudi government more than anything else, for example. For fundamentalists, as for Communists, the greatest enemy is the one who claims to be of your faith but doesn't follow your line exactly. Communists, once they are in power, have always persecuted Trotskyites, anarchists, and Social Democrats with much more venom than capitalists. The first enemies of the Islamists are the moderate Muslims.[8]

Benjamin Barber's "Jihad vs. McWorld" metaphor is a more interesting way of framing things. Barber argues that the major conflict in the world today is between those who want a holy war or crusade for purity (jihad) and those who think everything in the world should be for sale (McWorld). He knew he was risking misunderstanding by using the term jihad, which in his framework is pretty much fundamentalism as I define it. He said of jihad, "In its mildest form, it betokens religious struggle on behalf of faith . . . I use the term in its militant construction to suggest dogmatic and violent particularism of a kind known to Christians no less than Muslims, to Germans and Hindus as well as Arabs" (p. 9).

His definition of McWorld corresponds with what I would rather simply call capitalism. "McWorld forges global markets rooted in consumption and profit, leaving to an untrustworthy, if not altogether fictitious invisible hand issues of public interest and common good" (pp. 6–7). He goes on to debunk the myth that free markets lead to freedom and that consumerism is the same as citizenship.

The most valuable part of his analysis stresses how the two forces feed each other:

> Jihad not only revolts against but abets McWorld, while McWorld not only imperils but re-creates and reinforces Jihad. They produce their contraries and need one another. (p. 5)

This is not surprising, he argues, because both forces share a disdain, perhaps even hatred, for democracy. He concludes that the real struggle today is jihad and McWorld versus democracy. But then he argues that within them there are crucial positives. Hostage to his clever categories, he says, "McWorld's modernization has created a healthier, wealthier world in which at least the conditions of greater equality are present"[9] (p. 295). He also tries to rehabilitate fundamentalism but can't come up with an argument for jihad. Unfortunately for his analysis, he has framed jihad and

McWorld in such a way that they seem only to have a dark side. Both, as he freely argues, reject civil society and are opposed to democracy, but it turns out that McWorld can coexist with (and actually comes out of, uses, and makes possible) Barber's *liberal* form of democracy, so he finds it difficult to reject it systematically.

He might have done better to keep with the terms of his subtitle, *Globalism and Tribalism*, even if it might have hurt the book's marketing. Globalism and tribalism are more complex categories than jihad and McWorld and they do have many positive characteristics, even as they have McWorld and jihad within them. But the bigger problem with Barber's schema is that it is binary. Binaries, even dynamic dialectical ones, aren't complicated enough to explain reality. They always pose the danger that our rich, complex world will be dichotomized into "us" and "them," which is the stunted logic of war.

The officials are right about one thing at least—it will be a long war. Cold War I went from the late 1940s (it too had multiple beginnings) to 1989, although some communist regimes still linger (at least in form), and the whole thing could be revitalized if Chinese Communism undergoes another Maoist phase, which, although not likely, is not impossible. Cold War II started in the late 1960s but its roots go back further, at least to 1948 and the establishment of Israel, but probably back to World War I and the betrayal of the Arabs by the British and French.[10]

But it didn't become clear until September 11. Why has the second Cold War come out into the open now? Here Samuel Huntington is helpful. He wrote in *Foreign Affairs* in 1997 that the United States needs an enemy. He even quotes Rabbit Angstrom, the main character from a number of John Updike novels, who whines, "Without the cold war, what's the point of being an American?" (p. 29). At least Rabbit can be glad that the Cold War has returned. Huntington must be gratified as well. At the end of his article he argues for keeping U.S. resources uncommitted until some future "security threat and moral challenge" requires "Americans once again to commit major resources to the defense of national interests" (p. 49). September 11 was perfect for the new mobilization Huntington called for in 1997.[11]

As far as the "other" side is concerned, it seems they've been trying for years to do something like this. Clearly, for them, the war has been ongoing. A whole string of attacks have been launched at the United States over the last decade by the network/culture that destroyed the World Trade Center. They finally got the world's attention.

NO SURPRISES

September 11 was not a surprise for many analysts. It wasn't even the worst thing predicted. Horrible as it was, it could have been much worse. On one level, it should be taken as a terrible warning about what might happen if this Cold War lasts decades as the first one did. If the same policies are pursued in response to the attacks that, in fact, led to the attacks, there will be many more days such as September 11 and more horrible ones. The continued development and proliferation of weapons of mass destruction in the context of the current international system means that we can predict even more terrible acts of terror in the near future. These assaults could come from independent groups, from government proxies, or from states themselves.

Although it is no surprise that some leaders have warned that democracy should not be destroyed in order to save it, others seem much less concerned. Trent Lott, the leader of the Republicans in the Senate, proclaimed, "When you're in this type of conflict, when you're at war, civil liberties are treated differently" (Madden 2001). The old Cold War became a rationale for innumerable illegal acts and abridgements of freedom by the government, all in the cause of saving those very freedoms. There will be similar attempts during this "war" against terrorism. Many of the loudest patriots say that the United States should sacrifice some freedoms for greater safety, when actually freedom can be preserved only if it is valued above safety. To have freedom one must be willing to sacrifice security and life itself.

That the United States is hated by many people around the world should come as no surprise to anyone paying attention. The United States has made many enemies. It has overthrown democracies and supported dictatorships in Iran, Guatemala, Chile, and dozens of other places in the name of realpolitik—short-term, instrumentalist, Machiavellian, cynical, amoral, political realism.[12] It has used high-technology weapons to kill thousands of people, including women and children, in Southeast Asia, Central and South America, Africa, the Middle East, and the Balkans. It has trained thousands of terrorists, most recently Islamic fanatics in Afghanistan and right-wing Colombian death squads. Maybe some of these actions were justified, but in any event they angered many. There were long-term consequences, just as the conquest of Iraq will have consequences.

Both here and abroad, many people are also angry over the incredible disparities of wealth that the McWorld system produces, for the damage to the environment that it seems to depend on, and for the constant assaults on freedom and democracy that seem to go with it.

Why do they hate us? Why does the United States support dictators? Why does the United States bomb foreign countries and train foreign terrorists? Why must the environment be sacrificed on the altar of economic health (or is it corporate profits)? Why must democracy be sacrificed in order to save it? That's just the real world, we are told. Realpolitik, as Henry Kissinger would say. Well, it is this bloody minded realism that took down the World Trade Center.

UNINTENDED CONSEQUENCES

Edward Tenner has called the unintended consequences of technologies "revenge effects." He points out in *Why Things Bite Back* (1996) that the revenge of unintended consequences is so common that we must analyze each new technology with it in mind. It is not as if many of these consequences aren't predictable, they are just unintended. When you leap into a river on a hot day, the intended effect is to experience the pleasure of the flight and the coolness of the water. If the river is shallow and you break your neck, you realize that you should have looked before you leapt. Political decisions have unintended consequences as well. These have become so common in the netherworld of espionage and covert wars that a special word has been coined: *blowback* (Johnson 2000).

Osama bin Laden, the Taliban, and Saddam Hussein are all blowback. Once they were U.S. allies, if not America's creatures. Osama bin Laden, for example, was fostered through Pakistan's Inter-Services Intelligence Agency (ISI), which funneled the weapons, training, and funds the CIA wanted him to have in his war against the Soviet infidels. This is the same source that suckled the Taliban. They, and the other Islamists, were popular with the CIA because of their enthusiasm for killing Communists and because their virulent form of Islam was seen as a great "infectious agent" to introduce into the Muslim republics of the Soviet empire. Militants from bin Laden's group of volunteer "Arab Afghans" returned to their homes in Algeria to massacre moderate Muslims and assassinate Berber poets, to Egypt to slaughter tourists, and to Saudi Arabia, where they blew up the Khobar Towers (killing 19 U.S. soldiers), bombed Riyadh in

1996, and launched major strikes in 2003. They and second-generation Al Qaeda also kill Hindus in India, Jews in Israel, Russians in Moscow, Africans of all religions, and, as we know too well, Americans (and citizens of 60 other countries) in New York and Washington, D.C.

Zbigniew Brzezinski, one of the architects of this policy, defended it by asking, "What was more important in the world view of history? The Taliban or the fall of the Soviet Empire! A few stirred-up Muslims or the liberation of Central Europe and the end of the Cold War?" (quoted in Rashid 2000, p. 130). The verdict of history is not yet in. As late as 1998, Senator Orrin Hatch of Utah, the powerful Republican on the Senate Intelligence Committee, defended U.S. support and training of bin Laden. "It was worth it," he told the journalist Robert Windrem. "Those were very important, pivotal matters that played an important role in the downfall of the Soviet Union" (Moran 1998).

Is this Cold War logic the way the world must be? A choice between Communists and Islamists? Between George W. Bush and bin Laden? If so, we are doomed, morally and, thanks to the ever-increasing power of weapons, physically.

What else can we understand about our current situation through the Cold War analogy? The only good it does is to help us comprehend so we can predict, or even shape, what happens next. Analogy is not repetition. The second Cold War isn't any more like the first than the First World War was like the Second, but there were real similarities, and a real relationship, between the two World Wars and we should look for similar links between the Cold Wars.

In the first Cold War there was a disturbing tendency for the two sides to converge; Communists longed to become consumers and capitalists strove for a security state. The second Cold War is also an analogy to the Second World War. Perhaps the lesson to be drawn from World War II, and how easily it turned into the Cold War with nuclear overkill always lurking in the near future, is that hard choices have to be made about allies just as about enemies. The United States and the United Kingdom decided to support the Soviets so that they could bleed the Germans, thus sparing American and Commonwealth casualties. But at what cost? A nightmare for the people who lived in the Soviet empire, occupation for Eastern Europe, and the nuclear race of the Cold War. Short-term solutions often lead to long-term problems. At this point in world history it will take only one catastrophic war based on short-term miscalculations to destroy civilization.

19

The World Wars were about the organization of the international system. The Cold Wars are also about the organization of the world politically. In this case, the allies that have switched sides are the Russians and the Chinese. But that doesn't mean that this struggle is easily won, for the old rules of force don't apply. In postmodern war, God is not necessarily on the side of the big battalions.

What is new beyond the first Cold War? How is postmodern war changing? Manuel Castells, perhaps the greatest sociologist of our information society, has argued that power relations are profoundly shifting because of the centrality of information in all aspects of society. In *The Power of Identity* he argues,

> The new power lies in the codes of information and in the images of representation around which societies organize their institutions, and people build their lives, and decide their behavior. The sites of this power are people's minds. (1997, p. 359)

He continues, saying "projects aimed at cultural codes must be symbol mobilizers," describing two main agencies for doing this: prophets and networks. Prophets can be inspirational and nonviolent, such as the Catalan leader Jordi Pujol or someone such as Martin Luther King, Jr., or they can be revolutionaries such as Subcommandante Marcos of the Zapatistas, or they can be fanatics, such as the Unibomber or bin Laden (p. 361).

But, important as they are, prophets are expendable. It is networks (of people and technologies) that are the prime agency for change now, Castells argues. They are harder to recognize than the centralized movements of the past but are no less powerful for that. Because they aren't grounded on traditional forms of power they are difficult to pinpoint, let alone conquer or defeat. Sounds familiar, doesn't it? But this is not just the problem of this new Cold War. It is the problem with fundamentalism in all its forms. The forces that seek to commodify all life are also a real network and one that is even harder to see clearly than the network of links between bin Laden and Saddam Hussein and, symbiotically, with fundamentalists from totally different creeds.

The world is complex and living. Small events can have gigantic consequences (for example, the butterfly effect), they can forever change everything (singularities, bifurcations), and energies are drawn together around seemingly inconsequential entities (strange attractors) and where beautiful new systems can emerge out of chaos and dysfunction (emergence). It is a world that cannot have perfect information (Gödel, Church-

Turing), where not only do actions change reality but also observation—what we pay attention to—changes reality (Heisenberg). This is why Realpolitik doesn't work. It is based on illusions of pure rationality, crude cause and effect, a disjunction between beliefs and consequences, and, fatally, on very simplistic notions of power. We cannot be so simple-minded any more; the stakes are too great. And a good place to start thinking complexly is in our understanding of technology.

Nuclear weapons are symptoms of postmodern war, not its cause. The firebombing of Tokyo killed more people than were killed in Hiroshima or Nagasaki. It is not any particular technology that makes war too hor-rible to be "politics by other means" any more, it is technology as a whole. And it isn't just weapons of mass destruction, although they are the great-est direct threat. Even small weak groups can use the complex technolo-gies of everyday life to wreck incredible havoc. Without jet planes, and skyscrapers, both of which are totally dependent on computerization on every level from construction to utilization, September 11 would have been impossible. The broadcasting of the attacks and their aftermath around the world instantaneously and continuously, equally dependent on technology, magnified their impact a millionfold. The Vietnamese and the Afghans won against the superpowers because they used appropriate technologies for victory, not the most sophisticated technologies available. And they spent freely of their lives to liberate their homelands and to serve their implacable ideologies.

One other major difference between the first Cold War and the second needs to be emphasized. Victory won't be through the economic collapse of the weaker states this time. The economic troubles in the Third World are the fuel of this fire. The economic success of nations such as Afghanistan and the Sudan would be more of a setback to the hopes of bin Laden and the Taliban then any economic, or perhaps even military, blow could be. This must be balanced by an understanding that unrestrained corporate capitalism with its incredible inequalities and the hyperex-ploitation of humans and nature is not acceptable. We need a new world system that goes beyond postmodern war, the McWorld it nourishes, and the Cold Wars it spawns.

real war and postmodern illusions

POSTMODERN WAR AT THE END OF WAR

Politics is war without bloodshed, while war is politics with bloodshed.
—Mao Tse-Tung

On January 20, 2000, Sergeant Major Philip Stoniger, the last member of the U.S. military mission to Haiti, was withdrawn. For 6 years, since the U.S. invasion in 1994 to restore the elected government of President Jean-Bertrand Aristide, there had been a continuous U.S. military presence. With the departure of Stoniger, a Green Beret, that ended, although temporary humanitarian missions continued. His specialty? Political science (Perry 2000).

Welcome to postmodern war, where war is no longer an extension of politics; today it is politics that is an extension of war. But it is even more complicated than that. War is in the midst of a profound crisis. Only twice before has war changed so fundamentally. Thousands of years ago, ancient war developed from ritual (primitive) war about the time civilization arose. Five hundred years ago, the process that led to modern war was articulated in Machiavelli's call for total political wars. Decisive battles became the goal and total war the norm. With World War II, war became global, battle became continuous, and weapons became absolute. Atomic bombs made it clear that modern war's main assumption, of the political utility of total war, no longer held. Yet, most of the modern war system remains in place: the military-industrial complex, the military mobilization of technoscience, and the assumption that war is still the

most effective political tool available to policy makers. Hence, postmodern war.

The rise of modern war half a millennium ago coincided with the invention of nation-states, the spread of European colonialism, and the triumph of rationalism, especially as formalized in science and engineering. These developments were all related, so it should come as no surprise that the crisis of postmodern war parallels the decline of the nation-state, the collapse of European colonialism, and a growing critique of reductionist rationality. TerrorWar, the rise of the corporations, and deepening globalization are the latest manifestations of collapsing modernity.

In the last 50 years there has been another shift in the fundamental nature of war—the very existence of war is seen by many people as not just unnecessary but as a direct threat to human survival. And for good reason. In "postmodern war," instead of total war there are the resurgence of guerrilla war and its cousins (small war, dirty war, limited war, ethnic cleansing), continuous revolutions in military affairs, and constant production of new electronic and automated weapons. These developments can best be seen in the incredible proliferation of labels (see box) that have been proposed for war and new types of war since World War II.

Atomic War, Nuclear War, Thermonuclear War (various, 19451)
The Cold War (various, 1950s on)
Technology War (Possony and Pournelle 1970)
Militarism U.S.A. (Donovan 1970)
War Without End (Klare 1972)
Permanent War (Melman 1974)
Cool War (Pohl 1981)
AirLand Battle (U.S. Army 1982)
Star Wars (various, mid-1980s1)
Pure War (Virilio and Lotringer 1983)
Mind Wars (McRae 1984)
Postmodern War (Jameson 1984; Gray 1988)
High-Technology War, Technological War (Edwards 1986)
Technowar/Perfect War (Gibson 1986)
Low-Intensity Conflict (U.S. DoD 1986)
Imaginary War (Kaldor 1987)
Time War (Rifkin 1987)
Cyberwar (Davies 1987; Der Derian 1991; Arquilla and
 Ronfeldt 1993)

Computer War (Van Creveld 1989)
Light War (Virilio 1990)
High Modern War (Der Derian 1991)
Space-Age War (Trux 1991)
Hyper-Modern War (Haraway 1991)
War in the Age of Intelligent Machines (DeLanda 1991)
Third Wave War (Toffler and Toffler 1993)
SimWar (Sterling 1993)
Net War (Arquilla and Ronfeldt 1993)
New or Second Cold War (Jurgens-Meyer 1993, Gray 2001)
Information War, Info War, iwar (various, 1990s1)
Fourth Epoch War (Bunker 1994)
Command and Control Warfare (U.S. DoD 1995)
Neocortical Warfare (Szafranski 1995)
Sixth Generation War (Bowdish 1995)
Hyper-Real War (Bey 1998)
Infrastructural Warfare (Wilson 1998)
Knowledge-based Warfare (Gentry 1998)
Netcentric Warfare, Network Centric War (Cebrowski and
 Gartska 1998)
Mimetic War (Der Derian 1999)
Miniature World War, Gulf War I (Virilio 1999)
Cybernetic War (Virilio 1999)
Unrestricted Warfare (Liang and Wang 1999)
New War (Kaldor 1999, 2000)
Asymmetric Warfare (Foghelin 2000)
Cognitive Warfare, Inertia Warfare (Baumard 2000)
Littoral War (U.S. Marines for many years; Graicer 2000)
Non-Heroic War (Luttwak 2000)
Spectacle War, Virtuous War, Late Modern War (Der Derian 2001)
Fractal War (Virilio, in Der Derian 2001, p. 64)
Resource Wars (Klare 2001a)
Internet War (Keenan 2001)
Posthuman Warfare (Lenoir 2003)

New types of war based on new technologies, reprises of modern war, and even the spread of nonstate violence mark these times. Various labels offer important insights. Mary Kaldor explains her idea of "new war" to James Der Derian, a leading theorist of contemporary conflict: "The disintegration of state structures involves the disintegration of the state's monopoly of violence. . . ." But these wars aren't low-tech, even if

they are "small scale . . . dispersed, maybe nonhierarchical" (Der Derian 2001, pp. 73–74). They still use powerful light weapons and excellent communication nets. For example, in the massacres in Rwanda, machete-wielding killers were directed by radio. The same range of appropriate technologies can be used in profoundly asymmetrical wars of small nation-states against empires, as Vietnam and Afghanistan were and Afghanistan and Iraq are now. As the United States and its few allies have found in 2004, low-intensity conflict (the U.S. official military term) remains a very difficult problem to solve. Trying to use technology and force while ignoring politics and culture inevitably leads to defeat for empire.

Der Derian also interviewed Major General Ray Smith, U.S. Marine Corps, who warned a number of years ago that

> In war you fight people not machines. We're training to beat computers, instead of training to beat the enemy. You cannot model the effects of confusion and surprise, the friction and fog of war. (2001, p. 85)

Actually, in low-intensity conflict you want to convince most of the enemy that they are not your enemy, that they are on your side. You want to win their "hearts and minds." Even with men such as Sergeant Major Stoniger, it is necessary for the whole occupying army to be involved, and trained for, the strange kind of struggle counterinsurgency is. Casualties and years of fighting are necessary but not sufficient costs for victory in any serious guerrilla war, such as those in Iraq and Afghanistan. The situation is equally unstable on the other end of the postmodern war spectrum: apocalyptic war.

The contradictions between modern war and the technologies that render postmodern war absurd also make it incredibly dangerous and could well lead to conflict involving nuclear or biological weapons. Even if by some miracle it doesn't, many have pointed out that war is already colonizing civilian culture. The militarization of culture, which Paul Virilio calls "pure war" (1983), is driven by the invention of weapons of mass destruction: "the atomic bomb made necessary the development of the computer bomb, the bomb of totalitarian information" (Virilio 1999, p. 36). Meanwhile, a new kind of war, or perhaps even peace, struggles to be born. What does this mean in terms of politics? If apocalypse is our fate, then all bets are off. If not, there are real possibilities. To sort them out and estimate the chances for their realization, we must understand postmodern war and the driving force at its heart: *perpetual technological revolution.*

THE PERPETUAL REVOLUTION IN MILITARY AFFAIRS

The revolution in military affairs is but a name that has been given to a portion of the long running continuum in military technical development.

—Helprin 1998, p. 98

There has been a great deal of discussion in the last few years about how a *revolution in military affairs* (RMA) is fundamentally changing war. Sometimes it is electronics that drives this RMA, sometimes information, sometimes biology; the specifics seem to vary. The new types of RMA-generated war vary as well: Amorphous virtual war, devastating precision-munitions conflicts, and messy street fighting are just a few of the candidates. But a closer look at recent history suggests that today we have all of these RMAs and all of these wars—that actually there is no single RMA. Rather, since 1945 at least, we have been experiencing a *perpetual revolution in military affairs* (PRMA).

Why a perpetual revolution as opposed to a single revolution or a set of revolutions? Because it is neither one basic change in military policies and practices nor a series of discrete changes as marked the history of modern war. Since 1945 (or earlier; good arguments could be made for 1939 or 1914), when the use of two atomic bombs by the United States on Japan rendered the basic idea of modern war (total mobilization for total war) absurd, the very nature of war has been in constant flux. The different RMAs that have been postulated are really part of a system of continual changes in military technology and doctrine, a futile attempt to overcome the basic contradiction of war today: modern principles in the context of postmodern technologies. This means that Baron Von Clausewitz's modernist slogan "War is politics by other means" no longer applies. Instead, politics has become an extension of war, as Michel Foucault claimed, because since 1941 most countries, especially the United States, have been in a constant national emergency, mobilization, and political militarization.[1] The first Cold War with the Communists has been replaced by a more amorphous second Cold War, ostensibly against terrorism but actually of terror. But the basic structure of the postmodern war system remains the same: no total war but all other types of war, continual technological innovation, increasing speed and lethality (including the proliferation of weapons of mass destruction), the militarization of technology and science, more intimate human-machine systems (cyborgization), the fetishization of information, and ever-increasing fear.

Even though this system of postmodern war is now fundamentally at conflict with itself, it is still dynamic. The dominant doctrines call for perpetual military innovation, bureaucracies are dedicated to it, and the key engine of technological advance—the computer chip—doubles in power every dozen months or so. The "institutionalization of innovation" has met Moore's Law (the geometric increase in computer chip power) with startling effect producing major military innovations continually.[2] As Michael O'Hanlon summarizes,

> The list of military technologies that have emerged since World War II includes helicopters, reconnaissance satellites, infrared-vision devices, laser range-finders and target designators, electronically steered radars, high-performance air-to-air and surface-to-air missiles, the modern jet engine and supersonic aircraft, the cruise missile, the global positioning system, stealth materials and designs, the thermonuclear warhead, and the intercontinental missile. (1998, p. 72)

He goes on to describe these innovations as having an "evolutionary, not revolutionary" impact, but this is not logical. Perhaps his conclusion excludes nuclear submarines, interactive armor, incredibly powerful munitions, extraordinary medical services, drones and remote-controlled aircraft, the militarization of space, and the development of new and more effective biological, chemical, and nuclear weapons of mass destruction. If this isn't a perpetual revolution in military affairs, then what is?

Consider the earlier RMAs. Andrew Krepinevich has given one account of military revolutions throughout history that includes the infantry revolution (14th century), the artillery revolution (15th century), the revolution of sail and shot at sea (14th to 17th century . . . a slow one), the fortress revolution (16th century), the gunpowder revolution (16th and 17th centuries), the Napoleonic revolution (18th century), the land war revolution (19th century), the naval revolution (19th and 20th centuries) and then a series of revolutions between the World Wars (mechanization, aviation, information) and the nuclear revolution afterward (1994). At first revolutions followed one after another, century after century, as infantry supplanted cavalry, artillery took over the battlefield, gunpowder smashed fortresses—continual improvements in effective carnage. But then comes the 20th century and the pace of change accelerates markedly with revolutions running into each other and overlapping until we have today's constant innovation.

The PRMA is a major part of the postmodern war system that, since World War II, has been continually producing deep, if uneven, changes in military doctrines and practices (*affairs*, if you will) without producing complete military superiority on even a temporary basis, let alone permanently. As for perfect security, we know today that there will be no such thing no matter what the RMA, for three fundamental reasons: the fog of war, the limits of information technology, and the postmodern war system.

As the preceding list shows, dozens of new names for war have been advanced since World War II. Cold war, electronic war, pure war, computer war, and information war are just a few of these. The related confusion about what is the "real" RMA is clear in the profusion of different definitions. Is it precision weapons? Electronics? Biomaterials? Nanotechnologies? No, it isn't any one of these, but the various proposed RMAs do make a map of the PRMA and it shows that from the depths of the sea to the orbit of the moon new weapons are constantly being introduced. They lead to, or come from, new theories on war fighting based on new illusions of intelligent weapons and supereffective systems (Gentry 2002–2003). In the real world, a handful of hijackers can kill thousands, and hundreds of thousands continue to die the old-fashioned way in retrowars, hacked with machetes, shot with guns, blown up with iron bombs while weapons of mass destruction proliferate relentlessly.

Mikkel Rasmussen, a Danish political scientist, points out that RMAs "require a transformation of episteme as well as techne" (2001, p. 1). In other words, a true RMA has to change the way we think about war, not just how we wage it. Instead, new RMAs are put forward as solutions to the traditional problems of uncertainty and casualties and how they might change war itself is ignored. Yet war is changing, and these changes are related to a basic "social paradigm shift," as Rasmussen argues, that is revolutionizing the international system with profound implications for international security. War is no longer a separate and clear political instrument that can be used to provide a decisive victory between two state antagonists. It is a messy and limited process in which often even clear "victories," such as the United States overrunning Afghanistan or Iraq, can lead to more problems and confusion and many of the antagonists are not states or even protonations. This is all the more true with our 21st-century PRMA.

Instead of increasing war's utility as a useful political instrument, which is the dream of each new RMA, the continual development of new weapons and systems has become the central driving force of confusing,

asymmetrical, and very indecisive postmodern war. Nowhere is this clearer than with that horrifying category: weapons of mass destruction.

WEAPONS OF MASS DESTRUCTION

By the fifteenth day, the tiny bruises on Ustinov's body had turned dark blue, and his skin was as thin as parchment. The blood pooling underneath began oozing through. It streamed from his nose, mouth, and genitals. Through a mechanism that is still poorly understood, the virus prevents normal coagulation: the platelets responsible for clotting blood are destroyed. As the virus spreads, the body's internal organs literally begin to melt away.

—Alibek 1999, p. 131

Nikolai Ustinov worked at a Siberian bioweapons laboratory called Vector. In 1988 he accidentally injected Marburg virus into his thumb. His horrible death makes him a good symbol for 21st-century weapons of mass destruction.

Biological warfare is not new. Poisoning wells with dead bodies was an ancient tactic, and hundreds of years ago Native Americans were given the blankets of smallpox victims. During World War II, the Japanese and the Germans experimented on humans with bioweapons and the British, Soviets, and Americans researched them as well. Many experts have argued that biological weapons are not so effective and even repeated this during the anthrax attacks of the fall of 2001. But they didn't account for the terror that even ineffectual weapons can spread. Although the death tolls were low, their potential was clear.

In 1942, the Japanese were already experimenting with anthrax on the Chinese in the camps of Unit 731. They discovered that if it infects the lungs the victim can expect first to feel the symptoms of the flu or a cold. Then there is an "eclipse" period in which the initial discomfort recedes. But the bacteria are merely proliferating. Suddenly they release a toxin that fills the lungs with liquid, turning the victim's skin "a faint bluish color." Choking and convulsions follow. As one former Soviet biowar expert notes, "The end usually comes suddenly: some victims of pulmonary anthrax have been known to die in the middle of a conversation. The disease is fatal in over 90 percent of untreated cases" (Alibek 1999, pp. 7–8).

But the infection need not be pulmonary. In 1979, technicians at Compound 19, a biowar plant in the Siberian city of Sverdlovsk, forgot to

replace a clogged filter. Dry anthrax spores, of the military strain 836, were released on the city. Between 66 and 105 civilians died. The exact number is unknown, thanks to the skill of the cover-up, coordinated by the local Communist Party official, Boris Yeltsin. Whereas most of the initial victims died of pulmonary anthrax from inhaled pathogens, some were later infected through cuts on their skin by spores stirred up by disinfection procedures ordered by Yeltsin. The cutaneous infections produce black ulcerous swellings of the skin. If left untreated, the bacteria soon produce toxins that bind to the cells of the body, especially white blood cells, killing them and then the host (Alibek 1999, pp. 76–77). Why make such a terrible weapon whose main target would clearly be civilians? The history of strategic bombing offers an answer.

As with biological weapons, the idea of bombing cities originally provoked great horror among most civilians and military officials. But it is now accepted, not only as a key weapon for war but as a major tool for peacemaking, as the many bombing campaigns show. Even though it was fascists who bombed Guernica and it was Japanese royalists who bombed Shanghai, it was airmen from the great democracies, the United States and the United Kingdom, who bombed Hamburg, Dresden, and Tokyo in such a way as to create artificial weather systems called firestorms that consumed tens of thousands of women, children, and workers. In the 1930s, even while the government of the United States was denouncing the bombing of civilians at Barcelona, Guernica, and Shanghai, the U.S. Air Force was perfecting the B-17 superbomber. Soon after, exiled antifascist Germans and Italians built the atomic bombs with U.S. and UK scientists (Gray 1997, pp. 134–137).

The system that produced strategic and atomic bombing spawned biological weapons. Biological (and chemical for that matter) weapons have not been used as much as explosives because of their seeming ineffectiveness. Difficult dispersal and slow infection rates have made them inferior weapons. But they have been used, and they will be used again if war continues.

Modern war was hard to think about because it was so horrible. Its best critics expressed themselves through literature and art, as we can see with the World War I poets, the great antiwar novels from *Red Badge of Courage* to *Catch 22*, and artists from Goya to Picasso. Postmodern war is even harder to think about because it is so politically indecisive, but on the level of combat it is as horrific as modern war and the potential is even worse: apocalypse.

Yet, it is all based on a discourse, as war has always been (Mansfield 1982). This discourse is articulated in bodies, for without the maiming and destruction of bodies you cannot have war (Scarry 1985). The discourse of war is now in profound crisis. War is no longer acceptable just as ritual, or as nature's judgment on the weak, or even as "politics by other means." Today, war's only justification is peacemaking and peacekeeping, and the proliferation of WMD has called even that into question. What good is rational force in the presence of fanaticism if both have absolute weapons?

Recent and quite predictable advances in biology and weapons platforms mean that in a matter of years biological warfare will be very effective. In particular, the field of genetic engineering promises that soon bioweapons with heightened effects, defined targets (even racially determined), and resistant to treatment can be created by altering and combing existing pathogens. Missile, aerosol, and explosive technologies have improved so much that the delivery of these weapons is no longer the insolvable problem it has been in the past. The high quality of the U.S. anthrax used in the 2001 attacks is proof of this. The molecular biologist Keith Yamamoto and the journalist Charles Piller pointed out in 1988 that genetic engineering was profoundly militarized, that defensive research on bioweapons could easily be converted to offensive (as the 2001 attacks showed), and finally that the only way to prevent the development and spread of genetically engineered biological weapons would be a moratorium on military bioresearch enforced not just by political bodies but by scientific associations as well. Preventing war is too important and difficult to be left to generals and politicians now.

Improvements in technology also explain the recent return of chemical weapons, hardly used since World War I. Saddam's Iraq deployed them against Iran and against rebellious Kurdish villages, and it seems likely they will see more action. Biological and chemical weapons are often called the "poor man's nukes" and there is much truth to this. However, it disguises the fact that biological weapons in particular have more potential than nuclear weapons both for proliferation, because their production is becoming easier all the time, and for destructiveness. A single biological weapon could kill hundreds of millions of people; even the most powerful nuclear weapon could not be so deadly. Still, nuclear weapons have already been used and therefore they are an accepted (if insane) part of international relations. This is why they have continued to proliferate. The fundamental hypocrisy of the nuclear powers—we have nukes and you don't and you can't—has meant that the nonproliferation treaty

is ineffectual at best. It is the technical and domestic political problems that have slowed proliferation but hardly stopped it. Now that India, Pakistan, and North Korea have entered the nuclear "club," it is inevitable that more Muslim and Asian countries will acquire nuclear weapons. That Iraq has not had a nuclear program since 1991 and Libya decided in 2003 not to start one and allow inspections doesn't change the basic situation. As long as some nations have them, and especially if they use them aggressively as threats (as the United States does) or actually in combat (as the United States plans to do), the weapons will continue to spread.

This means that nonstate actors will eventually acquire weapons of mass destruction. Walter Laqueur, a leading "defense" intellectual, long argued that this threat was overrated. In 1999, he changed his position completely:

> The ready availability of weapons of mass destruction has now come to pass, and much of what has been thought about terrorism, including some of our most basic assumptions, must be reconsidered. The character of terrorism is changing, any restraints that existed are disappearing, and above all, the threat to human life has become infinitely greater than it was in the past. (1999, p. 7)

Considering the nonsuccess of the Nuclear Nonproliferation Treaty, we can only expect that similar arrangements for biological and chemical weapons will also fail.

Weapons of mass destruction need to be delivered. In the short term the problem is weapons in boats, in toy planes, in shipments of drugs, in trucks full of cattle. In the long run the weapons will be tiny and potentially anywhere, which makes the U.S. rationale for weapons in space quite suspect.

President George W. Bush came clear with his plans for so-called strategic defense, better known as Star Wars, right before the suicide planes took out the World Trade Center, raising many cynical comments about the efficacy of such a system. In place of the minimalist Clinton proposal, Bush signed on to a full system including sea, land, air, and space components. President Reagan had his own reasons for his Star Wars, but the real goal of both plans is the militarization of space. The powers that be have decided that now is the time to seize the high ground once and for all. Control of near-Earth space is control of Earth itself.

There is no need to reprise here all the arguments against the Star Wars proposals or the militarization in space, but something needs to be said about the particular perspective of the role of information in military

systems of this type because those objections hinge on a pragmatic com-
bination of lived experience with information systems and what we have
decided about information theory itself.[3] In light of the work on the lim-
itations of computers in relation to Star Wars specifically and weapons in
general, and of more general critiques of science and technology, the
faith that the U.S. government and others show in technology is disturb-
ing. They don't care that what they want is deemed impossible now; they
assume that eventually *anything* will be technologically possible.

The limitations of ballistic missile defense in general render the whole
idea of an intercontinental ballistic missile (ICBM) defense nonsensical.
It isn't just that it costs the defender 10 to 100 times more to counter a
deception by the attacker. The idea that any small state or nongovern-
mental organization would choose to deliver weapons of mass destruction
by rocket instead of some other way is simply not credible. The system's
effects are multiple. It isn't just the impossibility of predicting the out-
comes of complex systems, which is discussed in the technical articles.
Rather it is some of the larger effects of ballistic missile defense that are
foreseeable that we should be concerned with.

If the Star Wars system was really meant as a defensive system only
(which is impossible in actual military terms, but one can pretend), it
would be trying to use an impossible technology to solve a horrible prob-
lem that was brought into being by technology in the first place. But,
because the actual goal of the current plans is just to make the next step in
the militarization of space a reality, it is a political goal being met by an
impossible technology. The political goal is to make space the point from
which the rest of the world can be dominated by various weapons, includ-
ing those of mass destruction.

The militarization of space and its domination have been an explicit
goal of parts of the U.S. military since the mid-1940s. Now there is a
consensus at the Pentagon, and it is shared by the rest of the executive
branch and much of the national legislature strengthened immeasurably
by China's decision to become a space power. A Unified Space Command
is in place and there are plans for a Space Force, a new military branch to
join the Air Force, Navy, Marines, and Army.

General Joseph Ashy said in 1996 that

> It's politically sensitive, but it's going to happen. Some people don't
> want to hear this, and it sure isn't in vogue, but—absolutely—we're
> going to fight *in* space, we're going to fight *from* space and we're going
> to fight *into* space. (Quoted in Scott 1996, p. 51, original emphasis)

The Commission to Assess United States National Security Space Management and Organization, chaired by the soon-to-be-appointed Secretary of Defense, Donald Rumsfeld, reported that

> In the coming period the U.S. will conduct operations to, from, in and through space to support its national interests both on the earth and in space. . . . We know from history that every medium—air, land and sea —has seen conflict. Reality indicates that space will be no different. Given this virtual certainty, the U.S. must develop the means both to deter and to defend against hostile acts in and from space. This will require superior space capabilities. (Rumsfeld et al. 2001)

The National Missile Defense and its resulting occupation of space by the U.S. Space Corps are deemed necessary in order to avoid a "space Pearl Harbor." So defensive "preemption" becomes the rationale for the abrogation of the treaties preventing war in space and the beginning of the military exploitation of "the last frontier," which is fortunately infinite. To its supporters, it seems inevitable.

> It is our manifest destiny. You know we went from the East Coast to the West Coast of the United States of America settling the continent and they call that manifest destiny and the next continent if you will, the next frontier, is space and it goes on forever.
>
> —Senator Bob Smith (R–New Hampshire), Senate Armed Services Committee (quoted in the documentary, "Star Wars Returns," February 2001)

Militarizing space is just part of a major refocusing of military priorities for the United States. Down the line, we can expect that nanotechnology could produce new types of weapons of mass destruction, and from space effective lasers could do very bad things, but these are far enough away that we need not worry about them for a decade or so. Meanwhile, defense intellectuals and established militaries have been flogging a new type of war, based on information, and promising easy, maybe even bloodless, victories.

INFORMATION WAR AND REAL COMBAT

War is not an intellectual activity but a brutally physical one. War always tends towards attrition, which is a competition in inflicting and bearing

> bloodshed, and the nearer attrition approaches to the extreme, the less
> thought counts.
>
> —Keegan 2003, p. 321

The fighting in Iraq, and Afghanistan to a lesser extent, is certainly tend-
ing toward attrition, although the United States keeps hoping that infor-
mation war doctrines and technologies will lead to victory. At first glance,
what victory would be in Iraq is unclear. The official reasons for the pre-
emptive invasion—WMD and terrorism that threatened the United States
—were unconvincing even before they were revealed by events to be
totally bogus. The real reason is probably summarized nicely by *Wall
Street Journal* reporters Robert Greenberger and Karby Leggett: Bush's
"dream is to make the entire Middle East a different place, and one safer
for American interests" (2003, p. 1). Iraqi oil is just part of this equation;
geopolitical strategy and cultural factors are even more important. The
reasons behind the inevitable failure of this policy are revealing and have
much to teach us about the differences between naive technophilic mili-
tary doctrines and real war. The plan to gift Iraqis with a model capitalist
democracy runs into a number of complicated realities.

The actual impact of the U.S. occupation has been to strengthen anti-
U.S. forces and sentiment throughout the Muslim world and to alienate
the United States from many of its most important allies. It has also led to
U.S. acceptance of Israeli and Russian policies against Palestinians and
Chechens that are equally unpopular and that fuel Islamist claims of an
anti-Muslim Crusade.

Effective antiguerrilla operations and nation building involve accept-
ing continued U.S. casualties, something that is politically unpalatable in
the long run. Fear of casualties and faith in information as a force multi-
plier have led the United States to recruit former members of the Iraqi
security services (*Washington Post* 2003), to torture prisoners, and to plan
assassinations and terrorist operations of its own with Israeli advice
(Hersh 2003). Decisions such as these, to fight terrorism with terrorism,
will certainly haunt the United States for years to come.

In any event, the U.S. military is unsuited for nation building, as
Wesley Clark has argued convincingly. It was built to fight big wars, not for
peacekeeping operations (2003). Turning the U.S. military into a "military-
entertainment complex" (Lenoir 2003, p. 175) or a "military-industrial-
media-entertainment network" (Der Derian 2001, p. xi) through
embedded reporters and the like may help sell wars in the short run, but
it won't sell them in the long run (when the soldiers turn against the war

and tell their friends, the reporters, all about it), and it won't help win them, ever.

Turning the war and occupation into a profit center for favored Republican corporations has meant bad food for the soldiers (Krugman 2003) and an incompetent cost-plus "state socialism" war effort. Although the United States does make good money selling weapons—it is the world leader and raked in $57.8 billion between 1997 and 2001 and has the biggest "private" military companies (mercenaries, not weapons makers) that are expected to reach over $200 billion in "sales" by 2010—it doesn't translate into effective military power (Johnson 2003, pp. 54, 56).

All theories of information-focused war, whether they are net war, virtual war, cyberwar, shock and awe, or massive special operations ("manhunts" as Rumsfeld likes to call them), are impoverished, instrumentalist, wishful thinking. Political, psychological, and cultural knowledge, and real sacrifice, are needed for anything other than a short-term occupation against a population that doesn't want to be occupied. While the United States focuses on Iraq, the Islamists work toward new terror strikes and strive to destabilize Muslim countries such as Pakistan (with its nuclear weapons), Indonesia (the largest Muslim country), and Saudi Arabia. The attacks on the Indian parliament and assassination attempts against the Pakistani leadership are much more dangerous, and effective, moves in the TerrorWar than the U.S. conquest of Iraq, which, when all is said and done, may well end up a defeat for the West.

The real role of information in postmodern war is more complicated than U.S. doctrine would have it. The technology is only one small piece of it, and it is more important to have the appropriate technology than the state of the art. Two days before Christmas 1999, the British Broadcasting Corporation (BBC) reported that the Revolutionary Armed Forces of Colombia (FARC), a Marxist guerrilla group, was year 2000 (Y2K) compliant. Juan, FARC's systems manager, proudly announced that they had upgraded all of their complex databases, which chart kidnappings among other things, to Windows 2000. Thanks to satellite telephones and laptops, FARC maintains "Internet access even in the most remote jungle camps" (McDermott 1999).

FARC's wired status shows why it cannot be denied that computerization is changing war. But does this mean that a whole new type of war, info or net or cyber, has been created? No. These new war theories come out of two interrelated crises. First, there is the growing power of information technologies in contemporary culture causing numerous economic and

political dislocations. Second, there is the crisis of war itself, which has reached its *reductio ad absurdum* in postmodern war.

It was globalization that triggered the deluge of information war theories. In the 1990s two RAND researchers, John Arquilla and David Ronfeldt, noticed that the Zapatista movement in Mexico was using the Internet to mobilize international support effectively. They stitched together a set of theories that took certain aspects of postmodern war—the centrality of information, the world communications system, the claim that politics (domestic and international) is now war by other means, the proliferation of undeclared wars and conflicts, the spread of war to every possible battlefield—and made of them absolutes. For a while there was a veritable craze for info/net/cyber war and, no coincidence, massive funding requests to prepare for these "new" types of war. But now that the hysteria has worn off and the funding is in place, information war approaches are being integrated into contemporary war practices and the idea of war fought totally in cyberspace has been abandoned. But illusions persist; the latest version, netcentric war, still promises much more than it can deliver, as Iraq demonstrated.

U.S. confusion about the real uses of information war can be traced, in part, to the shift public attention can bring to conflicts. It actually demilitarizes them somewhat by limiting the usefulness of military means. The worldwide media attention the Zapatistas and their groups focused on Chiapas, along with the influx of rights activists to the area, sharply curtailed the Mexican government's ability to respond violently. What in other times would have been a bloody insurgency turned out to be a largely nonviolent conflict (Mathews 1997, p. 54). José Angel Gurría, Mexico's foreign minister, concluded, "The shots lasted ten days and ever since the war has been . . . a war on the Internet" (quoted in Mathews 1997, p. 54).

During the conquest of Iraq, much was made of the embedded reporters making the war "real" and the incredible "shock and awe" power of the netcentric coordinated juggernaut that overran Iraq. But once the first rush was over and combat devolved into guerrilla war, public support fell. Massive coordinated firepower is as apt to produce more guerrillas and supporters as deter or kill them. In low-intensity conflict, quality information is as difficult to obtain as it is valuable.

In the United States, the Unified Space Command has been put in charge of information war operations. This seems logical because, in many ways, control of cyberspace is similar to the control of outer space in its relationship to traditional battle, but it is nonsensical in terms of the

real world. Massive intelligence (i.e., information) failures have marked U.S. policy since 1945. The list is long: the Eastern European uprisings, the Korean War, the Soviet-Sino split, the Vietnam War, the Soviet defeat in Afghanistan, the collapse of Communism, the attacks of September 11, finding Osama bin Laden, the nonexistent WMD in Iraq, and taking months to capture Saddam Hussein.

Putting information war operations under the Unified Space Command is a continuation of the overreliance on electronic information at the expense of real knowledge and accurate theories about the world. The United States seems to want to win wars with systems and high technology, not with real understanding. During the 1999 bombing war against Yugoslavia, the United States used offensive "cyber war" weapons. Although Army General Henry Shelton, the chairman of the Joint Chiefs of Staff, did not specify what they were, one can assume various viruses were sent to try to disrupt and disable Yugoslavian command and control and air defense systems (Associated Press 1999b). The mixed results of the Serbian operations show just how limited infowar operations can be. Other than some hacking attacks on pro-Serbian and pro-Kosovo Web sites, there seems to have been little that was new in the Yugoslavian campaign.

The same was true of the sweep into Iraq. A few more drones were used, a bit more coordination of mobile elements than in earlier campaigns, but all in the presence of an incredibly degraded opponent, operating without air cover in an already truncated national territory that had been recently defeated, then bombed and kept under surveillance for a decade.

War, as a very complex and volatile system, cannot be controlled, it cannot be managed, and it cannot be predicted. This is as true of "real" bloody war as it is of virtual "cyberwar," as if any war that didn't damage and destroy bodies could really be called a war. So, although information war will not happen, "regular" wars will not happen either. As the first advocates of infowar point out, "Look around, no 'good old-fashioned war' is in sight" (Arquilla and Ronfeldt 1997, p. 1).

The push for automating and informating war continues unabated, despite the continued decline of military force as an effective political instrument. For every instance in which a political leader might be pressured into changing policy through military action, as Slobodan Milosevic was with the massing of North Atlantic Treaty Organization (NATO) troops during the bombing, there are many more cases of the utter failure of military action to achieve political goals, even with overwhelming force superiority. Somalia is a good example.

Abokoi could see the mob descend on the Americans. Only one was still alive. He was shouting and waving his arms as the mob grabbed him by the legs and began pulling him away from the helicopter, tearing at his clothes. He saw his neighbors hack at the bodies of the Americans with knives and begin to pull at their limbs. Then he saw people running and parading with parts of the Americans' bodies. (Bowden 1999, p. 195)

This account of the downing of a U.S. helicopter in Mogadishu, as seen by a Somali wounded by helicopter fire, is in Mark Bowden's book *Black Hawk Down*. It illuminates several other strange dynamics of contemporary war. When the Black Hawks were shot down, incredible efforts were made to retrieve the bodies of the crew. In postmodern war a veritable fetish over the bodies of the dead soldiers has developed in the militaries of the industrial world. It seems eerily familiar to the homage that we see paid to the dead by primitive warriors who believe that the unhonored dead cannot rest. In ancient war defilement was horrible, as the *Iliad* makes clear with the dragging of Hector's corpse around the walls of Troy by Achilles, much as the Somalis dragging the dead American soldiers through the streets of Mogadishu horrified not just the world but even many Somalis.

Such honor for dead bodies has not always been the practice. In fact, often during modern war's history the corpses of the dead were left to rot where they fell. Years after Waterloo, English contractors collected the bones of the dead from both sides, ground them up, and sold them to fertilize English gardens (Ignatieff 1997, p. 113). Yet now there is an absolute mania to recover the dead, even to the extent of assuming that if their bodies cannot be found, they are hidden away in some secret enemy camp. This is denial of what war does, denial of how horrible war is, denial of how fragile all our bodies are. The only way war can survive today is to deny what it does to soldiers and what it might do to us all.

Seemingly far removed from massacred pilots and the heroic efforts to retrieve their bodies are stories about little portable computers, Palm Pilots, which the Associated Press (2001) tells us are sweeping through the U.S. military. The Navy issues them to all graduates of Annapolis and most other officers. Palm Pilots are now playing a major role in facilitating the incredible information flows that the U.S. Navy depends upon. This shows how computer dependent the contemporary military is. From sea, air, land (SEAL) commandos to tank mechanics to stealth bomber pilots, all jobs in the military today integrally involve computers and other technologies in intimate integration with humans.

Despite tenacious resistance, this computerization continues, and it seems that it will eventually remove most pilots from the sky and put them on the ground controlling vehicles from afar and will replace the majority of ships crews with a few sea "pilots" who will practically "fly" large ships with the help of complex automated equipment (Gray 1997). The import of these changes cannot be trivialized, especially when you consider how pilots dominate the U.S. Air Force and Navy politically and how much they love to fly. But the pressure to minimize casualties through maximizing technology is irresistible, even if it hasn't been proved militarily. Quite the reverse is true. Again and again, close analysis shows that the highest technology can't win the simplest conflicts, such as the fighting in Somalia. In one revealing incident, during the raid that led to the destruction of the two Black Hawks, the rescue convoys were being controlled from the air. Instead of going straight to their objectives, they were routed around and around through ambushes and back through them again because the big high-technology troop carriers couldn't fit down many streets and the controlling observers, high above in helicopters, couldn't really see what was happening on the ground (Bowden 1999, p. 112).

For all the flash of high-tech cyborg systems, war is still political and it always comes down to what is done to messy bodies. Consider another incident from the fighting in Mogadishu:

> Then there was the woman in a blue turban, a powerful woman with thick arms and legs who came sprinting across the road carrying a heavy basket in both arms. She was wearing a bright blue-and-white dress that billowed behind her as she ran. Every Ranger at the intersection blasted her. Twombly, Nelson, Yurek, and Stebbins all opened up. Howe fired on her from further up the hill. First she stumbled, but kept on going. Then as more rounds hit her, she fell and RPGs [rocket propelled grenades] spilled out of her basket onto the street. The shooting stopped. She had been hit by many rounds and lay in a heap in the dirt for a long moment, breathing heavily. Then the woman pulled herself up on all fours, grabbed an RPG round, and crawled. This time the massive Ranger volley literally tore her apart. A fat 203 round blew off one of her legs. She fell in a bloody lump for a few moments, then moved again. Another massive burst of rounds rained on her and her body came further apart. It was appalling, yet some of the Rangers laughed. To Nelson the woman no longer even looked like a human being, she'd been transformed into a monstrous bleeding hulk, like something from a horror movie. (Bowden 1999, pp. 217–218)

This is war. Call it what you will: postmodern, cold, low-intensity, asymmetrical. This is terror.

ASYMMETRY

Wars are almost always asymmetrical; that is why somebody wins and somebody else loses. But when Colin Gray claims that therefore "asymmetry essentially is a hollow concept," he is being willfully obtuse (2002, p. 5). What makes asymmetry such an important idea now is that many different types of and approaches to war exist in the postmodern war system. The old solution of the militarily dominant combatant, total war even to the point of genocide, is no longer an option (not that is hasn't been tried even recently). So, more than ever, war is political, not technological. This is why the greatest military power in world history and the second greatest both lost wars to relatively tiny opponents (Vietnam, Afghanistan). The conflicts were so radically asymmetrical that the great military advantages of the United States and the Soviets (based on such revolutionary weapons and ideas as helicopters and vertical envelopment and the electronic battlefield) weren't enough to overcome the fundamentally political rules. When the political situation is favorable, as with the U.S. war against the hated Taliban (hated by the Afghans most of all) or the degraded and disgraced regime of Saddam Hussein, easy victories are forthcoming. But the same opponent, in a different situation, can be deadly. Or one's opponents can morph, from anti-Shah students into Islamist mullahs in Iran or from Bathists to Iraqi nationalists. War is never simple and it never stays still—to forget this lesson is to court disaster.

One of the common themes of RMA advocates is that the right RMA will do away with the "friction" of war, Baron von Clausewitz's term for war's uncertainty. Even Michael O'Hanlon, a critic of RMA advocates and their talk of achieving "complete situational awareness," "full-dimensional protection," "agile, rapidly deployable, automated, precise, and long-range strike force[s]," and "spacepower" anchoring the "reconnaissance-strike complex," claims that "We should not ignore the promise of high technology and resign ourselves to operate forever within Clausewitz's famous 'fog' of war" (1998, pp. 2, 3, and 12).

But the fog of war will never lift because it is generated by the three main "problems" of war: your side's behavior, your antagonist's behavior, and nature (physics, biology, weather). How will your soldiers act in the

face of death? How will your machines perform? What will your enemy do and how will they react to what you do? How well will they perform? What will the weather be? These questions are not completely answerable, let alone predictable or controllable. They never will be. In terms of information theory, these are incomputable, complex systems. War is an intractable problem conceptually; really, the only way to know how a war is going to come out is to fight it.

RMA theorists, such as those O'Hanlon criticizes, want to shape U.S. military policy around weapon systems that will give complete situational awareness, full-dimensional protection, precise targeting, and so on. Complete, full-dimensional, precise . . . in other words, perfect information.

This impossible dream has inspired the militaries of the postindustrial nation-states into developing a whole range of specific technologies (electronic battlefield, robotics, intelligent munitions) and information-saturated doctrines (AirLand Battle, InfoWar, Netwar). War, however, remains stubbornly confusing and quite bloody. The experiences of the United States in the Middle East show this quite clearly; from the wounding of the USS *Stark* to the war hunt in Afghanistan against the Taliban and Al Qaeda to the guerrilla war that haunts Iraq following the death and capture of the Husseins, things have never turned out as predicted. No plan or illusion survives contact with the enemy or even the future.

Once, battles were won by the god-favored and the brave, or so the story goes. Magical weapons helped, but internal qualities and just blind luck were more important in most people's view. Yes, Sun Tzu, the ancient Chinese philosopher of war, and his commentators knew better, but history shows that few generals, let alone soldiers, fought war as intelligently as Sun Tzu analyzed it. Still, in mass hand-to-hand combat the dedication of individual soldiers did make quite a difference; it was often decisive. Even clever generals played their role. As modern war supplanted ancient, however, the power of the weapons (increased through a series of RMAs), especially their force of fire, became crucial. War became more a matter of logistics and stubbornness than of élan, culminating in the industrial slaughters of the World Wars, the mirror image of industrial production.

In postmodern war, information has become the ideal, the main "force multiplier," as the military likes to say. The approach to it has usually been industrial (more is better) and often it has succumbed to the illusion that there might some day even be enough (perfect) information, although one of the few things we know about the nature of information

is that it can *never* be perfect, thanks to the various paradoxes of representation, meaning, and systems (i.e., information) in general, discussed in Chapter 4.

Almost every theory of the current globalization process implicates information technology (IT) as its primary engine. IT is also the culprit in most of the numerous proclamations that we are experiencing this or that RMA, and it certainly underlies postmodern war. Yet, the discourses that analyze globalization and contemporary war are seldom brought together. This has to change, for they are part of the same sociological and technological phenomena that have produced our so-called information society.

One can look at the elements of postmodern war (Gray 1997, pp. 68–94) and see that they do map closely onto the current globalization process. These are among the most salient:

- The central role of information and information technology. IT underlies the PRMA and the global economy.
- An increase in the speed of transactions and processes, leading to an increase in the pace of globalization and in RMAs that hope to dominate battle through more, and better, information sooner.
- A bricolage of different forms of war and politics from the totally new to the very oldest. In modernity the nation-state and total war were the dominant forms; in postmodernity, corporations, regional alliances, tribes, nations without states, nongovernmental organizations (NGOs), international governmental institutions, networks, and ethnicities share power and propagate various types of organized violence from mass rape to nuclear coercion.
- Increased human-machine integration (cyborgization). This is at the heart of new business practices, most new military technologies, and the self-conceptualization and actualization of many individuals and groups worldwide.
- The lack of any one unifying narrative, in politics, in religion, or in military affairs, hence the proliferation of RMAs without any one RMA being clearly the answer.
- A complexification of gender. The proliferation of IT-driven systems has allowed the integration of women into most military occupations and civilian jobs. Physical strength is now much less important in war and in work than skill and intelligence.
- Peace as the main justification of war. So security becomes dependent on risking the whole planet (as with the nuclear arsenals and ideas such as preemptive war), and war proliferates into culture.

These doctrines are almost always based on unrealistic expectations of RMAs, such as the nuclear RMA and now the precision weapons RMA.

Clearly, the problem of postmodern war is the problem of our current globalization process and the international system that is framing it—a strange stew of empires, nation-states, giant corporations, international alliances and NGOs, and nonstate military actors (also known as the terrorists of official discourse).

globalization: who will rule the world?

EMPIRES

Empire is formed not on the basis of force itself but on the basis of the capacity to present force as being in the service of right and peace.
 —Hardt and Negri 2001, p. 15

Indeed, the word "empire" has come out of the closet.
 —Joseph Nye 2003, p. 60

Empire has never gone completely out of style. In fact, in the early twenty-first century, it has become quite popular for describing the current international system. In particular, there is a growing recognition that the United States is an empire.[1] Of course, most of the world saw the United States this way already, but it comes as a bit of a shock to the "homeland."

The "new" U.S. empire is usually linked to the claim that it is the only remaining superpower and will continue the civilizing missions of the British and Romans—Pax Americana. There are two major fallacies in this story: that the United States is uniquely powerful and that its imperial goal is spreading democracy.

The power of the United States in the early twenty-first century is greatly overrated. It is true that it deploys amazing cultural, economic, and military resources, but their efficacy is very limited. Culturally, there is no instrumental power. Economically, U.S. power is awesome and is very good for forcing bad deals on Third World countries, yet it too is difficult to bring to bear consistently and directly, especially on the other great

powers. And the United States is as dependent on the world economy as the world economy is dependent on it. But it is in terms of military power that the United States is most overrated.

Consider these statements from three different articles in an issue of *Foreign Affairs,* the premier policy journal in the United States, after the fall of Baghdad:

> If anyone doubted the overwhelming nature of U.S. military power, Iraq settled the issue. (Nye 2003, p. 60)

Joseph Nye is Dean of the Kennedy School of Government at Harvard University. His hubris was matched by that of Max Boot, a fellow at the Council of Foreign Relations, who gushes despite the overwhelming odds they faced in conquering Iraq:

> That the United Sates and its allies won anyway—and won so quickly— must rank as one of the signal achievements in military history. (2003, p. 44)

"One of the signal achievements in military history"? The overrunning of an emasculated and incredibly unpopular minority regime by the gigantic and expensive U.S. military machine? And what of the bloody quagmire that followed? Finally, the last imperial enthusiast in the issue draws a purported lesson from the great U.S. victory:

> American hawks were right. Unilateral intervention to coerce regime change can be a cost-effective way to deal with rogue states. (Moravcsik 2003, p. 74)

The cost has just started coming due in good will, broken bodies, and lives, not to mention dollars. Dollars can't buy zero casualties anyway. Yet, even liberals have bought into this myth of the military colossus. Benjamin Barber's generally fine book on the danger of making fear the central engine of U.S. foreign and domestic policy, *Fear's Empire,* includes a bevy of pompous announcements on U.S. power, including "American hegemony is not in question" (Barber himself), "The U.S. makes the rest of the world look Lilliputian" (Tim Wiener), ". . . the only nation that polices the world" (Michael Ignatieff), and ". . . sole global power" (Walter Russell Mead) (2003, p. 19). The reality is that although U.S. military spending far

outstrips that of its top five rivals and allies and, on paper, its military is stronger than that of the top 15 next-strongest nation-states, the great empire is remarkably constrained in terms of its military options.

First, as the fighting in Afghanistan and Iraq shows, militarily and politically the United States can barely handle two small, low-intensity conflicts. Obviously, its ability to go adventuring militarily is quite limited. Second, it isn't the only superpower or empire by any calculation. China, Europe, and Russia have large militaries and nuclear weapons and have to be considered superpowers. India, Pakistan, Israel, and North Korea have nuclear weapons and so are immune from attack. China is clearly an empire, and one could argue that Britain and Russia are as well. Neocolonial and other structures of domination mark the relations between France and its old empire. And in Africa and Asia there are so-called nation-states (Nigeria and Indonesia are good examples) that are really more like tribal or ethnic empires than anything else. Empire is more complicated than a simple U.S. *über alles* story.

The old "new leftists" Michael Hardt (an American professor) and Antonio Negri (a formerly imprisoned far-left Italian revolutionary) have put forward a gigantic neo-Marxist analysis of the current world system called, simply, *Empire.* Their "empire" isn't the traditional system of domination emanating from one nation or nation-state. Instead, it is a new organization for the world economy. As the book's blurb proclaims:

> Imperialism as we knew it may be no more, but empire is alive and well . . . the new political order of globalization should be seen in line with our historical understanding of Empire as a universal order that accepts no boundaries or limits. (2001, back cover)

It is very radical indeed, being postmodern with shifting identities and hybrid forms. Opposed to it, in fine dialectical fashion for this is still a Marxist analysis, is the multitudes. Not a class, not the people. . . . A bit like civil society but, no, not that either. Actually, it is a bit hard to get a handle on the multitudes, something a number of critics have whined about.

The tremendous popularity this book has garnered on the Left since being published (in English by Harvard University Press, ironically enough) is strange for a number of reasons, most notably that, as Negri himself points out, it doesn't describe the current situation but rather one that Hardt and Negri think is coming. As Negri told the Italian interviewer Ida Dominijanni, the current aggressive U.S. empire is a throwback, "A

regressive backlash contrary to the imperial tendency. It is an imperialist backlash within and against Empire that is linked to old structures of power . . . " (Negri 2003).

So, proof of the thesis will apparently have to wait. Meanwhile, it is notable that with a lot of Marxist contortions *Empire* does reach some surprisingly postmodern and anarchist conclusions. Apparently the postmodernism is acceptable now in the academic Left, but Hardt and Negri felt compelled to put in several pages explaining that they weren't anarchists, all evidence to the contrary.

A better book is Alain Joxe's *Empire of Disorder*. His is a truly postmodern work, so it is short on absolute conclusions, but in the details of his analysis he helps us notice some crucial things about our world: the incredible instability, the viciousness of war ("atrocious little wars" he calls them), the reality of military power, and its limits for making political solutions. No one will agree with all his points, but the careful reader will learn from them, whether agreeing or not. His critique of Hardt and Negri's *Empire,* for example, is spotlighted in the following:

> I do not think they have taken the military question seriously enough. They have a somewhat idealistic vision, perhaps even a Clintonian vision, of the expansion of the capitalist system. (2001, p. 74)

The battles of Afghanistan and Iraq certainly support Joxe's critique. Globalization also seems much more the confusion he describes than the clear system Hardt and Negri try so hard to bring to life.

NEOLIBERAL GLOBALISM

> The rules of the game in international relations are changing and the origins of an extraordinary number of those changes can be traced to the Information Revolution.
> —Rothkopf 1998, p. 325

> [T]he neoliberal vision of "globalization" is pretty much limited to the free flow of commodities, and actually increases barriers against the flow of people, information, and ideas.
> —Graeber 2001, p. 12

Human globalization started when our prehistoric ancestors first left Africa, but there is no doubt that today's globalizing process is quantita-

tively and qualitatively different from anything before. The level of communication, even integration, between the humans of the world is undoubtedly the highest ever by an order of magnitude and it is increasing. This would be impossible without the incredible new IT-driven transportation and communication technologies, the same technologies that lie behind almost every RMA being advocated.

Of course, the amount any particular person, family, clan, village, or tribe is integrated into the global grid (net, community, economy) varies enormously. Still, the world (of people) is knit together today in a fundamentally new way. We can even talk now of one human polis, one political community, inhabiting our one world, which is indeed one living system. This polis is pretty chaotic. What coordination there is politically is through the United Nations (UN) and a few dozen other international networks that are usually military (NATO) or economic (World Trade Organization [WTO], International Monetary Fund [IMF]). The most important connections between people are personal and take place outside the established lines of political and economic authority. The lifeblood of the international polis is the constant movement of people, ideas, and goods between the communities of the world.

This world polis is one of profound inequality. There is no need to rehash the incredible numbers here, but suffice it to say that the great wealth of North America, Europe, and a handful of Asian economies such as Japan makes it clear that it is a very asymmetrical world system indeed. There is resentment of this in many parts of the world.

> If there is any symbolism in the collapse of the World Trade Center, it is not that the Twin Towers stood for capitalism per se, but of *virtual* capitalism, of financial speculations disconnected from the sphere of material production. The towers symbolized, ultimately, the stark separation between the digitalized First World and the Third World's "desert of the real." (Slavoj Žižek, 2001, p. 25, original emphasis)

Nowhere is it as widespread as in Muslim regions, as recent history has shown.

> It is sad to say that Arabs in particular and Muslims in general are the biggest victims of globalism in all its forms, economic, cultural, and security. (Abud-Bari Atwan, quoted in Bodansky 1999, p. 290)

Atwan, an ally and a confidant of Bin Laden, elaborating on globalism, says, "culturally, CNN and the Internet have begun to rule the world. The

American event and its instruments have changed Arab cultural life completely." The particular enemy of the Islamists is the younger generations of military officers and intellectuals who have been "indoctrinated" by Europe and America. They want to "join in the modern globalism." Their most obvious traits, according to Atwan: "ability to use the computer, belief in policies of market economy, permanent decisiveness, and the continuation of the Hebrew state." Some Islamist intellectuals call this process "Westoxication" (Bodansky 1999, p. xiv). Atwan concludes that only Islamist terrorism, exemplified by Bin Laden, can hope to defeat globalism.

Although the Islamists feel attacked, their goal is not defensive, it is expansionistic. Not only should all current Muslim countries become fundamentalist Islamists, they should be united in one *khilafah* . For most of the Islamists it should include any lands that were once Muslim, including most of Spain (*al Andalus*) and most certainly Israel. Even this is not enough for some. A leading Iraqi Shiite scholar, Ayatollah Muhammad Baqui al-Sadr, argues, "The world as it is today is how others shaped it. We have two choices: either to accept it with submission, which means letting Islam die, or to destroy it, so that we can construct the world as Islam requires" (Quoted in Bodansky 1999, p. xiv). Sheikh Assam, one of Bin Laden's mentors, is just as clear. He declared,

> Jihad must not be abandoned until Allah alone is worshiped. Jihad continues until Allah's word is raised high. Jihad until the oppressed peoples are freed. Jihad to protect our dignity and restore our occupied lands. Jihad is the way of everlasting glory. (Quoted in Bodansky 1999, p. 10)

However, something else is raised high in the world today, and it isn't godly unless, as some Christians have claimed, God supports the "free" market. What name should we give this currently dominant spiritual-political order? "Empire" and "McWorld" were covered earlier, and the "informational capitalism" of Castells and "hypercapitalism" of Rifkin will be discussed later. "New world order" is not descriptive enough. "Monopoly capitalism" leaves so much out; although capitalism strives for monopoly, it usually achieves only significant market share at the most. Perhaps "neocapitalism" is a good compromise or "neoliberal globalism?" Why "neoliberal?" The Zapatistas and their supporters have done a great deal of work to spread the label and they have some useful comments.

In a charmingly named e-mail ("What is Neo-Liberalism and How to Go to Globalization Conference in Cuba this November"), Elizabeth

Martinez and Arnoldo Garcia explain, "Neo-liberalism is a set of economic policies that have become widespread during the last 25 years" (August 8, 2001). They are exemplified by:

1. The rule of the market
2. Cutting public expenditures for social services
3. Deregulation
4. Privatization
5. Eliminating the concept of public good or community

When you consider how these policies are linked to the ideology of the free market, which its proponents claim is an integral and necessary part of freedom itself, you can understand the sweeping changes being called for by neoliberalism. The citizen is set to be replaced by the consumer.

Clearly, nationalist and religious systems are not the only ones vying for the right to define the body politic in contemporary nation-states; there are economic conglomerations as well. Many observers see nationalism as declining and predict that the defining institutions of the future will be the industries that meld great skill at information processing and personnel management into tremendous profits and powers. Corporations are legally recognized as individuals in the United States;[2] in global terms a company such as Microsoft is as much a sovereign state as Luxembourg, perhaps more so; and the big oil companies are more involved in foreign policy negotiations and diplomacy than many UN members.[3] These corporate bodies are spread over vast areas, linked by computers, faxes, and other communications technologies. Along these nets (made of copper, glass, and wavelengths) real power flows, strengthening the corporate version of the world. Not only do multinational corporations seem to be accruing sovereignty, but they are forming great alliances of corporations that seriously challenge all but the most powerful countries.

This has led to a role reversal between the state and the corporation. The axis of competition is shifting from nations to corporations, and so is economic initiative and power. Richard Gordon, the late political theorist, marked four major aspects of this "new world economy":

1. The importance of telematics. In other words, information, especially in terms of the telephones, faxes, modems, and computers that make transnational corporate alliances possible.
2. The liberation of investment and the liberalization of credit.
3. The globalization of production.

4. The shifting material logic of production. Specifically, the increasing research and development costs, the shortening of production cycles, the change in demand structures toward diversity and variation, and the convergence of much production technology. (1989)

As corporations form mega-alliances, the capitalist class (yes, the people who control capital) unite on a different level in a number of different political bodies, often disguised as private clubs or public service organizations (the Davos meetings) or international groups (Trilateral Commission, WTO, IMF). They manifest their power by controlling funds; by setting standards, tariffs, and regulations; and by the ideological shaping of the economy of the future. This is one of the most potent weapons at its most public: economic and political influence. In both these realms money and physical force are important, but so is rhetoric, known today as marketing. Back in 1980 Holly Sklar pointed out,

> Marketing—the art of repeatedly displacing and creating new "needs"—is the key to expanding consumption. But it is more. Marketing, like militarism, is a means of managing social change. (p. 20, original emphasis)

With the end of the capitalist/communist Cold War, the possibility of a world dominated by a Pax Americana seems quite real at first glance. But in reality, it is to be a world dominated by markets. Iraq, for example, is most important as a geostrategic and cultural base in the heartland of the Arab market. It is important for oil, of course, but also as a consumer of military and civilian goods. This centrality of markets in all decisions, social, cultural, and political, has begun to disturb a wide range of observers. As Manuel Castells notes,

> At first sight, we are witnessing the emergence of a world exclusively made of markets, networks, individuals, and strategic organizations, apparently governed by patterns of "rational expectations" (the new, influential economic theory), except when these "rational individuals" suddenly shoot their neighbor, rape a little girl, or spread nerve gas in the subway. (1998, p. 355)

Rational people also lie, cheat, and steal with regularity and even promulgate stupid and immoral wars and commit other murders for ideology and for profit. This raises an important question: If capitalism is so great, why does it manifest such despicable values? Everything is commodified. A few minutes of watching television will reveal the most bizarre

images: a man who makes his baby cry so he can drive his new van; people worshiping a new car; processed and spiced meat (Slim Jims) as a powerful drug; lite beer that is better than love; and finally, the enigmatic slogan "drive = love."

The hubris of the corporations mirrors their rise and the continuing decline of the state. Some observers claim that states will continue to survive in this new world order because their role is to serve corporations.

> The state is not disappearing, it is disaggregating into its separate, functionally distinct parts. These parts—courts, regulatory agencies, executives, and even legislatures—are networking with their counterparts abroad, creating a dense web of relations that constitutes a new, transgovernmental order. (Slaughter 1997, p. 184)

Is this the state we know? Hardly. If it stays on in some vestigial form, as with today's English monarchy, it won't be the same. It may reign, perhaps as a brand name, but not rule. Kalle Lasn insists this process is already under way: "America is no longer a country. It's a multitrillion dollar brand" (1999, p. xii).

The America brand features "new improved democracy" as one of its best selling points. In October 2001, a TV commercial started playing that made this point beautifully. It was a series of images of September 11 and its heroic aftermath, set to music. It emphasized firefighters and other selfless volunteers who do not do what they do for money. The last images were of the New York Stock Exchange, the sponsors of the ad, and the ringing of the opening bell by firemen. The only words used then flash on the screen, "Let Freedom Ring." Ah yes, the liberty bell and the stock exchange bell—icons of freedom. As if the stock exchange had anything to do with freedom and was not just about making money. After all, there is nothing that says capitalist systems need democracy.

> Capitalists may be democrats but capitalism does not need or entail democracy. And capitalism certainly does not need the nation-state that has been democracy's most promising host. (Barber 1995, p. 15)

Actually, city-states and tribes nurtured democracy long before there were nation-states. Democracy is messy, but if there wasn't a state, capitalists would want to invent one, if for no other reason than to keep the consumer-citizen guessing as to who is really in control. It is all part of the process of stabilizing markets. Barber adds that capitalism "seeks consumers susceptible to the shaping of their needs and the manipulation

of their wants" but really it aims to create consumers, not just find them. So the need of democracy for "citizens autonomous in their thoughts and independent in their derivative judgments" (p. 15) is a problem. Autonomous citizens are unreliable consumers. Inevitably, "capitalism wishes to tame anarchic democracy" and favors stability imposed by tyranny over freedom.

The so-called new economy that so many business pundits love is nothing other than our infosociety, which more sober theorists argue is an information-rich mode of capitalism. As Manuel Castells puts it, " . . . the new technoeconomic system can be adequately characterized as informational capitalism" (1997, p. 18). The implications of this "informational capitalism" are just being revealed. One of the most disturbing is how citizen-consumers' daily lives are being commodified through the concept of access.

In his book, *The Age of Access* (2000), Jeremy Rifkin calls this new economy *hypercapitalism* and defines it as a shift from owning property to controlling access to property and experience. The parts of life that have not yet been commodified are now prime opportunities for profit growth.

> While the industrial era was characterized by the commodification of work, the Age of Access is about, above all else, the commodification of play—namely the marketing of cultural resources including rituals, the arts, festivals, social movements, spiritual and fraternal activity, and civic engagement in the form of paid-for personal entertainment. (p. 7)

Although the old form of capitalism intimately controlled the lives of its workers for 10 or 12 or 16 hours a day and exercised a great deal of political power, directly and indirectly, large parts of workers' lives were still unmediated. Civil society flourished not just in the unsupervised, unsurveiled, and self-employed margins of the working world, but in the streets and in most family life and play. In hypercapitalism, however, work is totally controlled and the colonization of play is advancing at a rapid pace. Consumers (workers off the job) are now managed as carefully as workers on the job. It is the new stage of capitalism the situationists warned of.

> Capitalism is reinventing itself in the form of networks and beginning to leave markets behind. In the process, new forms of institutional power are developing that are more formidable and potentially more dangerous than anything society experienced during the long reign of the market era. (p. 56)

Markets as separate entities dissolve when living becomes consumption, not life. Rifkin argues that play is the highest form of freedom and a tremendous site of power not yet totally commodified, and it must be kept free or "civilization risks deconstruction on a grand scale" (p. 265).

Fair warning. But what will this mean for political structures? To sort this out, it might be helpful to look at the ideology that fueled the great revolutions of the last few hundred years that resulted in our current international system of nation-states: nationalism.[4]

NATIONALISM

States are above all cultural artifacts. Another way of looking at this is to see states as information produced by and through practices of signification—from the writing of foundational documents (constitutions) to the discourses of smart bombs and the global spread of Coca-Cola. Sovereign identity, then, is comprised of bits rather than atoms. (Everard 2000, p. 7)

The emotional system we call nationalism is not just about nations or nation-states. It gets its power from the human tendency to grant loyalty to ideas, even of place or persona. This is what vitalizes the "nation of Islam," the dream caliphate, whether it is over traditional Muslim lands, any place that has ever been Muslim, or all the world; the Taliban proudly proclaim that they don't fight for Afghanistan but for all of Islam. It inspires the kingdom of Christ, to be brought to us by Armageddon. It is the return of the Raj and the castes that fundamentalist Hindus believe in, even though it is all Maya. It is one communist world. Basically, it is making everyone the same, sometimes on a limited scale (ethnic cleansing), sometimes on a global scale.

Is global capitalism calling on this same emotion? Fostering the desire to fight for the right to be shoppers above all else? The malling of America and the Disneyfication of the world? Sure, McWorld is another form of nationalism: all consumers are created equal in their capitalization. Still, even while some nation-states are becoming regions (the European Union) or just weakening, nations are proliferating.

It is a paradox of postmodernity that even as technologies (the Internet, telecommunications, jet travel) that knit the world together multiply, there has been a resurgence of nationalism and a proliferation of nations,

some aspiring to statehood and others not. Manuel Castells (1997) has gone so far as to argue that the new technologies of "the information age" actually produce "nations without states," and he uses Cataluña as one of his main examples.

Where has the power of nation-states gone? Not to the nations, despite the desperate scrambling of Serbians and Kurds and Pashtuns. It has gone, in part, to corporations, of course, but a significant amount of power has also gone to nongovernmental organizations (NGOs). Jessica Mathews, of the Council on Foreign Relations, claims that:

> The most powerful engine of change in the relative decline of states and the rise of nonstate actors is the computer and the telecommunications revolution, whose deep political and social consequences have been almost completely ignored. (1997, p. 51)

Mathews goes on to detail how NGOs (such as the Red Cross, Amnesty International, Catholic Charities) and other groups are supplanting states and state-supported alliances such as the UN. NGOs deliver more development assistance than the UN (p. 53), and in many countries they deliver the services that governments no longer can. She adds, "Technology is fundamental to the NGOs' new clout." Fifty thousand NGOs, for example, use the Association for Progressive Communications for net connections. "The dramatically lower costs of international communications have altered NGOs' goals and changed international outcomes," she adds (p. 54).

The same dynamic has changed financing:

> Again, technology has been a driving force, shifting financial clout from states to the market with its offer of unprecedented speed in transactions—states cannot match market reaction times measured in seconds—and its dissemination of financial information to a broad range of players. (p. 57)

Global trade is growing incredibly fast as well. Mathews adds that "Again technology is the driving force, shifting financial clout from states to the market with its offer of unprecedented speed in transactions." She concludes that, "More and more frequently today, governments have only the appearance of free choice when they set economic rules. Markets are setting de facto rules enforced by their own power" (p. 57).

Note how all of these dynamics are based on the spread of information technology and the proliferation of human-technological systems—cyborgs, in other words. They are producing a series of cyborg body politics.

Our 21st-century global society is organized by the WTO, policed by NATO and the UN, owned by burgeoning transnational corporations, and ruled through devolving nation-states, so why begin theorizing the body politic with Thomas Hobbes, the apologist for the monster Leviathan state? Because his vision haunts our politics still. Earlier Western bodies politic emphasized the analogy of the organic body to the social body, usually with strict hierarchies of status and function. Head, heart, stomach, legs, and arms—all corresponded to groups and warranted their placement in a system of difference enforced by might. From Plato and Plutarch through St. Paul and John of Salisbury on to Shakespeare, writers attempted to lend coherence to the diversity of actual political and social situations by means of organic and physical analogy. This sought-for coherence, however, was illusory even on the textual level, as various political writers and actors manipulated the body metaphor for their own ends. An organic conception of the state was often used to justify social inequality, but it was also deployed to stress the necessary cooperation of parts of society and to contest the collapse of parts into the "head," be it Henry VIII's or an imperial Pope's.

For Hobbes, however, the body politic is not as much an organic metaphor as a mechanistic one: A robot body politic but with a soul. The state is a machine, its people are parts, all in imitation of the "body natural." Only the "sovereign" is significantly more, because he or she is a divinely created "artificial soul." The soul and God are crucial parts of Hobbes' commonwealth. The correspondence of this conceit to René Descartes' description of the human individual as a mere automaton with a divine soul is no accident. Today, Hobbesians and Cartesians certainly don't talk much about souls or the gigantic absence left in the commonwealth and in Cartesian man if their souls are missing. Yet, as Michel Foucault explains,

> It would be wrong to say that the soul is an illusion, or an ideological effect. On the contrary it exists, it has a reality, it is produced permanently around, on, within the body . . . This real, non-corporeal soul is not a substance; it is the element in which are articulated the effects of a certain type of power and the reference of a certain type of knowledge,

the machinery by which the power relations give rise to a possible cor-
pus of knowledge, and knowledge extends and reinforces the effects of
this power . . . The soul is the effect and instrument of a political
anatomy; the soul is the prison of the body. (1977, pp. 29–30)

Today, the "effect" and the political "instrument" are the control sys-
tem—cybernetic, informatic, defining, determining—and the soul is that
of a consumer, imprisoned by things—and by the hunger for more. Infor-
mation, impatterned and wild, is the very context of life as well as the
simulcula of essence, whether it is called consciousness, personality, indi-
viduality, or a unique cognitive system. Having machines or seeing one-
self as a machine is one thing. Controlling machines and oneself is
another. In hindsight it seems as if the Machine Age inevitably had to give
way to the Control Revolution. It is a whole system we are caught in and
are part of, organic and machinic. We cannot destroy it without destroy-
ing ourselves, but we can reconfigure it if we understand it and if we try.

By the end of the seventeenth century the Machine Age had tri-
umphed in most philosophical and political thinking, at least rhetorically.
By the nineteenth century it was hegemonic in the form of Western impe-
rialism. The Machine Age is now coming to an end and with it the dom-
ination of machine metaphors. In the Information Age what metaphor
could be more fitting than that of the organism as an information system
linked to prosthetic machines—the cyborg? If webs of information and
power/knowledge incarcerate the organism today, they sustain and move
it as well, just as Hobbes and Descartes felt the soul sustained (and vital-
ized) the automaton body and the artificial body politic in a larger whole.

The postmodern nation-state (or empire or network) is certainly
more of a cyborg than it is a machine with a divine soul. This contempo-
rary state is a strange and still powerful creature that mixes humans,
ecosystems, machines, and various complex softwares (from laws to the
codes that control the nuclear weapons) in one vast cybernetic organism.

Today's leviathan is not only soul and machine—it is also clearly text
as was the monster Hobbes imagined. The burden of Hobbes' introduc-
tion to *Leviathan* is to show how to read the text of the body politic.
Hobbes chides those whose notion of political reading consists of gossip
and censure; instead, he advises, "*Nosce teipsum*; Read thy self." That is,
read the self as if it were a state, with passions that are similar in all men
(and in all actual states). It is not enough to read men's actions, or the
objects of their desires, for "He that is to govern a whole Nation, must read

in himself, not this, or that particular man, but Man-kind" (1965, p. 1). The only way to understand this strange machine-body of the state is to read the actual machine-body of the human being.

Even in Hobbes' time, we have an intersection of mechanical/scientific, discursive, and natural/organic metaphors for the state, which seems to be grounded on the discourse of actual bodies. From the Greeks on, theorists use the actual body and bodily functions to explain problems or loss of control or harmony in states. How can or ought the state work? What controls the automaton or machine and how might one decipher this control? This in turn splits actual humans into natural and artificial bodies, "individuals" and decidedly di-viduals, humans split between citizen and subject, person and self, machinic and organic life.

The answers Hobbes came up with are authoritarian to us—but they are certainly not foreign. The same questions bedevil our own times and structures; if anything, the invasion of the body by discourses of science and politics has accelerated beyond all imagination. We live in a society of automatons, of machines tightly coupled with "organic" bodies themselves denatured and reassembled, discursively by the teacher, politician, and boss as well as literally under the knife of the surgeon or the hand of the prostheticist. The process that Hobbes saw and helped institute, the proliferation of selves, the joining of machine to natural image to make a hybrid, is with us with a vengeance. Hobbes joined the discourses of Galilean physics and Christian theology with the figures of the automaton and of the king; we confront the discourses of post-Einsteinian physics, cybernetics, and democracy with the figures of the cyborg citizen and the cyborg body politic (Gray 2001).

Contemporary informatics make the postmodern state logistically workable just as modern technologies made the modern state possible. Modern states, as well as modern science, the Machine Age, modern war, and European imperialism, all developed simultaneously in a messy, bloody conversation. This is all the more sobering when we realize that today we are in the midst of a similar conversation, or more likely an elaboration of the same "modern" one, as technoscience and politics make another staggering transition, this time under the sign/trope of the cyborg instead of the soulful automaton.

The nation-state wanes as empires, corporations, fundamentalist religions, international organizations, NGOs, and networks of various kinds wax. What does this mean for the international system?

INTERNATIONALISM

For Hobbes, the world was a community of leviathans, autonomous nation-states with clear borders and stable sovereigns. Today, the world map is considerably less clear. There is a proliferation of political forms that overlap and even contradict each other. While postmodern states struggle against devolution from below and empire from above, their bodies are drained of sovereignty by multinational corporations on one side and NGOs and international subcultures sustained by worldwide mass telecommunications on the other.[5]

A young knowledge worker in Barcelona may be a Catalan, a Spaniard, an English speaker, an IBM bureaucrat, a feminist, a physicist, a mother, a European, a bisexual, a rock and roller, and other intermittent and ongoing allegiances all at the same time, all linked to cyborg body politics.

The crude and bloody prosthetic political surgeries that were performed on Yugoslavia and on various limbs of the former Union of Soviet Socialist Republics were replayed daily on TV as various retro body politics struggled for survival. Similar tendencies to reconstruct the past out of the bodies of today can be seen on the same newscasts, whether about the body politics of Europe and Central Asia delimited by language or dialect (Catalans, Welsh, Basques, Scots, Walloons, Québecois, Kurds), the tribes of Ethiopia and the Sudan, or the clans of Somalia. Movements that seek to establish ideal Christian or Jewish states, or the somewhat successful efforts of Hindus (in India) and Muslims (in Iran), can also achieve state power.

For now, in the "new world (dis)order" we can see the proliferation of cyborg body politics and polities within a general frame that seeks to continue the basic competitive structure of the modern world system, which is to say that war and rumors of war seem likely. Some nervous Western analysts predict economic, maybe even real, war between the competing powers of the future.

Note the development of an Asian common market linking Japan and the four tigers/little dragons and Australia. There is now a united Europe around a united Germany, and an American bloc is developing, incorporating north and south. The United States' borders with Canada and Mexico are practically open economically. Canadians no longer need documents to come into the United States, and for practical purposes most Mexicans don't need them either. These blocs are growing, but at the same time there are other alliances—the Organization of Petroleum

Exporting Countries (OPEC), the Arab League, and the Organization of American States (OAS)—that mark how the general advantage of the West and Far East economically over the rest of the world is hardly permanent and, indeed, is slowly shrinking.

Paul Kennedy, the historian of empire, sees this as inevitable:

> [T]here will be a shift, both in shares of total world product and total world military spending from the five largest concentrations of strength to many more nations; but that will be a gradual process, and no other state is likely to join the present "pentarchy" of the United States, the USSR, China, Japan, and the EEC in the near future. (1987, p. 538)

Just as possible is something considerably more benign than a new round of world war, even if it is cold. Perhaps the UN, that strange cybernetic organism, that loose network with a growing number of battalions in the field, that dream of a world body politic, might evolve into something that can reconcile many different large political bodies, from nation-states to multinationals, with the many small ones, communities, and persons. In the 1990s the UN grew stronger, running its own wars and, through the World Court, pursuing war criminals in Africa and the Balkans.

If Thomas Hobbes is at all right, and people must be protected from each other, it is even more true that the people of the world must be protected from their state governments and those governments from each other. One way this might happen is from above, as the UN seeks to do. But the same idea can spread from below, through identities such as cosmopolitan, internationalist, and world citizen.

The resurgence of the idea of an internationalist identity at the end of the twentieth century can be traced to the resistance to the WTO:

> Beneath the window-smashing and the Rage Against the Machine concerts, the anti-WTO activists are doing something profound, even in these early days of their movement. They are thinking like a swarm. (Johnson 2001, p. 226)

So what is the swarm thinking? As one slogan, used when the top economies have their meetings, puts it: "You are G8, we are 6 billion!" And what is *internationalism*? The living together in an imagined community of numerous smaller imagined communities? We can learn much from the old leftist internationalism. Sullied as the concept is by a thousand betrayals by Stalinists and Trotskyites and Maoists, it was also an idea beloved of

the anarchists who didn't try and impose it from above. Probably better for these days is the term I first heard from the Zapatistas: International Civil Society.[6] There is also cosmopolitanism. It has much to recommend it in light of the reality that the truly multicultural sites are cities, some as strong and beautiful as Sarajevo.

The first salient reality of postmodernity is that we can destroy ourselves with weapons of mass destruction. That has to be a factor in every possible understanding of our current situation. But the second factor is that we all live together on one earth. In the context of globalization all struggles are about control of the future, politically (which means technologically), and so it is all about revolution—within nations, nation-states, and regions certainly, but most important of all covering the world. It is about world revolution. Islamists want an Islamic world, Western leaders want Western markets, citizens want self-determination.

A wide range of aid, cultural, and professional NGOs are proliferating across frontiers. Jessica Mathews, a senior fellow at the Council of Foreign Relations, proclaimed the following in 1997:

> Except in China, Japan, and the Middle East, and a few other places where culture or authoritarian governments severely limit civil society, NGOs role and influence have exploded in the last half-decade. Their financial resources and—often more important—their expertise, approximate and sometimes exceed those of smaller governments and of international organizations. (p. 53)

But all is not sweetness and light. In the Middle East powerful NGOs have organized, but only for the Islamist revolution. Bin Laden's whole network and the other nets of Islamists such as Egypt's Muslim Brotherhood are nongovernmental. This just shows that to be an NGO is not necessarily to be on the side of the angels. The WTO, after all, is an NGO.

A good litmus test is to ask, where does the NGO stand in terms of the citizen? The Islamists act for their definition of Allah, not for any person; the WTO serves corporations, not people. We are starting to understand that citizens must have rights beyond belonging to a state.

Even though the UN was set up by states to protect states, it has taken more and more interest in people. The Universal Declaration of Human Rights was a major symbolic step. In 1991 the UN General Assembly declared in favor of intervening on humanitarian grounds without the relevant state's approval. In 1992 the Security Council authorized the use of force in Somalia "on behalf of civilian populations." As Mathews points

out, "Suddenly an interest in citizens began to compete with, and occasionally override, the formerly unquestioned primacy of state interests" (1997, p. 59).

The next step is some sort of world government, an improvement on the UN. The realities of the global market, single world ecology, and other arguments for a world-political system are overwhelming. We just don't need a single world-powerful nation-state, but rather a decentralized net encompassing various forms of citizen power, including international civil society.

But what does civil society, new internationalism, or cosmopolitanism mean in practice? Is it one world society? Are cultural distinctions significant? Doesn't it really begin at the micro level with the individual, and with fundamental change taking place only if we have working democratic communities? True internationalism can only be built on human rights and democracy.

There is a fierce debate about human rights, in academia and among the NGOs. Long a project of liberal reformers and revolutionaries, who succeeded in getting the Declaration of Human Rights accepted by the UN right after World War II, the idea has become a potent force in international affairs (Ignatieff 2001, Robinson 2000). It played a major role in the collapse of the Soviet system, especially as it encouraged the growth of civil society in Russia, Poland, and Czechoslovakia (Thomas, Daniel 2001). There are some critics who argue that human rights are a Western construction that is often used to attack directly non-Western cultures (Estava and Prakash 1998). There is some truth in this, especially when "human rights" are mobilized for corporate aims and end up privatizing the environment for sale instead of preserving it for traditional communal uses. But these cases are actually more about the abuse of the human rights ideal, not the idea itself. The way human rights are conceived has to involve real determination by local people in terms of how resources are utilized and to reject the facile equation of so-called free markets and freedom itself. The bigger problem is, how does one weigh indigenous culture against freedom?

Should we all respect the right of cultures to have human sacrifice? To have slaves? To treat women as inferior to men? To ban many types of sexual expression? To insist that everyone in the culture share one set of religious beliefs or at least practices? Where does one draw the line? In almost all countries people cannot sell themselves into slavery, even if they wish. Is this a restriction on their freedom? Perhaps, but their enslavement threatens the freedom of us all.

The other fallacy is to assume that human rights are a Western invention and that if it weren't for Western imperialism people around the world would be happily living in their traditional cultures no matter how oppressive. Yet the ideals of human rights exist in most cultures, even if they are often under attack. Again and again we hear voices from non-Western cultures arguing that they too have a right to human rights. Reza Afshari, for example, has written *Human Rights in Iran: The Abuse of Cultural Relativism* (2001), and it is Salman Rushdie who argues that September 11 was "about Islam" and that the only way to end terrorism is freedom.

> The restoration of religion to the sphere of the personal, its depolitization, is the nettle that all Muslim societies must grasp in order to become modern. The only aspect of modernity interesting to the terrorists is technology, which they see as a weapon that can be turned on its makers. If terrorism is to be defeated, the world of Islam must take on board the secularist-humanist principles on which the modern is based, and without which Muslim countries' freedom will remain a distant dream. (2001, p. 10A)

Yes, such a culture won't be the "pure" Islam that the Taliban strove for, with women sequestered, no cheering at soccer games except "God is great!," no music or kite flying. This may be a loss for cultural diversity, but people want the right to choose their religion, their music, their style of facial hair. If a culture must mandate personal behavior, if a culture cannot be tolerant, it doesn't deserve political power.

Ideally, a man could still find a woman and a congregation who wanted to live that way and they could keep their children from hearing music or flying kites or cheering at soccer games, at least until they came of age. The issue is, should they have the right to impose their lifestyle on everyone because they believe that God has commanded it?

Just as some have argued that when Westerners call for human rights for others they are being culturally imperialistic, the same has been said for the more general advocacy of democracies. Yet there is evidence that democracy fosters peace, at least among themselves.

In his book, *Never at War*, Spencer Weart has crafted a compelling case that democracies do not go to war with other democracies. Weart argues that the way people learn to deal with political differences within their polis shapes how they deal with others outside.

> ... the beliefs that a group's members hold about how people ideally ought to deal with one another and their beliefs about how people really do deal with one another in practice, when groups are in conflict. (1998, p. 76)

So democracies that have learned to accept the ebb and flow of democratic processes deal with other democratic governments in the same way. Democracies, or oligarchies for that matter, don't go to war with their counterparts because they have learned through their own internal politics not to use violence against other political decision-makers, either citizens or oligarchs (fellow elitists).

> Practices do not just passively reflect beliefs but reinforce or even impose them. People who have spent their lives amidst free debate will think one way about politics and human relations; people who have spent their lives slavishly obeying commands will think differently. (p. 77)

Just as importantly, people look for consistency in other people's beliefs and practices and they strive for them in their own. They operate within coherent, if not always articulated, rules of discourse.

The goal of internationalism or cosmopolitanism, whatever you want to call it, has to be democracy. Yes, it is important to respect all cultures, but it is even more important that those which are undemocratic either change or pass into history. There would not have been an American Revolution if it hadn't been for internationalists such as Lafayette and the intervention of the French and Spanish empires. If, as seems the case, democracy can contribute fundamentally to peace, then we must have it. To quote from Weart one last time,

> If democracy is to survive and expand, many people must devote their lifetimes, many must give their very lives, as millions before us have done. Even with such ardent efforts, no rule of history promises us that we are bound to achieve universal democracy. Yet the goal is worth even more than has commonly been supposed. For if we can attain this, we will at the same time attain universal peace. (p. 296)

4

the politics of technologies/the technologies of politics

TECHNICS, ARTIFACTS WITH POLITICS, AND ACTANTS

Most of the West, and all of the elites of the world, live in a cyborg society so intimately interfaced with various technologies that the technical world has in many respects become our new natural world. Nature is becoming just another managed environment. Human culture is a technology itself and human existence has always been linked to knowing how to make and use tools and establish complex dynamic systems useful for survival and reproduction, such as families and tribes, using both evolved technologies (language, religion, writing) and captured ones (fire, agriculture).

In the few hundred years that people have been thinking about how technology is changing humanity, a few things have become clear. The first is that technologies are complex systems. Even if the tool is simple, the context of how it is developed and used, and the information about how to use it, is never simple. Lewis Mumford, one of the first great analysts of technology and human culture, coined the term *technics* to describe both a tool or machine and the knowledge of how to use it, including the science behind it. It is a good reminder that technologies don't sit out there in reality by themselves, working their "magic." They come from and are embedded in cultures; they come from and are embedded in politics.

There are many theories about the relationship between technics and politics, including Mumford's:

From late neolithic times in the Near East, right down to our own day, two technologies have recurrently existed side by side: one authoritarian, the other democratic, the first system-centered, immensely powerful, but inherently unstable, the other man-centered, relatively weak, but resourceful and durable. (1964, p. 1)

He writes of his fear that authoritarian *megatechnics* will create a "uniform, all-enveloping, super-planetary structure, designed for automatic operation" and that humans will become "passive, purposeless, machine-conditioned" animals (p. 3). He was not optimistic about the modern era.

Power, speed, motion, standardization, mass production, quantification, regimentation, precision, uniformity, astronomical regularity, control, above all control—these became the passwords of modern society in the new Western style. (p. 294)

Prescient as he was, this also seems a bit simplistic and pessimistic for describing the actual politics of technologies. Still, Mumford is unsurpassed in noting the authoritarian aspects of many of our basic technological decisions. And it is certainly true that authoritarian priorities, especially war-making, have been central to the development of all sorts of technologies, from crude metalworking to digital computing.[1] The relationship between the military and computer technology is a particularly intimate and disturbing connection (Gray 1997).

Some historians, most notably John Nef (1963), argue that war has been the engine that drives human progress. If this were true the irony would be almost unbearable, for war's progress may well destroy us. But, clearly, war has profoundly influenced the shape of our current technologies.

Another hard-earned insight is that technologies are not politically neutral. Benjamin Barber, for example, falls into error when he warns,

Democrats should not be the Luddites Jihad's anxious tribal warriors have become; they cannot afford to make technology and modernity enemies of self-determination and liberty. Technology is a neutral tool: allied to democracy it can enhance civil communication and expand citizen literacy. Left to markets it is likely to augment McWorld's least worthy imperatives, including surveillance over and manipulation of opinion and the cultivation of artificial needs. (1995, pp. 273–274)

Of course "Jihad's anxious tribal warriors" are not afraid of technology, because they have mobilized it so effectively to network and to kill. Ironically, however, they are Luddites. Barber makes the common mistake of labeling as Luddite anyone who is opposed in general to new technologies, when actually the correct term would be *neoprimitivist*. The Luddites, who smashed weaving machines in the English midlands in the 1800s, were defending their way of life, based on different cloth-making technologies, from innovations that would destroy it. They were not against all technology; they were the skilled workers of their day. What they were interested in was technology appropriate to what they wanted to do. So the attackers of September 11, 2001, were Luddites philosophically, as they used appropriate technology (jet airplanes) to carry out their horrific mission.

Luddism is really not a question of no technology versus the latest technology; it is which technologies, when and where? What role will technology have in our culture? Will it serve the culture or will the culture serve it? We all must become Luddites or become slaves to any new technics. There are many different ways that societies can frame their relationship to technology. Neil Postman has created a term for a clearly technophilic society: *technopoly*. He defines it as, "the submission of all forms of cultural life to the sovereignty of technique and technology" (Postman 1992, p. 52). Parts of Western culture have accepted this as a given, including the military and the majority of businesses. To assume that technologies are inevitable is the first fallacy of technopoly. To assume that they are inevitably beneficial is the second. Together, these fallacies establish a profoundly authoritarian technics. Only by asserting political control over the creation and use of artifacts can a society produce a democratic culture.

Langdon Winner, a philosopher of technology, insists that artifacts do indeed have politics that we can and must shape. In *The Whale and the Reactor*, he draws connections between political and technical decisions:

> Let us suppose that every political philosophy in a given time implies a technology or set of technologies in a particular pattern for its realization. And let us recognize that every technology of significance to us implies a set of political commitments that can be identified if one looks carefully enough. What appear to be merely instrumental choices are better seen as choices about the form of social and political life a society builds, choices about the kinds of people we want to become. (1986, p. 52)

The dynamism he tries to give artifacts, although not falling completely into technological determinism, leads him to argue that "technologies are forms of life" and to postulate the "social determination of technology" (p. 20). This may be going too far, for it seems that it is not so simple. To say technology is always socially determined is as wrong as to say society is always technologically determined. New technologies are strongly shaped by social forces, and established technologies strongly shape society, but never are they absolutely deterministic.

Manuel Castells has a point when he calls "technological determinism" a "false problem" because one cannot untangle "society" from its "technological tools"—this is (in my terms, not Castells's) a cyborg society, after all (1997, p. 5). Castells goes on to remark, "Technology does not determine society: it embodies it. But neither does society determine technological innovation: it uses it" (p. 5, fn. 2). It is a complicated dance.

At times, society clearly determines which technologies develop; at other times the "technological momentum" (in Thomas Hughes's phrase) of technologies (especially large institutionalized ones) drives social development. New technological forms, invented by innovative individuals or institutions, can run wild in culture doing all sorts of strange, unexpected things. This does not mean that we shouldn't always try to think through the possible consequences, unintended and otherwise, of new technologies, and here Winner is also quite helpful. He developed three rules for dealing with new technologies:

1. No innovation without representation
2. No engineering without political deliberation
3. No means without ends (quoted in Tiles and Oberdiek 1993)

Mary Tiles and Hans Oberdiek have some pithy comments on these rules. On "no innovation without representation," they argue,

> Just as we no longer tolerate taxation without political representation, so a robust democracy should not allow technological innovation without representation, both at political and shop floor levels. (1995, p. 127)

Now, what could be more reasonable than that? Why should power and profitability for the few be the main criteria? "No innovation without representation" should apply to all engineering, not just public projects.

> What a private corporation wishes to do is *private*, where that means "nobody else's business." The absoluteness of the distinction, however, cannot be maintained . . . because the effects of private engineering

decisions spread far beyond corporate front doors. (pp. 127–128, original emphasis)

You should not be allowed to poison the water system "from the privacy of your own home" any more than you can put your children at risk by abusing them. "Public and private" are false dichotomies in terms of living nature, actual culture, and the science of ecology—as is framing "means and ends" as opposites. Means (actions) flow to certain ends, as Winner's third principle stresses:

> To consider ends in isolation from the means needed to attain them amounts to sheer sentimentally or wishful thinking. To divorce means in isolation from intended or probable ends constitutes a form of willful blindness. (Tiles and Oberdiek, p. 128)

Notice the careful wording. It isn't just *intended* consequences that must be considered; *unintended*—yet likely—consequences are the responsibility of innovators as well. This is why it is so important to be clear about the relationship of technology to social change. It has been a major focus of much of the work in the interdisciplinary field called "the social, or cultural, studies of science and technology." Donna Haraway, for example, exemplifies an activist and feminist perspective, arguing that people must take responsibility for the technologies we create and live with, including resisting their authoritarian aspects. To do this we must understand what is behind the development of new technologies, which more often than not is the search for profits and/or instrumentalist power.

Haraway's approach is particularly valuable in that she doesn't just theorize, she gets involved. With a Ph.D. in biology, she has worked for more responsible genetic engineering, as a citizen she has been arrested protesting nuclear weapons, as a dog lover she is involved in the ethics of dog raising and breeding. Unfortunately, many theorists never practice what they preach, which is a political decision on its own. On the other hand, many groups who are actively involved in technological politics seem to be less than reflective about what they are doing.

For example, there are neoprimitivists who reject all or almost all technology despite the consequences (Zerzan and Kintz 2002). Then there are protechnology groups such as the Extropians, who believe that some invisible hand (of progress and economics) will produce space travel, super-posthumans, and immortality. Somewhere in

between are the self-proclaimed technorealists, who try to balance the costs and benefits of new technologies. But cost and benefit for whom? Anthony Wilhelm is correct when he points out that technorealism "wields too broad a brush to produce sufficient clarity in demonstrating the key pitfalls and virtues of the virtual public sphere" (2000, p. 8). Or any public sphere.

In many cases it seems that the views of some individuals and groups toward technology are based more on their own experiences than on any systematic analysis of the relationship between society and technology. To label oneself a primitivist or an Extropian or a technorealist is as much personal as political.

In Caleb Carr's novel, *Killing Time,* Malcolm is a supergenius who was genetically modified by his father (an Internet founder), resulting in his extraordinary intelligence, but also in a crippled, constantly painful, body as well. When the narrator, Gideon, urges him to "resolve" his feelings toward his father, he replies,

> "Oh, they're *resolved,* Gideon," he answered. "I'm *resolved* that I hate the world that my father and his kind built—a world where men and women tamper with the genetic structure of their children simply to improve their intelligence quotients so that they can grow up and devise better and more convenient ways to satisfy the public's petty appetites. A world where intelligence is measured by the ability to amass information that has no context or purpose save its own propagation but is, nonetheless serviced slavishly by humanity. And do you know the hard truth of why information has come to dominate our species, Gideon? Because the human brain *adores* it—it plays with the bits of information it receives, arranging them and savoring them like a delighted child. but it loathes examining them deeply, doing the hard work of assembling them into integrated systems of understanding. Yet that work is what produces knowledge, Gideon. The rest is simply—*recreation.*" (2000, p. 235, original emphasis)

Although this is a harsh take on information society, it does capture the hubris of our age and its cost. But where did it come from?

Part of what "information society" means is that life is organized, indeed quantified, into tractable units. The clock is the perfect instrument for doing this. You cannot have an information society without good communication and the production and retrieval of accessible data. According to Mumford, in his masterful *Myth of the Machine* (1970), it

means synchronizing the various parts of society to a fixed framework and relegating natural time (sunrises, sunsets, equinoxes and solstices) to the margins. In many ways, Mumford is the father of all theories of an information society because he was the first to chronicle the political and social implications of the intense mechanization of culture, predicated on the production and control of massive flows of information.

So, is the information society an outgrowth of industrialization or is it something fundamentally new? Frank Webster, a sociologist, has written a solid overview of the various theories, breaking them down into two camps: those that stress just how new it is and those that argue that it is basically a continuation of earlier trends. Those who stress continuity include the neo-Marxists (such as Herbert Schiller); regulation theorists (who come out of Marxism) who see information as the way capitalism perpetuates itself (pp. 136–137); David Harvey, also with an economistic perspective, who argues that postmodernity is information-intensive capitalism (pp. 190–191); Anthony Giddens, who points out that the state uses information-intensive technologies to keep its official monopoly on violence and to better monitor both its citizens and its enemies; and, finally, such modernist thinkers as Habermas, who argue that the proliferation of technologically mediated information is a degradation of enlightenment/modernist civil society (1995, pp. 3–5).

The theorists who emphasize the newness of the information society start with Daniel Bell, whose postindustrial society is the first fully articulated claim that a major turning point in human culture has been reached because of information technology. His many followers include most contemporary management theorists and armies of economists, political scientists, and historians. Unsurprisingly, the postmodernists, except for neo-Marxists such as Harvey, also insist that society has undergone a sea change, and that one of the key elements of postmodernity is new forms of information, both quantitative and qualitative. Related to these perspectives are what Webster (pp. 4–5) calls theories of "flexible specialization" (Michael Piore, Charles Sabel, and Larry Hirschhorn) and "the informational mode of development"(Manuel Castells). One would have to add to this group Negri and Hardt and those who agree with them.

Webster finds the theorists who stress continuities with the past more useful than those who see the information society as fundamentally new. That is because he discerns a great deal of technological determinism in Daniel Bell and some of the others. So he concludes,

[T]hose who explain informatization in terms of historical continuities give us a better way of understanding information in the world today. This is not least because they refuse to start with abstract measures of the "information society" and of information itself. While of course they acknowledge that there has been an enormous quantitative increase in information technologies, in information in circulation, in information networks and what not, such thinkers turn away from such asocial and deracinated concepts and back to the real world. And it is there, in the ruck of history, that they are able to locate an information explosion that means something substantive and that has discernible origins and contexts, that these types of information, for *those* purposes, for *those* sorts of groups, with *those* sorts of interests are developing. (1995, pp. 220–221, original emphasis)

It is not hard to agree with this sentiment. The reason to spend time with these theories is to come up with some useful insights for understanding and influencing the real world. But Webster has neglected to note that there are some who ground their analyses in "the ruck of history" and the mess of the present who argue nonetheless that we are in a fundamentally new era. Continuities are important, of course, but never before have humans so dominated the planet with billions of people and with technologies that not only permit instant communication to any corner of the globe and into near space, but also can deliver massive destruction everywhere as well. Never before have we been able to modify our bodies so completely, or to control our own evolution as we soon will, making the creation of posthumans not only possible but likely.

Donna Haraway's concept of "situated knowledges" (1988), for example, is exactly about the specificity of what we are living through. Without context, without detail, without history, we don't know what is happening and we certainly can't formulate a way of affecting it.

Carolyn Marvin (1988) has written a brilliant analysis of popular theories of electric communication in the nineteenth century and what they can tell us about current utopian visions of the information society. It is startling to find out that the wild claims of computer and cyberspace enthusiasts are almost identical to the faith of those old advocates of electrification. Their perfect, peaceful, politics-free world of abundance never came to pass, and that is a good warning about the fantasies of the technophiles of today. At a deeper level, Marvin shows that the use of new technologies first follows the pattern of older innovations, often to become sources of radical social transformation in the end.

Early uses of technological innovations are essentially conservative because their capacity to create social disequilibrium is intuitively recognized amidst declarations of progress and enthusiasm for the new. People often imagine that . . . new technologies will make the world more nearly what it was meant to be all along. Inevitably, both change and the contemplation of change are reciprocal events that expose old ideas to revision from contact with new ones. This is also how historical actors secure in the perceptions of continuity are eternally persuaded to embrace the most radical of transformations. (p. 235)

This is why, along with the conservation of technological realities, it seems the perspective that we are living in fundamentally new times is more compelling and useful than one that stresses continuities with the past. We must not go into an increasingly strange future hobbled with illusions that will be more of the same.

Of course, both perspectives are true in their broad outlines. Our information society is a continuation of industrial society. How could it not be so? But it also clearly represents a new type of economic and social organization because the technologies it is based on are fundamentally new. As Webster rightly points out (pp. 6–10), almost all these theories start with the incredible transformation that information technology has undergone, in particular with the development and proliferation of the digital computer. All of these theories have something to offer us because they emphasize different aspects of the transition we are going through. Some look at how culture is being transformed, others focus on shifting concepts of time and space in economics and work, and others are more explicitly political. Insights from these thinkers are sprinkled throughout this work, but all of them suffer from weaknesses in our current understanding of information itself.

INFORMATION RULES AND METARULES

Information is data, information is theory, information is metaphor, information is the pattern of patterns that knit together what we call reality. The terms "data," "information," "knowledge," and "wisdom" are used a great deal in computer science, with little agreement as to their meanings. In my computer courses I often explain that they are multiple and overlapping and then give the following example from SETI (search for extraterrestrial intelligence) research of how they fall on a continuum.

Radio telescopes pick up electronic emissions from the heavens. This is raw data. Computer programs sort the signals looking for patterns. That is processed data. Further programs are run to analyze the patterns and to eliminate those that are known (in form and location) from those that aren't. This is information processing. Then, humans analyze the remaining data and use their knowledge to determine, or at least speculate on, what they represent. Some day these patterns may indicate intelligent extraterrestrial life. What we do about that will take wisdom.

Albert Einstein's $e = mc^2$ explains mathematically the relationship between energy and mass. This is emblematic of the great strides science has made in understanding energy and matter. But reality is made up of one other fundamental aspect which we barely understand at all: information. Of course "$e = mc^2$" is itself information, but the formula is about energy and mass, not *why* energy equals mass times the speed of light squared. Our ability to manipulate energy and mass has allowed us to produce weapons of mass destruction; without a similar understanding of the laws of information we will probably use them to destroy ourselves.

Much information theory isn't about information at all. Claude Shannon's famous laws of information are about signal redundancy, not information.[2] Over the last 2,000 years discrete subsystems of information have been studied with some success: logic and mathematics by the ancients; statistics, natural processes, and more mathematics by the moderns. But only in the late twentieth century have people started pursuing a unified theory of information, as opposed to the wild Platonic idea that all information is already in our minds or the crude claims of mathematicians that to study mathematics is to study everything worth knowing.

Norbert Wiener coined the term *cybernetics* for this search for a unified information theory, and the very success of the idea has rendered the explicit discipline of cybernetics redundant. Instead, the information-processing paradigm has colonized most disciplines from physics and chemistry to genetics and medicine (where infomedicine formulations have supplanted biomedical metaphors), even into the social sciences and the humanities. There are also disciplines totally predicated on the information revolution: computer science, information systems, systems analysis, and ecology. The idea has gone further, of course, taking over military thinking to a large extent, and breeding that strange mythical beast "infowar."

Out of all this work has come some real advances in understanding information. And the first thing about information we have really under-

stood is the limits to our understanding. Kurt Gödel showed that any formal information system would either be incomplete or have paradoxes, or both.[3] He proved it mathematically and applied it to mathematics, which made some mathematicians, such as John Von Neumann, actually sick. What was sicker was the illusion that mathematics was the "language of God" and capable of explaining everything. It's nice, it's beautiful, it's powerful, but it isn't "complete." Alonzo Church and Alan Turing soon showed that Gödel's proof even applied to infinite computing machines as well: The perfect computer is impossible.

These proofs are related philosophically to the claims from quantum physics (which made some traditional physicists physically ill, by the way) that in many cases to know one thing is to be denied the possibility of knowing something else (such as electron behavior), and that the observer of an event is part of it and therefore affects it (Heisenberg's uncertainty principle).

The realization that from one perspective the observer is part of the system being observed shows just how difficult the concept of a system is. Any system is made up of subsystems and is, in turn, part of larger systems. This reveals both the complexity of experienced reality and the importance of definitions. To define a system is to determine just what is possible to know about it. Gregory Bateson was one of the first to explore the implications of this, and he concluded, among other things, that a part of a system cannot fully understand the whole system. Which means that humans cannot fully apprehend reality.

Bateson also looked for basic principles to better understand systems, and systems of systems. He noted the importance of symmetry, the significance of patterns and their similarities across systems, and the many complicated ways feedback can work. It can be positive, negative, simple, complex, or any combination of these four. Feedback loops can intertwine and interpenetrate with incredible complexity, and out of these dynamics other interesting properties become apparent.

There is the importance of recursion, for example, which lies at the heart of fractals, and complexity theory has shown that small events can have incredible implications, thanks to the multiplying possibilities of feedback loops. Ilya Prigogine has contributed his elegant work on dissipative systems to show that in some cases systems can transition into more complex systems with profound implications for our understanding not just of basic informational principles from physics (such as entropy and extropy) but also of complex systems such as life itself. Our understanding

of such systems, termed "out-of-control" systems by some because we can't control them (Kelly 1994), is growing significantly. However, in broad terms, what we know about information, and its relation to reality, is still rudimentary.

Albert Borgmann, a professor of philosophy at the University of Montana, has written a useful analysis of living information in his book *Holding on to Reality* (1999). Besides recounting what is now generally understood about information, he also develops a new categorization: natural information (information about reality), cultural information (information for dealing with reality), and technological information (information as reality). As we think about information, its limits and its power, we should keep these different modes in mind. We can discover things about natural information but cannot change them. We can improve, or at least change, forms of cultural information and these inevitably change culture, in fact are part of culture. And we create new forms of technological information continually, and while recognizing the potential of this form of information for positive change, Borgmann warns of its dangers as well.

> The ecology of things used to enforce an economy of signs. The technology of information, however, has loosed a profusion of signs and there is by now a rising sense of alarm about the flood of information that, instead of irrigating the culture, threatens to ravage it. (p. 213)

He goes on to caution that, besides the proliferation of cultural information, technological information threatens to "overflow and suffocate reality" (p. 213). In particular, he warns against slighting or even ignoring nature in our intoxication with cultural and technological information. Here again, we note the importance of the human body and nature as embodied life, as a balance to our infatuation with our cultural and technological creations. Just as energy and matter are interchangeable, interdependent, and fundamentally the same thing, so too is information in relation to matter and energy. Information cannot exist without matter in motion (energized). If we go off into fantasies of perfect information (scientific, political, or theological), of disembodied (virtual) information, of truth standing alone without the confusion of matter and of life, we will be courting disaster.

Information is not isolated data or facts. A "single piece of information does not make sense," as Gunter Ropohl puts it[4] (1986, p. 63). He goes on to point out that "Sense only arises from a significant ordering of pieces of

information." This sense is only social, coming out of societal knowledge —technical, personal, and cultural.[5] Ropohl has proposed seeing people as "sociotechnical action systems," which, although a bit clunky, does capture a number of important elements, in particular the dynamism of lived reality, its interconnectedness, and its cyborgian structure (p. 64).

When it comes down to it, information is for us. Yes, a tree makes a sound when it falls in the forest even if no one is there to hear it. If you define a sound as sound waves. But if sound presupposes hearing and understanding? If information is going to be useful, it needs to be as free as possible from pollution; it should be liberatory. We should resist the "chipping away of our information rights" both through "invisible and subtle" actions by governments and as "the paradoxical end result of the misuse of instrumental reason" (Maret 2003, p. 11).

But good information is only the first step. The novelist Caleb Carr warns, "For it is the greatest truth of our age: information is not knowledge" (2000, p. 5).

Information theory is knowledge, not information. Its most recent positive contribution has been the development of the idea that complex systems generate "energy" of their own. Complexity theory also shows that truly large systems cannot be controlled from outside but instead are dominated by their own internal dynamics. Still, very small events, if they take place at the right time and place, can have profound and far-reaching effects. This is the famous "butterfly effect," the realization that under very specific conditions the actions of one butterfly can change whole weather systems. This does not mean that every butterfly or even most butterflies do this. But large dynamic systems can be changed by the right event at the right time, causing a set of cascading results that lead to a fundamental turning point, a bifurcation, in the system's history.

Weather is certainly such a system. All evidence seems to indicate that war is another one. Change also comes to such systems through the traditional impact of many small events that don't cascade into bifurcations. This is water falling on stones, or attrition. Butterfly or rain, whatever the metaphor, we know now that "The future is not yet written." As powerful and horrible as our current international system is, based on violence, hypocrisy, and lies, it is still changeable. It isn't absolutely predictable either, but we can shape its future gradually, as a hard rain, while watching for the chance to be at the right place at the right time.

It would help if we understood the actual "rules of complex systems." Some of them are beginning to become clear out of the work of a number of different research programs, including sets of rules and metarules

(rules, about rules) that are quite counterintuitive, but very powerful, and full of potential for understanding how we might develop politics capable of bringing peace to the world. Why is this list something of a hodgepodge? In part, because information theory is still in its infancy, but it also reflects that paradox and imprecision are inevitable when information tries to explain itself.

The journalist Kevin Kelly (a founding editor of *Wired*) has pulled together a number of these rule sets in *Out of Control*. In particular, he is quite interested in the more complicated and dynamic systems that are usually associated with life: ecosystems, cultures, economies. He calls them: "networks, complex adaptive systems, swarm systems, vivisystems, or collective systems." These systems have, according to him, "four distinct facets of distributed being":

- The absence of imposed centralized control
- The autonomous nature of subunits
- The high connectivity between subunits
- The webby nonlinear causality of peers influencing peers

He then lists the benefits of these "swarm systems": adaptable, evolvable, resilient, boundless, novelty; and their disadvantages: nonoptimal, noncontrollable, nonpredictable, nonunderstandable, nonimmediate (1994, pp. 22–24).

Rupert Brooks, a Massachusetts Institute of Technology (MIT) roboticist, is one of Kelly's sources. Brooks has championed the latest artificial intelligence (AI) research paradigm, which is trying to "evolve" intelligence in active robots.[6] His approach involves putting complex learning robots into real environments so that they can develop their own understanding of reality through a process of distributed control. He has a set of rules for this learning process, which could also be called a "recipe for managing complexity." It is:

1. Do simple things first.
2. Learn to do them flawlessly.
3. Add new layers of activity over the results of the simple tasks.
4. Don't change the simple things.
5. Make the new layer work as flawlessly as the simple.
6. Repeat, ad infinitum. (Kelly, p. 41)

Brooks's robot machines then learn by following this hierarchy of behaviors:

1. Avoid contact with objects.
2. Wander aimlessly.[7]
3. Explore the world.
4. Build an internal map.
5. Notice changes in the environment.
6. Formulate travel plans.
7. Anticipate and modify plans accordingly. (Kelly 1994, p. 39)

From his work, Brooks has extracted five lessons:

1. Incremental construction—grow complexity, don't install it
2. Tight coupling of sensors to actuators—reflexes, not thoughts
3. Modular independent layers—the system decomposes into viable subunits
4. Decentralized control—no central planning
5. Sparse communication—watch results in the world, not in the wires (Kelly 1994, p. 48)

Other people are doing work in ecological systems, human-machine interfaces, and economics that has produced similar sets of rules. Kelly summarizes these system rules as "laws of God":

1. Distribute being
2. Control from the bottom up
3. Cultivate increasing returns
4. Grow by chunking
5. Maximize the fringes
6. Honor your errors
7. Pursue no optima; have multiple goals
8. Seek persistent disequilibrium
9. Change changes itself (p. 468).

Compare these with the rules that Steven Johnson, another journalist (co-founder of the e-zine *Feed*), has come up with in studying emergent systems. He proclaims that if you are going to build a system that will "learn from the ground level," in which "macrointelligence and adaptability derive from local knowledge," all you need are "five fundamental principles" to follow:

1. More is different.
2. Ignorance is useful.

3. Encourage random encounters.
4. Look for patterns in the signs.
5. Pay attention to your neighbors (2001, p. 77).

Johnson also recounts the rules that come from an interactive Web site with many moderated lists, Slashdot. Rob Malda, the programmer-founder, says it can work only if it follows these goals:

1. Promote quality, discourage crap.
2. Make Slashdot as readable as possible for as many people as possible.
3. Do not require a huge amount of time from any single moderator.
4. Do not allow a single moderator a 'reign of terror' (p. 154).

We are starting to see political principles emerge from these rule sets. Slashdot depends on high-quality thinking and lots of participation and cooperation on various levels. The Open Source movement, in which software writers freely and openly collaborate to create programs, is living proof of the value of these ideals. Its principles are "Share the goal. Share the work. Share the Result" (Goetz 2003, p. 164). These are among the values of anarchism. It was Peter Kropotkin, Russian prince, anarchist revolutionary, and a leading evolutionary thinkers of the 1800s, who first stressed the crucial role of cooperation for survival and for the stability of ecological systems. So it should come as no surprise that the anarchist architect Colin Ward in *Anarchy in Action* (originally published back in the 1970s) ends up defining emergent systems in political terms. His chapter headings are revealing:

The Theory of Spontaneous Order
The Dissolution of Leadership
Harmony Through Complexity
Topless Federations
Who is to Plan?

It is not hard to see that many of these rules are the same as, or close to, the rules for emergent systems that come out of the scientific research Kelly and Johnson describe.[8]

But what are we supposed to do with arguments that something such as information theory supports anarchist principles? First, pointing out

such relationships is a metaphorical way for understanding very complex dynamics. Much of human understanding is based on metaphor. Second, use the understanding as a focus and a guide. To the extent that it isn't all just a metaphor, note that it only claims to say it is possible for anarchistic organizational principles to work; it does not argue that they are natural, inevitable, or even likely. Finally, take comfort. At least we know that the free market is certainly no more "natural" and inevitable and "efficient" than hierarchical dictatorships or anarchist revolution.

Despite the enthusiasm of the attack dogs of economic correctness, there is no evidence that the free market is "natural" and certainly not proof that it has an intimate relationship to political freedom. Freedom is won with power by those who desire liberation; it is not the gift of the market's invisible hand.

Making peace is also a question of power. To understand what is possible we have to know more about information and truth. Information can be thought of as the raw material out of which we make truth. From what we know of the world we construct many different truths, and that ability is one of the greatest powers, perhaps *the* greatest, that we have for making our future.

Of course, some actually contrast truth to power. Not in the sense of that wonderful slogan "Speak truth to power" because it is clear that truth is powerful in that dynamic. Truth can sometimes trump naked physical power. But for some self-consciously unnaive analysts, truth is not powerful. Benjamin Barber, writing about his experiences as an advisor to President Clinton, admits that he was quite swept up in the idea that he might exercise power by influencing the president.

> Power is an elixir, whether aspired to, possessed, or envied; it can intoxicate even when being passionately confronted. However, in opposing power, truth stays honest (the virtue of impotence). In counseling power, it risks contamination (one must often act without knowing). (2001, p. B8)

Barber uses exotic imagery ("elixir," "intoxicate") to confuse us about the real nature of power and seals the mistake in false dichotomies (power vs. truth, virtue vs. effectiveness). This is the deeper message of realpolitiks, which isn't so much about how the world really works, witness its manifold blowbacks and too-clever-by-half failures; rather it is an argument for immorality in politics.

Moralists and philosophers who set the agenda of conscience with an appropriate antipathy for compromise have no business in politics, where the only choices are rival compromises, and where not good intentions but merely satisfactory outcomes count. Moralists are the conscience of a democracy, but their task is to act as irritants from the outside, bearing witness to truths that oppose complacency but yield no viable solutions. On the inside, there is room only for those who understand that politics begins where truth ends. (p. B9)

Morality is an "irritant from the outside"? You can't ever have a moral compromise? Do all possible political solutions involve a betrayal of conscience? No. This is not just profoundly wrong. It is also a very impoverished idea of what power actually is.

POWER

We should define power, not as an instrument some agents use to alter the independent action of others, but rather as a network of boundaries that delimit, for all, the field of what is socially possible.
—Clarissa Rile Hayward 2000, p. 3

The state is not something which can be destroyed by a revolution, but is a condition, a certain relationship between human beings, a mode of human behavior; we destroy it by contracting other relationships, by behaving differently.
—Gustav Landauer, quoted in Ward 1992, p. 19

Behaving differently is what Landauer did, by joining the revolution in Bavaria after World War I and serving as a minister with Marxists, despite his anarchist misgivings. He was murdered by the "whites," who were soon to become fascists. But, like many anarchists, he understood how complex power actually is. As an Australian group once proclaimed in the title of one of their booklets, "You can't blow up a social relationship."

Mao Tse-Tung could not be more wrong than when he said that "Political power grows out of the barrel of a gun" (Rawson and Miner 1986, p. 281). Political power comes out of social relationships; it is based on what people believe and how strongly they believe it. This is why Big Brother had to torture Winston in Orwell's *1984* until Winston loved Big Brother. Capturing him and killing him were not enough. Big Brother had to break his mind. This is actually the function of torture in the real

world, as Elaine Scarry demonstrates with frightening details in her masterful work, *The Body in Pain*. Yes, coercive power is a form of power, but it is weak and secondary compared with the positive power to shape perception.

Michel Foucault warns that defining the effects of power as repression " . . . is a wholly negative, narrow, skeletal conception of power." It is a weak definition of power, for "if power were never anything but repressive, if it never did anything but to say no, do you really think one would be brought to obey it?" Instead, power

> . . . produces things, it induces pleasure, forms knowledge, produces discourse. It needs to be considered as a productive network which runs through the whole social body, much more than as a negative instance whose function is repression. (1980, p. 119)

Rollo May summarizes the negative and positive aspects of power: "the ability to cause or prevent change" (1972, p. 99). Technology, which always produces change, is both reified power and active power. Therefore, so is information, which potentially produces or prevents change. New information technologies that have allowed the creation of mass media, global communications, and postmodern war have produced a new form of power. As Manuel Castells explains in a paragraph I've quoted from earlier:

> *The new power lies in the codes of information and in the images of representation around which societies organize their institutions, and people build their lives and decide their behavior. The sites of this power are people's minds.* That's why power in the Information Age is at the same time identifiable and diffused. We know what it is, yet we cannot seize it because power is a function of an endless battle around the cultural codes of society. Whoever, or whatever, wins the battle of people's minds will rule, because mighty, rigid apparatuses will not be a match, in any reasonable time span, for the minds mobilized around the power of flexible, alternative networks. (1998, pp. 358–359)

Typologies of power can be helpful in sorting all this out. In *Power and Innocence*, Rollo May categorizes power as exploitative, manipulative, competitive, nutrient, and integrative (1972, pp. 107–110). This schema helps us desimplify our thinking about power and notice its many complicated aspects. But the important issue is, how does power itself get its power? What are the rules and metarules of what we believe?

Clarissa Rile Hayward carefully studied the institutional power dynamics at several schools in New England. She called her book on this research *De-Facing Power* because she felt that traditional concepts of power gave it an instrumentalist face; for her, power is "a network of social boundaries that constrain and enable action for all actors" (2000, p. 11). This is not a new idea for many peace activists and feminists, who have pointed out that systems of oppression, such as patriarchy, structure the possibilities of the powerful as much as of the powerless. In Hayward's detailed analysis she shows how power is diffused into all the corners of school life: in bus routes, school rules and traditions, zoning, laws, and many other social factors. Within this framework, teachers and principals, parents and students, police and suspects all act within the boundaries set for them. As Tim Jordan argues, "Power concerns not immediately obvious forms of politics, culture, and authority, but the structures that condition and limit these three" (1999, p. 7). And there is instrumental power as well.

That "Knowledge itself is power," as Francis Bacon claimed (Rawson and Miner 1986, p. 82), is not completely true. To be relevant to human affairs, power must be instantiated and embodied just as information must be. The destructive occupying power of the U.S. military is opposed by the power of the Iraqi resistance to move fast and, through sacrifice, to kill. As the eminent military historian John Keegan notes in his superb refutation of the infomania in the contemporary military, "Knowledge cannot destroy or deflect or damage or even defy an offensive initiative unless the possession of knowledge is also allied to objective force" (2003, p. 348).

In the case of the U.S. invasion of Iraq, perceptions about Iraq and 9/11 and about Iraq's supposed WMD were more important than real knowledge. The power of the government and mass media to distort reality trumped real knowledge, and corrupted democratic processes.

But power does not always corrupt. Rollo May is quite right when he argues that it is "powerlessness that corrupts" as well (1972, p. 23). It corrupts one's very relationship to reality.

> As we make people powerless we promote their violence rather than its control. Deeds of violence in our society are performed largely by those trying to establish their self-esteem, to defend their self-image, and to demonstrate that they, too, are significant. (p. 23)

May goes on to argue that powerlessness produces madness in both senses of the word: anger and psychosis (p. 25). Therefore, power can

produce happiness. As the poet Emily Dickinson wrote (quoted in May 1972, p. 99),

> *To be alive is power,*
> *Existing in itself*
> *Without a further function,*
> *Omnipotence enough.*

Being alive together, we have to figure out a way to live together. Many who have looked at this problem have noticed that the more mechanized official politics are, the more vibrant and necessary the wild patterns of civil society become.

MACHINE POLITICS AND CIVIL SOCIETY

> It's an election hall of idiots, for idiots, and by idiots, and it works marvelously. This is the true nature of democracy and of all distributed governance.
>
> —Kevin Kelly 1994, p. 7

Kevin Kelly is describing the decision-making processes of a swarm of bees, who basically decide anything of importance (and much that is not) by "mob vote" in the form of what they do with their bodies and their pheromones. But, Kelly wonders quite correctly, "who chooses the chooser?" "The hive chooses" is the answer he supplies, borrowing from William Morton Wheeler, one of the first entomologists to study the social insects. But really, no one chooses the chooser; it is the evolved rules the bees follow in their discourse that does the choosing. This discourse, as with all interesting discourses, isn't just made of "words," it is constituted of bodies and their pheromones and actions. Dancing is one of the strongest arguments among bees.

When anticommunist activists in Eastern Europe decided to create alternative societies within the state-imposed Communist society through many small, concrete actions (choices), they showed emergence in action and gave civil society theory an incredible boost. Anarchists have long recognized that most of what is important about human community exists separate from, even in spite of, the state. The people in Charter 77, in Solidarity, and in other groups have demonstrated this empirically and even showed that the state needs civil society more than civil society needs the state.

One way to sort out civil society from the state and other institutions is to look closely at the discourse of that society as a whole and to understand something of the general rules and metarules that govern it. Although there is one hegemonic discourse, alternative discourses (Foucault's "knowledges") always exist within it. Changing the dominant discourse involves what Michel Foucault calls an "insurrection of subjugated knowledges" (1980, pp. 81–84). Subjugated knowledges are "historical contents that have been buried and disguised" and "a whole set of knowledges that have been disqualified," such as the views of the "psychiatric patient," or "the delinquent," but also the "nurse . . . the doctor," in other words, "local popular knowledges" (pp. 81–82). In the discourse on globalization, the subjugated knowledges are both the erudite information of such technosciences as climatology and telecommunications and the voices of such disempowered groups as French farmers, Asian workers, the homeless, the stateless, and the politically marginalized.

When subjugated knowledges revolt they can constitute a new regime of truth. Not a simple yes/no, "just the facts, ma'am" truth, but a constructed truth. Foucault adds, "Truth is a thing of this world: it is produced only by virtue of multiple forms of constraint" (p. 131). Truth exists "in a circular relation with systems of power which produce and sustain it, and to effects of power which it induces and which extend," producing a "'regime' of truth."

> Each society has its regime of truth, its 'general politics' of truth: that is, the types of discourse which it accepts and makes function as true; the mechanism and instances which enable one to distinguish true and false statements, the means by which each is sanctioned; the techniques and procedures accorded value in the acquisition of truth; the status of those who are charged with saying what counts as true. (p. 132)

In other words, the rules and metarules of the discourse. Change the rules, and you change the truths. "'Truth' is to be understood as a system of ordered procedures for the production, regulation, distribution, circulation, and operation of statements" (p. 133). Discourse can be seen as a machine, actually, an information-processing cultural machine. The problem is that it is running us and it is out of our control.

This doesn't mean that discourses are totally arbitrary and divorced from the real world. They always have a history. But we have seen that societies and subcultures can be built on "truths" that seem quite improbable. Consider that martyrs to Islam will go to Heaven to be serviced by 72

virgins; or that, when Armageddon comes, the kind and forgiving Christian God will save only 144,000 souls and the rest will burn in Hell forever; or that Serbs, Croats, Pashtuns, whites, Tutus, Christians, men, Hindus, or whatever are superior to everyone else. What science learns, what nature tells us, what love offers, are often held in much less regard than the strange conclusions of some of the world's most powerful regimes of truth. Their sway is at its most powerful in war, and some of these "truths" represent the main obstacles to peace.

FIGURES 1 AND 2

The "Last Photo" Tourist and Dr. Evil with Mini-Me at the WTC

(Creator(s) unknown. Available at: http://politicalhumor.about.com/library/
images/blwtctourist1.htm and blwtctourist20.htm)

The story was that the film of the first picture was found in a camera in the rubble of the twin towers. It wasn't true, of course. But thanks to digitalization the actual horror of 9/11 is harder and harder to know. (Feeling it is another matter.) Savvy computer users soon flooded the net with variations of the doomed sightseer, including the second image, fantasy evil in the middle of real doom. Both pictures become another memory, to go with the moments the towers fell, seen "in person" by thousands in or near Manhattan and "live" by millions around the world.

FIGURE 3

Osama bin Laden and Bert

(Creator(s) unknown. Available at: http://politicalhumor.about.com/library/
images/blevilbert.htm)

Edgy fans of "Sesame Street" conceived of "Evil Bert" and digitalized pictures
of him meeting with various co-conspirators. This encounter between the mup-
pet and Osama bin Laden was posted on the World Wide Web. Eventually it was
downloaded and used on placards at pro–Bin Laden demonstrations in
Bangladesh, perhaps ironically, perhaps not.

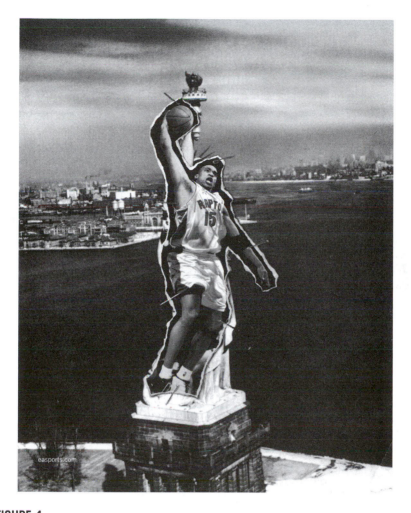

FIGURE 4

Virtual Patriotism—the Consumer Citizen

"Ours is a nation built on competition," claims Electronic Arts Inc., in an ad for their sports video games. They go on to challenge, "Think you are good enough to earn your citizenship?" Are they asking about the U.S. nation or EA Sports™ Nation? Does it matter? American patriotism is often mediated through electronics and such media companies as FOX Networks (especially the News) just as athletic recreation for many is virtual, twice removed from any real sacrifice. So why shouldn't our new Statue of Liberty be Vince Carter, who plays basketball for the Toronto Raptors? Why shouldn't Lincoln be replaced in his memorial by a football player and why shouldn't hockey players grace Mount Rushmore? One assumes these advertisements are trying to make the bizarre connection that: (1) Playing our game makes you special like these sports heroes. (2) These iconic sports heroes are patriotic. (3) Therefore, you too become patriotic by playing our game. Does this logic work? In what way? Moving product or debasing democracy? Both, probably.

WHAT IS GOVERNMENT?

TO BE GOVERNED IS TO BE WATCHED,
INSPECTED, SPIED ON,

REGULATED, INDOCTRINATED, PREACHED
AT, CONTROLLED, RULED,

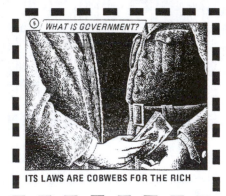

ITS LAWS ARE COBWEBS FOR THE RICH

FIGURE 5

"What Is Government?"

(*The Education of Desire: The Anarchist Graphics of Clifford Harper*, London: Annares Co-Op, 1981)

Pierre-Joseph Proudhon asks this difficult question. Three of his many answers are illustrated here by the British artist Cliff Harper. Government has morphed again and again throughout human history. Various tribal forms grew into a wide range of baroque theocracies—society became the state. Stability was brought to economic and military performance, but to incredible irrationalities as well. Experiments with democracy have often thrived, in North American tribes, Chinese peasant rebellions, and Greek city states. Today there is more democracy than ever and it has never been more threatened. The very technologies that foster the health and learning and communication of mass society democracy also are used for war, indoctrination, and propaganda to undermine it. This is as true of the Internet as anything else. Still, the global networking that has grown out of the latest web and net systems is new. Combined with a belief and passion for international civil society (whether or not it has ever existed before), it is a potent force.

La democracia llega a Irak

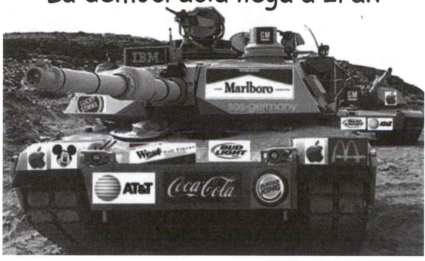

FIGURE 6

"La democracia llega a Irak"

(Creator unknown, bought in Barcelona 2003.)

This Spanish postcard is more than ironic. Free Market fundamentalism ("open markets 5 democracy and maximum efficiency") and the privatization of many military and police functions has integrated corporate capitalism into the U.S. military. This has climaxed in the occupation of Iraq with its billions of dollars of budget, no-bid contracts, and oil, precious oil. The Spaniards left out some of the more important beneficiaries of the Iraq adventure, including Halliburton (formerly CEO'd by Vice President Cheney), Bechtel (with numerous Republican Party interlinks), and JP Morgan Chase (traditional capitalism at its finest). Military equipment contractors are also missing, probably because the logos used here are the ones Europeans recognize. In any case, Iraqi intransigence may cut deeply into any profits, monetary or political.

FIGURE 7

Diablo Canyon Blockade Organizational Chart

This schematic by Bob Thawley was drawn for the Northern California Non-Violence Preparer's Collective manual in 1980 to help explain to potential protesters just how the Diablo Canyon Blockade made decisions. Non-hierarchical and decentralized, almost all of the participating collectives used feminist consensus process. The chart doesn't reflect it, but most of the decision-making power of the actual blockade was centered in the affinity groups and the task forces—under the principle that those who do the work decide. The framework was set by representatives of all the organizing groups, task forces, and affinity groups at meetings chaired by the San Luis Obispo (SLO) Project Office. The nonviolence and consensus process were heritages of the anti-nuclear movement (and its ancestors), especially California's Abalone Alliance. The radical structure was of the Blockade's own devising. During the action every affinity and working group decided what it would do, limited only by the agreements made to maintain nonviolence. Over the course of two weeks in 1981 there were 1,960 arrests. Diablo Canyon was the last U.S. nuclear reactor to go online.

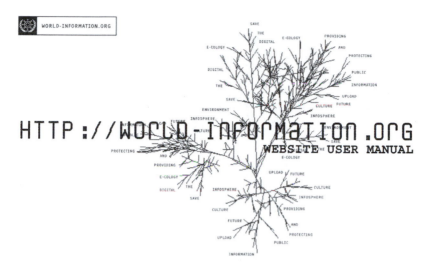

FIGURE 8

World-Information.org

One map among many of the website of World-Information.org, "a trans-national cultural intelligence provider, a collaboration effort of artists, scientists and technicians." Like a growing number of 21st-century political groups it seems to have dozens of identities, slipping effortlessly between them as it goes from UN-sponsored projects to cybertheory conferences to street demonstrations, catalyzing and mobilizing among various countries and subcultures from their bases in Vienna, Austria, and cyberspace: http://www.world-information.org.

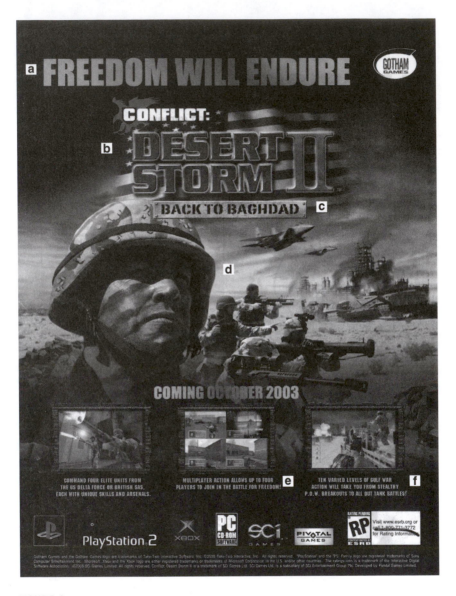

FIGURE 9

An ad from the October 2003 "E-likes" issue of *Electronic Gaming Monthly.* War is a very common theme in electronic gaming, as with much of the play of men and boys. It is hard not to read current events into them, even if they are not explicitly about the current TerrorWar. For example, "Freedom Fighters" (EA Games) fantasizes about a Russian invasion of Manhattan and warns "Many will Die for the Cause. Recruit Appropriately." Even more chilling, "Hunter, the Reckoning" by Vivindi Universal proclaims "There is No Peace—Not Even in Death," touting their horror offering.

a. An obvious play on the official name of the U.S. operations in Afghanistan—"Enduring Freedom." Iraqi resistance does seem enduring, as does the Taliban, but what that means for freedom isn't necessarily good. Freedom might be the loser although both the United States and the resistance in Iraq and Afghanistan claim that is just what they are fighting for. What isn't free is the game itself, which will probably costs nearly $50. The ad doesn't say.

b. Desert Storm II is not the occupation of Iraq's official title, which is "Operation Iraqi Freedom." "Enduring Freedom" is the Pentagon code name for the U.S. role in overthrowing the Taliban and continued operations in Afghanistan. Now naming prominent military operations has more in common with the TV networks than how less famous missions are named, although MSNBC's uninspiring and vague "Iraq After Saddam" and CNN's bland "War in Iraq" aren't very gripping. Still, compare them to D-Day's "Overlord" code name. What's that mean? For years now the labels of most operations have been generated by a computer to avoid giving away the target in its title. But perhaps that isn't a problem with such campaigns as "Enduring Freedom" either. Truth in advertising doesn't apply to PRed military operations, and in fact it is to be avoided, as the early abandonment of Bush's original antiterror "Crusade" made clear.

c. Actually, the United States didn't make it to Baghdad in 1991, but the British occupations a century ago were similar. Why did the United States need to revisit the 1991 Gulf War though? U.S. Iraq policy is a confusing trail that's as hard as following the twists and turns of 1930s Stalinism. Saddam is our friend; he is our ally against the Persians. Saddam is crazy, a little Hitler; he must be thrown out of Kuwait. But the little Hitler can stay in power while we sanction, inspect, overfly, and bomb the country. Saddam is too horrible; we must overthrow him. We can't find Saddam. Saddam isn't important. Saddam is running the resistance but he isn't important. So Saddam has been caught, but U.S. Iraq policy will probably stay as confusing as ever. Oil sometimes goes to the head.

d. For all the heroics of Jessica Lynch and the other women soldiers serving and dying in Iraq and Afghanistan, war is still gendered masculine with a vengeance. The squad is very multiracial, of course, as has been the tradition in mass-media portrayals of the U.S. military since the Korean War.

e. Just whose freedom does one battle for in Iraq? Halliburton's freedom to make a profit? An Iraqi's freedom to vote for Kurdish independence or a Shi'a state? Freedom is complicated.

f. Ten levels of reckoning, almost none of them applicable to the real fighting in Iraq. There were no "stealthy POW breakouts," just released prisoners, nor were there any "all out tank battles!" What there are are countless small bomb and grenade attacks that provoke massive U.S. responses that alienate most families and neighborhoods who then . . . well it seems to go on. It is nothing new. It is small war, dirty war, guerilla war, low-intensity conflict, asymmetrical war. And the United States is sliding deeper daily.

the responses

the future present of peace and resistance to war

Since wars begin in the minds of men, it is in the minds of men that we have to erect the ramparts of peace.

—UNESCO Charter

The ultimate weakness of violence is that it is a descending spiral, begetting the very thing it seeks to destroy. Instead of diminishing evil, it multiplies it. Through violence you may murder the liar, but you cannot murder the lie, nor establish the truth. Through violence you may murder the hater, but you do not murder hate. In fact, violence merely increases hate. So it goes. Returning violence for violence multiplies violence, adding deeper darkness to a night already devoid of stars. Darkness cannot drive out darkness: only light can do that. Hate cannot drive out hate: only love can do that.

—Martin Luther King, Jr. (quoted in my Working Assets phone bill for October 2001)

PEACE ORGANIZING AND THEORIZING

Organizing is an art, not a science. You can learn techniques and principles, but it always comes down to feelings because it is about building community. Whatever the sociologists say, you can't precisely define community, but you sure as hell know it if you have it, just like love. There are a few rules common to organizing and to falling in love:

Go with what you know.

The greater the gap between people, the less effective, the more alienated, the more problematic it is.

When you do stuff out of guilt it eats the relationship.

As each love is unique, so is each movement. In the last hundred years, the threat of war has fostered various movements for peace. Today it is no different, except for one crucial difference: they are coordinating together, thanks to IT, in more effective and new ways, creating what many have called the "other superpower." More than ever before, there is one peace movement and it is global (Schell 2003; Boyd 2003).

Who makes up the peace movement of the twenty-first century? In the West there are many of the "usual suspects" dating back to the 1930s or even earlier—the War Resistor's League, the American Friends Service Committee, the Women's International League for Peace and Freedom. Their position is often, but not always, pure pacifism. Although they are not large, their persistence has been extraordinary and their influence very real. In almost every country of the world there are groups refusing military service or directly resisting war, often based on religious principles, such as the Jains in India, the Baha'i, and various Anabaptists (Mennonites, Amish) and other Christians. Many social justice groups around the world are also antiwar, especially women, workers, and farmers. But in the last few decades there has been an incredible proliferation of organizations resisting war, including veterans, environmentalists, and networks against specific conflicts. Anywhere there is war there are protests to war, whether it is women in the Congo campaigning against military rape or Israelis and Palestinians uniting to try to stop the violence through such initiatives as the Jewish-Palestinian village of Neve Shalom/Wahat Al-Salam (Feuerverger 2001) or their own "people's" peace plan, which garnered major support in 2003.

Newer groups, from the 1980s or later, created for solidarity with liberation movements or for specific campaigns such as resisting the World Trade Organization, are usually less doctrinaire than the pacifists but are often based on sophisticated political and organizing principles from anarchism and feminism as well as pacifism and Marxism. When movements do become popular and garner a mass following, as with the anti–Iraq war organizing of 2002 to 2003, Marxist grouplets often try to hijack them through front organizations, but their need to hide their politics and put forward a moderate agenda, along with their hierarchical,

boring, numbers-focused efforts usually make them ineffectual in building their vanguard party. The cutting edge rests with the people organized in new ways that reject both Leninist democratic centralism and mass media–obsessed liberal bureaucracies.

During the ferment of the 1960s, activists in the West started forming affinity groups, first used by Spanish anarchists in the 1920s to protect organizing workers from management death squads, to bring coherence and emotional support to street protests. Sophisticated theories of nonviolence were inspired by India's satyagraha movement. The use of consensus was adapted from Quaker activists and enriched by feminist consciousness-raising groups. After the collapse of the big, hierarchical radical groups of the 1960s, there was a search for new forms of organization and new thinking about concepts such as leadership. In 1978, for example, *Win Magazine* published Bruce Kokopeli and George Lakey's article "Leadership for Change," which clearly differentiated leadership from leaders and critiqued authoritarian (patriarchal, Leninist, liberal) styles of leading. Affinity groups often became ongoing communities and ended up organizing as well.

In the antinuclear movement, experimentation with large networks, as opposed to formal groups, began to produce startling results. In the early 1980s the Love & Rage affinity group proposed to the Abalone Alliance, a California coalition of antinuclear groups, that the Alliance would be stronger if it consciously acted like a network and not a formal organization. Instead of complex, difficult, and watered-down decisions made on the state level, the working collectives and affinity groups could make their own decisions as long as they followed the network's principles. It was the Abalone Alliance network that staged the blockade of Diablo Canyon, the last nuclear facility to go online in the United States, but only after weeks of protest by tens of thousands of people leading to thousands of arrests.[1]

The Diablo protests (and the campaigns against Seabrook on the U.S. East Coast) catalyzed sister networks, with many affinity groups and individuals who belonged to more than one group that waged campaigns against dozens of nuclear power plants around the country, including Rocky Flats Nuclear Weapons laboratory (Rocky Flats Truth Force) in Colorado, the Livermore Nuclear Weapons Laboratories (LAG-Livermore Action Groups) in California, the perfection of first-strike weapons and the use of Kwajalan atoll as a test target (VAC-Vandenberg Action Coalition) in California, and nuclear testing in Nevada. The feminist, nonhierarchi-

cal (often explicitly anarchist), and nonviolent practices of these groups directly influenced many others working on various issues, including ActUp, EarthFirst!, and protests against the 1991 Gulf War.

In the 1970s and 1980s a related social movement grew up in Europe, as Eastern Europeans and Soviets started creating their own social networks (often consciously seeking to foster civil society), such as Charter 77 in Czechoslovakia, Solidarity in Poland, and various Helsinki Rights Groups in the Soviet Empire. As they reached out to nongovernmental activists in North America and Western Europe, it became clear that what was also happening was détente from below or people's diplomacy. Some people focused on this work, such as the brave Soviets in the Group to Establish Trust Between the United States and the USSR.[2]

The experiences of all these organizations was cross-fertilized by other movements (anarchists, sponties, and autonomans . . . often called the ultraleft) and campaigns such as the community uprisings by the metropolitan Indians in Italy, the antinuclear occupations in Germany and France, the antiroad networks in Britain, the Narita struggle in Japan, and various anti-authoritarian Third World groups, especially in India, South Africa (Women in Black and, later, Black Consciousness), and South America (Tupamaros and, later, Las Madres de la Plaza, the Landless Workers Movement in Brazil, and many others).

As David Graeber (2002) points out, the Zapatistas (Zapatista Army of National Liberation, EZLN) were a particularly important development. Most Marxist liberation groups were not liberatory, especially when they achieved state power, as Gérard Chaliand (1978) and others have explained. But the Zapatistas were, and are, different. They have an amorphous organizational structure that gives the indigenous people real power, and a sophisticated understanding of media (Henck 2002) and power. One of the key groups that catalyzed the first anti–corporate globalization protests (including Seattle 1999), called People's Global Action (PGA),[3] came out of the EZLN-sponsored International Encounter for Humanity and Against Neoliberalism, "which took place knee-deep in the jungle mud of rainy-season Chiapas in August 1996" (Graeber 2002, p. 2). Representatives from every inhabited continent and over 50 countries crafted the Second Declaration of Realidad:

> We declare that we will make a collective network of all our particular struggles and resistances, an intercontinental network of resistance against neoliberalism, an intercontinental network of resistance for humanity. Let it be a network of voices that not only speak, but also

struggle and resist for humanity and against neoliberalism. A network that covers the five continents and helps to resist the death that Power promises us. (Quoted in Graeber 2002, p. 3)

The old dream of a truly international movement for peace and justice has finally come to pass, thanks to new theories of network organizing and new networking technologies.

Many activists now mobilize information technology for their work, as the Zapatistas pioneered the use of the Internet to mobilize support. A good example is Witness, which puts video and real-time Web broadcasting technology into the hands of human rights activists and indigenous people under siege. Art is a related approach, used by collectives such as Art and Revolution (famous for their puppets), Reclaim the Streets, the Pink Blocks of Prague and Genoa, and the Living River of Québec. Most actions now combine art with technology (giant sound systems or thousands of portable radios for spontaneous street party protests), often with direct action or civil disobedience as well.[4]

But even when the practice is sophisticated, the theory of what is being done often is not. The very ideals of peace and social justice, so often proclaimed by peace activists, are usually quite unclear. There are still those who feel that you can win peace through violence, when everything that has been learned about the struggle for peace (and justice for that matter) suggests strongly that your means delimit your ends. You cannot achieve a peaceful or just system with violence or injustice. Much of the problem is how contested these terms are. Osama bin Laden and President George W. Bush both claim to be acting for justice and, in the long run, they insist, for peace. Are they both right? Or both wrong?

Almost all states argue that they need to prepare for war, and fight wars, to give their citizens security. But if we look closely at the troubles citizens have, we see that states are often the ones causing them. Jessica Matthews calculates that, of almost 100 armed conflicts from the end of the Cold War to 1997, "virtually all" were intrastate and many were about governments "acting against their own citizens," which usually means robbing, arresting, torturing, or killing them. So there is some disillusionment, even among government bureaucrats, about the "security" states offer.

A competing notion of "human security" is creeping around the edges of official thinking, suggesting that security be viewed as emerging from the conditions of daily life—food, shelter, employment, health, public safety—rather than flowing downward from a country's foreign relations and military strength. (1997, p. 51)

Matthews has noted "a growing sense that individuals' security may not, in fact, reliably derive from their nation's security." In "human security" the "conditions of daily life" have to be taken into account (1997, p. 51). If people do not have food, shelter, employment, health, safety, and freedom, they do not have security. Their country may be strong militarily and have lots of nice alliances, but that is national security and it often bears little or no relationship to actual human security.

The strongest national security states have been the ones to develop weapons of mass destruction, the ultimate threat to everyone's security, and the insecure national security states are the ones who will probably use them first or give them to NGOs that will.

So peace must be based on more than the absence of war, it must include social justice at home as well, and economic opportunity. Peace is not utopian, it is the most practical of things. But how do you get it? Governments still think you can build it with soldiers—peacemaking and peacekeeping soldiers building nations. Recent events, however, indicate otherwise, as the United States has learned in Afghanistan and Iraq. Foreign soldiers breed war as often as not; nations build themselves.

OFFICIAL PEACES: PEACEMAKING/PEACEKEEPING

The governmental view of peace is determined by governmental claims to a monopoly on violence. If only governments can legitimately use force, it makes many ethical calculations quite easy. But the reality of military peacekeeping is very different. In Srebrenica, Yugoslavia, the first-ever UN-guaranteed civilian safe area was overrun by Serbian death squads leading to "the worst massacre in Europe since World War II" (Rohde 1999, p. 270).

One could argue that the UN and other international bodies have failed miserably in their attempts to end postmodern conflicts and point to Somalia, Rwanda, and the Balkans, where a series of wars, ethnic cleansings, and international interventions have resulted in failed states and devastated regions. But a closer look shows that most of the responsibility for these failures rests with the nation-states that constitute the UN. In particular, the behavior of the U.S. was erratic or worse in all three of these cases. President Clinton's actions were particularly heinous (Shawcross 2000). Despite these manifest failures, the UN has been involved in more and more increasingly complex operations with mixed but very real success. Hundreds of troops have died fighting for the UN in dozens of oper-

ations and the trend will only continue (Lewis 1992). If freed from reliance on nation-states in general, and from domination by the great powers on the Security Council in particular, the UN might well become a useful part of a peaceful world-system, perhaps with its own security forces.

Is peacekeeping the future of all armies and warriors? Already such operations other than war (OOTW) are a major area of specialization among many military establishments, although not really in the United States. In practice, many armies have become basically peacekeepers; warriors as police (see "NATO troops use tear gas," AP 2004). This is particularly true of some of the Scandinavian forces. However, because even UN operations are almost always based on nation-state definitions of peace, military peacekeeping and peacemaking missions can be very militaristic, and indeed violent, just as many law enforcement practices are. Some missions are a hybrid of the two modes. Timothy Thomas, retired, Lt. Col., the U.S. Army has even coined the term "policekeeping" to describe them (2001).

Many soldiers who don't serve as peacekeepers end up getting arrested by them and labeled "criminals." The expanding international movement against war crimes, which has led to the establishment of a standing court in the Netherlands, may in retrospect be one of the greatest accomplishments of the postmodern war era. It is not just the direct perpetuators of atrocities who are being prosecuted either. General Tihomir Blaskic, a Croat commander, was sentenced in March 2000 to 45 years in prison for the crimes his soldiers committed (AP 2000b).

The criminalization of war offers real hope for ending this ancient institution, and it is intimately linked to the tremendous growth of anti-war sentiments and organizations over the last century. War is still good for many businesses and states and it still appeals to authoritarians of many ideologies, but claims that it is a healthy masculine preoccupation, that it is just a branch of politics, or that it is in some way natural to have collapsed under the realization that it has become too dangerous, indeed too horrible, to be any of these things.

Still, it is a long way from these realizations to actually ending war. War is an integral part of the international system as we know it, and it turns out that peacemaking justifies all sorts of war-making, in any case. To end war we'll have to dig deep into human culture, living politics, and the very way we understand the world and make some fundamental changes.

A good example of a fundamental change would be a convergence of military-practitioner and peace-activist thinking. It hasn't happened yet, but there has always been more traffic between the peace movements and

war movements than most participants in either are usually willing to admit. This shouldn't be a total surprise, considering the growth of military peacekeeping. Mahatma Gandhi often said that if you couldn't struggle for freedom and justice using nonviolent means then you should do so with violence; the worst failing was to do nothing. He even supported World War II, feeling that the evil of fascism was worth the dangers and limitations of using violence. Opposition to specific wars has, ironically, often been violent; even the form of many of the more comprehensive peace "campaigns" has been borrowed from the formal and informal military world. Gandhi and others have called for "peace warriors" or "rainbow warriors;" peace armies and peace brigades made up of pacifists and nonviolent activists have proliferated. But the similarities go deeper.

In postmodern war, the official main goal of the military is peace, as in the Strategic Air Command's old slogan "Peace is our profession." Even if military operations are really carried out for less noble reasons, it is clear that peacemaking and peacekeeping are now central military rationales. The reality of contemporary war is well known to the military, so it shouldn't be surprising that many of the most effective peace activists are ex-soldiers, and that former soldiers, from generals to privates, form one of the largest groups calling for the complete abolition of war.

In UN peacekeeping operations, UN troops often use nonviolence by interposing themselves between combatants as in Cyprus and Lebanon (Lewis 1992). Sometimes just their presence as observers makes the difference. The tactical principles that make UN peacekeeping effective are usually not militaristic at all but seem more like the approaches of peace activists. Rod Paschell, the former head of the Military History Institute and the drafter of the first peacekeeping doctrine for the U.S. military, has listed the main principles for "imposition" actions: "firm presence," "continuous, multilevel, multiparty communications," openness, "gaining and maintaining credibility," and "mobility" (1992). These rules echo those of emergent systems, but it is even more striking that they are also used by nonviolent affinity groups.

It seems there is some real convergence on fundamental epistemological, ontological, and ethical issues between parts of the peace movement and an interesting slice of the strategic studies community. Nothing has made this clearer to me than the Martial Ecologies conference of 2000, organized by Tel Aviv University (TAU) and the Israeli Defence Forces (IDF), that I attended.

Epistemology is the most important part of philosophy because all arguments are based on epistemological assumptions. The seriousness of the Martial Ecologies conference was reflected in the importance that epistemology was given. What was startling was that many of the epistemological approaches advocated by the strategic studies people are the same ones that ground the peace movement.

To be specific: feminist epistemology (Brig. Gen. Res. Dr. Shimon Naveh, IDF); the value of the "dialogic" (Prof. Edward Luttwak, Senior Fellow, CSIS, U.S.); discourse analysis (Mr. Gad Sneh, Head of Research, Praxis, Israel); the need for praxis (Dr. James A. Blackwell, Jr., Director, SAIC, U.S.); transcending dichotomies (Brig. Gen. Charles Grant, UK); truth is constructed in large part (Col. Douglas A. McGregor, U.S.); the usefulness of semiology (Brig. Gen. Gershon Hacohen, IDF); deconstruction as an analytic (Ms. Andrea Leitersdorf, Security Studies, TAU); an implicitly Freireian approach to knowledge production (Prof. Philippe Baumard); and the importance of littorals (U.S. Marine, Ofra Graicer, Security Studies, TAU). To explore just this last example, on the Left there is a large and important discourse about the importance culturally of the margins, usually framed in discussions of borderlands/La Frontera, cyborgs, coyotes, mestizas, and ecological transition zones. Littorals are clearly part of this epistemological claim that the edges are more important—on many levels from the tactical to the political—than the center.

Any epistemology implies a specific ontology that frames the limits of what kind of ethics are possible, because the epistemological is never just "practical." On reflection, it is not surprising that both feminists and military practitioners would gravitate toward an epistemology that leans heavily toward the material and specifically toward embodied experience. Both also stress the limitations of human knowledge and, in a bridge between epistemology and ontology, asserting that knowledge is "situated" specifically (in Donna Haraway's formulation) in time and place, that it isn't a free-floating abstract entity. An ontology that validates the physical and the embodied is an inevitable consequence of these positions.

Specific ontologies inevitably come out of epistemological choices. All rich issues are epistemological, ontological, and ethical; these are dynamically related categories. The ontological is not just material, it includes embodied practices as well, and heuristics (rules of thumb) are based on what we think happens in the "real" world. Simple deontological slogans and assumptions are gradually being rejected by more and more of the world's political communities. "War is only politics," "total victory," and

"force of fire" are some of those that seemed very questionable at the Martial Ecologies conference.

Consider such statements as "Success is not 'victory'" (Brig. Gen. Charles Grant, UK) and "communication is an action and actions are communication" (Brig. Gen. Gershon Hachoen, IDF). As with the related epistemological emphasis on discourse, signs, and so on, communication as a material effect is the fundamental assumption behind the very idea of protesting. The combination of symbolic and direct embodied actions is based on this world view. It carries with it a pragmatic ethics of responsibility and agency.

Both peace activists and many of the military and strategic analysts at the Martial Ecologies conference agree that it is best to minimize violence (Brig. Gen. Charles Grant, UK, and many of the IDF speakers); utilize distributed, nonhierarchical organizations such as networks, because organizational structure is an ethical and political issue, as organizations inevitably either foster or retard certain key specific values (most of the military and strategic speakers); and validate sacrifice and heroism. Mary Kaldor's discussion of the heroism and sacrifice of journalists in the "new war" zones was particularly moving because it parallels so closely the heroism and sacrifice often made by soldiers doing peacekeeping, as well as by peace activists in their "operations."[5]

The implications of the term "practitioner" deserve more attention, as do other labels that might knit together soldiers, activists, journalists, and international aid workers. All of them share an ethos of sacrifice, which is well and good and needed, but doesn't explain what they do, why they do it, and their similarities at other levels.

No doubt these overlaps will disturb many in the peace movement, but it cannot be denied that soldiers must be a key part of any successful attempt to end war.[6] As war has grown more horribly potent, due to new technologies, the number of soldiers who question its basic logic has increased. Meanwhile, many peace activists have seized on the same technologies to aid their cause.

ONE WORLD/ONE NET

If any one thing symbolizes and instantiates our global civilization, it is the Net. Many have argued that the Net, in and of itself, leads to democratization, and some have even put their money where their mouth is. The

most famous of these is the strange anticapitalist billionaire George Soros. His Open Society Foundation has spent billions hooking up the universities of the old Soviet Empire to the Internet and fostering cyber cafés across Eastern Europe in the hope that this would strengthen democracy.

The idea that the Net is automatically democratic (cyberdemocracy) is being challenged by the increasing attempts to tame it, as in the fight over control of ICANN and other Internet institutions. Advocates of democracy, such as the Civil Society Democracy Project, are struggling with corporate and government players who want to remove any public input from the managing of the Internet.[7]

The main players in the struggle over the political and technical future of the Internet can be broken down into four categories: governments, corporations, alliances, and individuals.

Among governments, the United States is preeminent. If anyone could have been said to "own" the Internet, it was the United States. Ironically, its ability to act has been severely constrained by the desires of other national governments to free the Internet from theoretical U.S. control. The Net has become semiautonomous, self-regulating, and "the world's largest functioning anarchy," but corporations, states, and alliances of them both continue to try to control at least part of the Web, with varying degrees of success. The U.S. government, however, has been forced to give up most of its formal power.

First, it tried to pass on administrative control to a number of for-profit corporations. However, the competition between corporations for guaranteed profits (notice the alliance against Microsoft), and the opposition by governments, alliances, and individuals to granting such monopolies, have precluded any permanent for-profit administration. Instead, because of the competition among those who would prefer a more structured and policed Internet, the governments and the corporations, much technical power remains with the voluntary alliances of computer professionals (including many of the key working committees that set Web standards) and others who have played major roles in making the Internet what it is today.

The political articulation of the liberatory potential of the Internet preceded the actual computer-human system. Often, it came from the voice of those who work with computers. There are many interlocking and overlapping groups that involve computerists, but one of the best is Computer Professionals for Social Responsibility (CPSR), which I have belonged to for many years.

CPSR grew out of organized opposition to the Strategic Defense Initiative (Star Wars) among computer scientists, but now it takes up many other issues as well, such as privacy, computer voting machines, computers and work, computers and gender, and the role of the Internet in society. CPSR's Internet principles can be seen in their "One planet, one Net" initiative:

1. There is only one Net.
2. The Net must be open and available to all.
3. People have the right to communicate.
4. People have the right to privacy.
5. People are the Net's stewards, not its owners.
6. No individuals, organizations, or governments should dominate the Net.
7. The Net should reflect human diversity, not homogenize it.

What is it that motivates computer professionals to become so involved in the politics of this "virtual" world? First, especially for those who have not been seduced by cyberspace, it is important to understand that for many people it feels like a real place. For the professionals who have helped shape it and who spend tremendous amounts of time "in" it, there is a powerful sense that it is a real place where they live, at least part time.

For a variety of reasons, a powerful, articulated ethic of "responsibility" and an unarticulated assumption of "service" have developed that define good citizenship for those whom I call, for want of a better term, Netizens.[8] These values can be directly traced to both the hacker subculture and the 1960s counterculture that many of the key technical players adhere to. Even when they aren't "countercultural," they often share general computer-culture assumptions about the incompetence, if not the perfidy, of large institutions such as the government and corporations.

On the other hand, the central institutional players are committed to quite different values related to profits and militarization, and they have the resources to buy a great deal of technical expertise.[9] Skirmishes around "virtual civil disobedience" and the growth of "hactivism" have illustrated this well. Attempts to protest Mexican policies in Chiapas, for example, by mass "denial of services" attacks on Mexican and U.S. Web sites led to Pentagon-organized counterattacks that crashed the computers of some of the individual activists taking part. Divisions among Netizens about the

efficacy and wisdom of making cyberspace an arena for political struggle reveal real confusion about the nature of "virtual" citizenship.

The conflict between the values of the anti-authoritarian techno-elite (supported by many interested Netizens) and the cyberinstitutions can be seen in a number of issues. Once one understands that all these technical and political struggles are about who will govern (or self-govern) the Internet, it becomes possible to understand what's at stake in the controversies around cyberporn, computer crime, privacy, encryption, domain names, communication standards, hacking, and infowar.

Initially the U.S. government saw the issues of cyberporn and computer crime as ways of exerting direct control over the Internet. Constitutional questions, business resistance, and Netizen outrage have since forced the government to step back from such positions as allowing the FBI to read e-mail whenever they want based on the claim that e-mail is not "real mail," which was rejected by the Supreme Court. Projects such as the Clipper Chip, designed to make every computer open to government snooping, failed because of their negative effects on the export of U.S. computer hardware and software. However, military enthusiasm for Infowar offers a much stronger and much more sweeping justification for not only the domestication of cyberspace, but its remilitarization. If that weren't enough, the War on Terror does the rest.

The military's claim that cyberspace is a crucial battleground for future wars and for terrorism today has already justified the creation of a number of military and police institutions charged with monitoring the Internet. Future plans to design ways to forcibly occupy certain parts or even all of cyberspace are overriding the democratic infrastructure that is now in place online. For all the Internet's potential to exist among the cracks of the postindustrial infrastructure and to create, in Hakim Bey's term, temporary autonomous zones (TAZs), when push comes to shove it is hard to see how the Internet can resist occupation if the real-world political situation is manipulated to produce the resources needed. On the bright side, the divisions among governments and corporations, and the growing sophistication and numbers of Netizens, indicate that the future of cyberspace is yet to be determined.

Many technical innovations produce unintended consequences for the political future of the Net. In just one example, a relentless wave of improvements has made the Web much more user friendly, not just to the computer illiterate but to programmers as well, through a more open, cooperative style as opposed to the "microworld" approach, which

incidentally is the military's frame set (see Edwards 1996). This has led to the increasing feminization of the Web; online participation by women has gone from 5 percent to almost 50 percent in 10 years in the United States. It would be naive to think that women are "naturally" against war and incapable of contributing to militarization (see Enloe 1982), but this does represent a drastic shift from the Internet's traditional military forms and its traditional militarization, perhaps mirroring how computerization itself has shifted gender identity within the U.S. military (Gray 1988).

The presence of more women on line may have further impact. The implicit feminist values of the "cyberrgirrrl" aesthetic mesh well with the emerging hactivist movement and other dissident currents. Although hardly the same, they share an anti-authoritarianism, as well as the Libertarian assumptions of many in the computer industry, the older hacker ethic, and the values of responsibility and service the computer professionals who dominate the technical aspects of cyberspace. How they will interact with the paranoia implicit in infowar and cybercrime scares, and the profit drive of most corporations, remains to be seen.

The virtual world isn't an actual place in itself, and therefore "virtual society" is an oxymoron. Virtual society is just part of, perhaps a prosthesis of, embodied society. The virtual world is based on physical systems: humans, computers, connections. As Anthony Wilhelm points out in his call for telecommunications reform:

> Control and ownership of the slender glass filaments and coaxial cables through which our ideas and aspirations travel at the speed of light will partly determine our ability to articulate a common voice in virtual (public) spaces. A new activism and experimentation with the technology will be pivotal, but it is conceivable that there will be too many banner advertisements and artful diversions online to maintain our identity as citizens and not just as consumers or Internet travelers. (2000, p. 158)

While cyberdemocracy is a necessary condition for meaningful citizenship now, it is not sufficient in and of itself. In the end, we are still bodies trapped in political systems and market economies and sustained by friends, families, lovers, and civil society. We can't just bathe in the infoflow; we have to act.

> Digitally mediated political life offers little hope of delivering easy or seamless answers to address entrenched problems on a global scale. The ceaseless exchange of high-speed information and the proliferation of political forums demand more of the global citizen, not less. These

developments command, among other things, greater critical reflection on the credibility and usefulness of the information being disseminated as well as greater responsibility in developing solutions to political and social problems that through mainstream avenues may remain neglected or ignored. (Wilhelm 2000, pp. 156–157)

Fortunately, many groups and individuals are committed to not only understanding our postmodern world but changing it, too. They come from a variety of traditions and are proliferating a wide range of new forms of activism. At first glance they might seem unrelated, but where theory and practice merge in praxis, there is remarkable harmony.

ONE PEACE/MANY PATHS—A BETTER WORLD IS POSSIBLE

The reform of consciousness consists solely in the awakening of the world from its dream about itself.
> —Karl Marx; quoted in Der Derian 2001, p. 54,
> quoting Walter Benjamin quoting Marx

"Anarchism" is the revolutionary idea that no one is more qualified than you to decide what your life will be.
> —CrimethInc. 2001, p. 41

Freedom is power. It is power for the many against oligarchy and dictatorship; it is power for the few against the many. The struggle for freedom has been long and uneven, and it isn't just against oppressive or undemocratic political systems. Authoritative spiritual and cultural institutions have been just as deadly, if less obvious, obstacles to people authoring their own lives. Freedom isn't something one is given; it has to be taken and used in actions, in ideas, and in life.

There has been progress. In most of the world today people at least pretend to not accept slavery, to view other people as human, women as human, children as human. Everywhere there is at least the pretense of democracy. Matrices of freedom do exist everywhere, sometimes protected by technologies such as constitutions or the Internet, sometimes sheltered behind ancient traditions, and often in the extralegal, temporary autonomous zones that subcultures foster.

On the other hand, the rich have never been richer nor the poor more numerous. Tremendous, indeed apocalyptic, technical power is in the hands of the very few, in democratic states as much as in overtly

authoritarian states, companies, and nongovernmental organizations. Overall, the picture is bleak. War continues, with more horrible weapons, and the dominant superpower promulgates preemptive wars, the militarization of space, and the development of nuclear weapons for combat. Ecological stresses increase daily with the growing human population and the incredible consumptions of the developed world. Democracy is threatened everywhere, by fear most of all, but also by the hatred that true believers foster, and by the incredible new technologies that make surveilling, manipulating, locking up, torturing, and killing humans en masse so much easier. So, as many have asked before, what is to be done? It has to be better than what has been done before.

There is no one theory—there are many. Better yet, there are many theories in practice. Contradictory theories can both be true; dualisms often separate concepts that, if they were taken together, would enrich our understanding of what can and must be done. Two recent articulations of radical theory make this point better than any generalization could. At first, they seem to represent two completely different approaches to understanding the world and our theorizing about it. One is austere, zen-like in its rejection of superfluous or not-provable assertions. The other is baroque, Taoist in its embrace of the living, thriving contradictions of life.

Ana Peraica is a young veteran of the Balkan wars, a peace activist, and a philosopher who has proposed Project De/light me! In it, she argues theory must be succinct—a koan, a "zipped statement," "a meme"—because she insists, quoting Tintin, "Keep it short; my time is more valuable than yours." Theory, in her view, is mechanistic; it represents "stabilization of thought or movement, control and war rhizomes" (2000, p. 1). Moreover, "Theory is a technology, automatics of thinking, not completely independent of what it produces. Thoughts fabricate, and are fabricated at the same time" (p. 2). Peraica distrusts theory even as she produces wonderfully useful and sophisticated theories. There are no grand narratives for her; they are too dangerous. There must be action for peace, for justice, and the theory (or perhaps antitheory) that's used should be "underground," "of weird production," "lower or down," "non-academic," "second-hand."

On the other hand, Maria Serrano and Silvia Lopez, Spanish activists who help sustain La Eskalera Karakola, a feminist center in a squat (*occupacion*) in Madrid, explain their work with an analytic that incorporates political economy, psychology, postmodern philosophy, and lush, powerful rhetoric. But, as with Peraica's writing, they reject claims to total knowledge, instead using feminist epistemology and discussions of

embodied praxis to make explanations and proposals about prefigurative politics (2003).

This is the most important point of unity between these seemingly opposed approaches to theory: the refusal of certainty. But there is more, for, despite her minimalist claims, Peraica is incredibly careful and erudite, building on the many failed theories of revolution that clog the discourse today and never neglecting second-order effects, feedbacks of unintended consequences, and the problem of reflexivity—the need for the self-theorizing of theory. Serrano and Lopez do the same, but they apply a prosthetic incorporation of everything they find useful, instead of surgically excising all but the core of anything potentially extraneous as Peraica does. Like her, they challenge received wisdom at every turn, remarking on rights, for example, that they "are a useful but insufficient charity, perverse in their disciplinary capacity" (p. 1). Both of these approaches are incredibly fresh and transgressive, two qualities that are desperately needed in thinking toward a future worth living.

Sue Golding, also known as johnny danger, is a radical philosopher in thought, deed, and persona. She has explained the power of this refusal to accept old frameworks and the drive to keep experimenting with theory and bodies in terms of the *transgressive*; it is intimately linked to a radical conception of democracy.

> If we get a sense of the transgressive as that which does not get absorbed, and we think of a system that needs to be thought through, that we may call democracy, as an entity that proliferates difference that cannot be absorbed by the law, then what we have is system of transgression, as it were, which yields a certain kind of creativity. (1999, p. 149)

This is not just a very important issue in its own right, it is also a lens for working out how new technologies in general affect politics. The very concept of "international relations" is being reconstructed by the globalizing effects of a whole range of new technologies that will have the most profound implications for all aspects of politics in the twenty-first century and beyond. At the center of this change is the idea that democracy, or perhaps something beyond democracy, can do what we hope democracy can do, but better. Sue Golding has an important insight about this as well:

> I believe that there are horrible things in the world that can be changed. Whether or not the system that will be appropriate for it is actually called democracy or something else altogether we have not invented yet,

remains to be seen. But one should not give up on attempting to make sure that things are better. Perhaps there is only ever degrees of democracy? However one would phrase it, there are democratic ideals that can become lived ideals, but not in a closed or problematic way. (p. 149)

Thomas Jefferson said that the tree of liberty has to be watered regularly by the blood of patriots, every 20 years or so. Now *that* is a transgressive story if I've ever heard one. But his point is compelling. Liberty is absolutely transgressive and it will always be under attack, and in danger of becoming "absorbed" or "coopted" or "closed" or made a sham. The word itself, as with the word *democracy,* is always on the edge of slipping away into some other, maybe even opposite and oppressive, meaning. Turn on the television and you can no doubt hear great patriots explain why we need government spying, searches without warrants, secret military courts, indefinite detentions . . . all to preserve liberty and democracy.

To resist this cowardly but compelling story we need a rich understanding of what is going on. Any liberatory use of theory has to embrace multiple viewpoints; this goes hand in hand with the realization that our subjectivity is complex, our understanding of the world is limited, and our need for alliance and solidarity is absolute. This is in marked contrast to the theories held by those in power.

For all the claims of realism by nation-states committed to realpolitik, they are really exercising realism "that purports to be realistic, yet takes no account of differing realities" as James Der Derian rightly points out (2001, p. 43). Richard Falk, Princeton's famous professor of international law, explained in an interview with Der Derian that the current system produces "shallow interventions and a 'politics of gesture'" (p. 72). Because states don't have values or friends, merely interests, truly humanitarian interventions (as opposed to the majority of "humanitarian" wars that use the label as a cover story) are the results of public protests, such as those that made the Armenian genocide a public issue over 100 years ago. Now there is a network of international NGOs and UN agencies, but states still have the soldiers, so interventions are often not effective. Real people die for illusory realpolitiks.

This is absolutely different from how theory and practice are integrated in the opposition. For example, the Critical Arts Ensemble (CAE) (2001) combines provocative art-action interventions with organizational theories such as floating hierarchies (in which projects have empowered

"leaders" but the leadership varies) (p. 70), coalitions above commu-
nity,[10] and "tools not rules" (a pragmatic approach to tactics coalitions
might take up) (p. 77). Their own collective work is based on "trust,
altruism, and pleasure" (p. 79).

In particular, CAE makes much of their idea of "Recombinant Theater
and Digital Resistance." They claim that

> Over the past century, a long-standing tradition of digital cultural resis-
> tance has emerged that has used recombinant methods in the various
> forms of combines, sampling, pangender performance, bricolage,
> détournement, readymades appropriation, plagiarism, theater of every-
> day life, constellations, and so on. (p. 85)

In their view, many people operate under the principle (which they term
analogic) that order leads to chaos and chaos to order, in a sort of truncated
dialectic. They advocate instead a view that they term *digital*: order leads to
order (p. 87). They see a special potential in information technology:

> . . . liberationist performers now must find a way to splice greater con-
> ceptual complexity and a more broadly based pedagogy into their per-
> formative models. CAE would like to suggest that one potential solution
> is to use elements from the emerging theater of information and its
> attendant technologies. Mechanisms that can deliver specialized infor-
> mation in a fast, aestheticized manner have become increasingly neces-
> sary and more useful than ever. (p. 104)

Quite different in style, but equally provocative, is the romantic, anti-
work web that calls itself CrimethInc. They praise interlocking desires,
reality over ideology, and idealism over realism. There are thousands of
such projects as Project De/light me!, La Eskalera Karakola, CAE, and
CrimethInc. around the world, seeking new ways of understanding and
acting to make a better world.

One such intervention I have been involved with is the Syndicate for
Initiative—a dozen or so activist theorists in Europe and the Americas who
have written a "Modest Manifesto" that tries to bring together many of the
principles that lie behind the various initiatives we find useful, without ide-
ology, and framed by an information theory based on an open episte-
mology. It is one story among many.

THE MODEST MANIFESTO:
A BETTER WORLD IS POSSIBLE
1.2

"Neither Slave nor Master"

—Camus

We need to start our manifesto with epistemology, not just as homage to the age of information, but because working knowledge starts with understanding how we know what we know. Hubris indicates excessive naiveté about epistemology because:

- Knowledge is situated.
- Knowledge is deeply empirical and relentlessly discursive.
- Heteroglossia is better than genius.
- Praxis is the process.
- Trust the process.
- Freedom is a process.
- The best answers are beyond binaries, even beyond dialectics.
- Thesis, antithesis, synthesis, prosthesis, and again.
- Idealism over reality.
- Reality is beyond materialism versus idealism.
- Reality over ideology.
- Reality is infinitely complex, not pure.
- Reality is improbable, not random.
- To be whole is to be part.

Our understandings:

- The personal is political; the political is personal.
- Bodies are personal.
- Technologies are embodied.
- Technologies have politics.
- Politics is about bodies.
- Bodies are sources of power.
- Knowledge is power; grace is power.

A better world will be based on commons, not just of nature and resources, but of knowledge. Commons assume community.
A better world will be based on liberatory practices, both strategic and practical.

Strategic practice:
- Nonviolent direct action for political change.
- Prefiguration in art, action, and life.

- Resistance: personal self-defense, non-cooperation, to property as violence.
- Mutual aid.
- Reclamation: of nature, of politics ("throw them all out!"), of community, of morality.
- Effective theory and total education.
- Liberatory Information: open source, shareware, anti-commodification. We want information so we can be free.

Tactical practices:

- Détournement, irony, reversion, subversion, seduction, inspiration, sacrifice, communication, coordination, humor, wit, to listen.

A better world is based on principles, not prescriptions:

- Solidarity.
- Tolerance.
- Autonomy—community.
- Commons—land and knowledge.
- Nature—bioregions, sustainable, active.
- Cultures—autonomous, sustainable, actants.
- Markets—controlled by individuals, families, and syndicates.
- "Thin" government—many democratic institutions at many levels. (The more governments, the less government.)
- Property—individual, family, syndicate, NOT corporate.
- Syndicates—affinity groups, unions, alliances, NOT corporations.
- Families—Based on complexity, life, choice, and tolerance, not nuclear ideology.
- Work—Those who do the work, decide.
- Labor—If it is alienated, it is oppression.
- Economics—Profit is not policy, efficiency, or "natural."

"The Future is not yet written."

—Sara O'Connor, *The Terminator*
—The Syndicate for Initiative

art as politics
by other means

ART AND WAR

Breathe in poetry; breathe out experience.
—Bruce Andrews (quoted in Wieja 2001)

"Breathe in experience; breathe out poetry" is apparently a truism in the study of poetics. But really, shouldn't it also go the other way around, as the language artist Bruce Andrews suggests? Art should inspire us, breathe into us the energy to make a better world. Art has played a major role in shaping the cultures we live in, the way we see and experience the world. Although it is hard to prove and difficult to articulate how it happens, art changes us all the time, and so it changes the world. Art also changes the metarules, the rules about rules, of our culture. Now, more than ever, we need art to change the cultural system that most threatens human survival: war.

That said, it seems art is even harder to define than war. Certainly, something is not art unless we are supposed to pay special attention to it. But that is not enough. Danielle Boutet argues that:

> . . . the art creation process is a languaging practice, for it implies making meaning with materials—or better yet, making material meaning. (1996, p. 41)

She goes on to explain that art differs from "discursive language" in that it does not "transmit meaning through sets of codes." Instead it transmits through "form and content" that "makes sense to the psyche." The meaning is "actualized" in "time, space, body, and matter" because it

must be "experienced." For Boutet, art is therefore a "sensual and aesthetic experience."

One could argue that there are still "codes" involved, but I think Boutet is right in not accepting the term. The codes of language discourse are formal in most respects (narrative, logic, experiment), and firmly set, by and large. The codes that do exist in art seem to fall somewhere between explanations after the fact, publicity, and wishful guessing. Whatever explanation is deployed around a piece of art is window dressing compared with the work itself. Either the art "manufactures meaning" (in Beulah Gordon's phrase) or it doesn't.

Art is cultural production, and more important, it is an agent of cultural change. For example, it can change how we feel and think about war. Consider the great painting *Guernica* about the Fascist bombing of the sacred Basque town of the same name by the German Condor Legion during the Spanish Civil War. It is dominated by a bull running amok, a figure that was often interpreted rather literally. But Picasso (1945, p. 487) insisted that, "No, the bull is not fascism, but it is brutality and darkness." His point being that the problem of war is not a simple one of good political systems versus bad political systems. Picasso was a Communist, but not because of its rather simplistic, if dynamic, Manichean view of the world. The real world is not so easily categorized. Some forces are greater than class. War is the epitome of brutality and darkness, and the problem of war is that now war is always war against what is best in us. In this struggle, art can be one of our best allies if we don't put it above the fray. For, as Max Kozloff (1975) notes, "There is no escape from ideology, either in the creation or the interpreting of art."

It is an old argument: What is the relationship of art and politics? Personally, art without meaning is not interesting; nor is art that celebrates, let alone monumentalizes, war. Just as bad is art that claims to be innocent. It cannot be. As Hal Foster notes, we can't get "outside" of representation, nor of the politics of representation (quoted in Sandler 1996, p. 361).

How can art help us think and act to overcome war? A good example is *N*, a piece about biological weapons, history, the environment, and what they all mean to us. Gruinard Island, located off Scotland, was the primary biowar testing site for the British military during World War II, and it is contaminated by anthrax spores to this day. Lloyd Gibson and Mark Little, two British artist-philosophers, were appalled by this history and fascinated by contemporary local legends of mutants and other strange doings on Gruinard. So they conceived and produced a smart-

metal sculpture of a child to be placed there to be automatically filmed through the seasons as it morphed itself in response to changing temperatures. The meaning was, in part, to notice how we interact with our environment in ways determined to some extent by our technological choices. Also, it was to highlight how fostering the capabilities, and therefore the potential, for biological war is as much a choice as is putting a metal child on Gruinard.

After all, it wasn't the fascists who turned little Gruinard Island into a biowar site in 1942, it was one of the world's great democracies. Of course, the argument is that the British Empire needed to develop biological weapons, anthrax in this case, to protect itself in case the Axis powers used bioweapons. But, as it turns out, the British planned to use biological weapons not just in retaliation to a first use by the Axis, but in the case of potential defeat, as well (Bernstein 1987). Fear breeds monsters, some of whom still seem to haunt Gruinard.

They inhabit many of the corners of our possible futures. We have the future of anthrax, already tried as a weapon by the Japanese Aum Shinrikyo cult (who used sarin as well) and more successfully in 2001 in the United States by person or persons unknown, as of this writing. Today, as you read this, scientists in biowar laboratories are seeking to engineer anthrax genetically to be vaccine resistant, more easily deliverable, a better killer (Thacker 2000).

There is also the future of the environment, symbolized by Gruinard Island itself. It is a place of heather, wildflowers, sheep, Scots, and weaponized anthrax spores washed with formaldehyde. Nature is not unmediated anywhere anymore, not at the edges of Scotland nor in the wilds of Montana where I write surrounded by fields of ICBMs.

We have the future of the human body to consider. It cannot and will not stay the same. It is being modified continually by militarized technoscience, consumerist mania, and technological art. It is changing through conscious and unconscious participatory evolution. These transformations can be biological, such as the reprogramming of immune systems to, it is hoped, resist anthrax infection as a vaccine would, or they can be conceptual, as Gibson and Little are doing with their smart-metal child. Jody Berland (2000) argues that the statue-child represents a stark reality—it isn't a matter of whether the body is going to change, but of how.

Related to all these futures is the future of war. It has often been said that war is too important to leave to the generals. It is too important to leave alone as well. The possible futures of war, of the human body, and of

the embodied earth (the so-called environment) are inextricably inter-twined. It isn't a problem of one particular political system, but of human politics. We shouldn't overemphasize the role of capital(ism) in our cur-rent dilemma. It is an easy error to commit in light of the collapse of state socialism and in this era of unbridled consumption, unmitigated greed, and the commodification of everything from the human body to the cri-tiques of commodification itself. But, as even recent history shows, turn-ing little beasties such as anthrax into killers is not restricted to the semicapitalist nation states. Imperial Japan, Marxist-Leninist USSR, the British Empire, Islamist cells, and even the strange Buddhist-Asimov–worshiping Aum all have joined with the United States (and so many others) to weaponize biology. The real problem is the metadiscourse of war, which is linked inevitably to even older stories, such as patriarchy and the long, sad tale of human-nature alienation.

The responses we make to war must be carefully and continually nuanced, as the weather-beaten statue on Gruinard Island is. We must look to relationships "with the natural world" that are "bound by respect and dependency, rather than by mastery and control" (Hall 1994, p. 10). We must invest our analysis not just with careful research, sophisticated aes-thetics, and wit, but with ourselves. This is why the work of Lloyd Gibson and Mark Little on Gruinard Island seems so appropriate. There is a technoscientific body embedded in besieged nature, telling its own his-torically specific tale about hubris, war, and science.

Another appropriate artist for these times of TerrorWar is the South African painter and performer Beulah Gordon. In 1998, after months of posting the simple message "Wake Up!" around North America, she created a multimedia production about postmodern war, animal slaughter, and other horrors, and then shaved her head and took a month-long vow of silence to establish herself as a new order of pacifist monks, an order of one.

The suffering metal child on the island is another order of one. It invokes a religion of peace, of harmony, of awareness, linked to no mass ideology. Religions of lots of people are dangerous, prone to premodernist certainties, modernist hubris, and armed with postmodern technologies. Better we leave our religious certainties to our artifacts and learn from them just how precious, and how contingent, life is. Art helps do this, but only if we pay attention.

Many have said that attention is the precious commodity in today's information economy, and that is true enough. Humans evolved with

senses that were open to some stimuli but impervious to others. In the state of nature, extreme stimuli were rare, but civilization has developed to produce incredible levels of stimulation so that now we are saturated (and beyond) in a media cacophony that always grows worse because the purveyors of commodities and politics need more and more attention from consumer-citizens to survive. They seek to snare it with subtle and unsubtle appeals to our interest in color, movement, pattern, violence, and sex. That is why, in English, we "pay attention;" it is being commodified.

In some important ways one can define a human-machine cyborg (which most of us in industrial society are already to a great extent) as a creature modified to "pay" attention differently than "natural" humans do. Depending on the type of cyborg, this involves a greater spectrum of stimuli (as with all augmentations for viewing infrared, telescopically, microscopically, and so on), a lesser spectrum (as with workers and soldiers who should pay attention to their tasks and not to their alienation or mortality and the whole range of neomorts and unconscious cyborgs), or a different one (as with virtual reality, and mediated reality).

The liberatory promise is that cyborg technosciences can break the economy of attention through augmentations and transformations that produce proliferations, displacements, and participation. But the opposite is also possible, of course, as many popular-culture horror myths make clear. In the short-lived television series *Max Headroom*, where many issues of the commodification of experience were explored, one episode was about the development of a new way of transmitting advertising information in concentrated forms. These "blipverts" had the side effect of overloading the nervous systems of some viewers so that their bodies actually exploded. Things have not gotten quite that bad, although a deluge of bad commercials seem as if they could make one's head explode, but it is clear that our very consciousness is now for sale. In the political resistance to this, some designer-activists see the Achilles heal of the dominant neoliberal, semicapitalist Western consumerist WTO, McWorld system.

CULTURE JAMMING

And the man in the suit has just bought a new car from the profits he's made on your dreams.
—"Low Spark of High-Heeled Boys" by *Traffic*, 1971

The genuine liberation from an epoch, that is, has the structure of awakening in this respect as well: it is entirely ruled by cunning. Only with cunning, not without it, can we work free of the realm of dreams. But there is also a false liberation; its sign is violence.
—Walter Benjamin (quoted in Der Derian 2001, p. 43.)

Guerrilla theater has been a staple of protests for over a hundred years, dating back at least to the labor pageants that supported the great strike at Lawrence. Others tried to make "legitimate" theater protest, most notably the communist Bertolt Brecht and the anarchist Dario Fo. In the 1960s the theater moved right into the street and for some groups, such as the Yippies (Youth International Party—"Tune in, Turn on, Take Over"), theater became a potent conceptual weapon. Throwing money onto the floor of the stock exchange, and ritually levitating the Pentagon are two of their more famous actions.

Similar things were happening in France. In the late 1950s and early 1960s a number of French radical thinkers, most notably Guy Debord and Raul Vaneigem (eventually called *situationists,* or *situs* for short), started diverging from Marxism in a very interesting way. Where Marxism claims that everything depends on economics, specifically the relation of different "classes" to "the means of production," the situationists said that what was really important was the cultural control the contemporary "society of the spectacle" exercised over consciousness. For Marxists, culture is "superstructure" and consciousness comes only from your class position, although you can have "false consciousness" if you don't buy the party line. To the situationalists this seemed quite improbable; they felt the construction of consciousness is much more complicated. Freedom was an important value, especially everyone's freedom to choose the life they want. If put into the right "situations," people could come to understand how their consent in both communist and capitalist societies was manipulated and could begin to think for themselves and then create the situations of our lives. In particular, taking an important idea from the dominant culture and representing it in a new way could produce such ruptures. This is called *détournement.* As ad activist Kalle Lasn explains:

> Literally a "turning around," *détournement* involved rerouting spectacular images, environments, ambiences, and events to reverse or subvert their meaning, thus reclaiming them. (1999, p. 103)

By 1968 situationist ideas had infected much of the French student left, through cartoons, festivals, and analysis such as the pamphlet "On the

Poverty of Student Life."[1] Their slogans were particularly effective: "Bourgeoisie, you have learned nothing!," "Imagination = Power," "Live Without Dead Time," and "Under the Paving Stones, the Beach."

In May 1968 a series of *situ*-inspired "manifestations" turned into open revolt in the student quarters of Paris and then, when the students reached out to the workers, it became a wildcat general strike. The communists and socialist labor leaders arranged a raise, which mollified the workers and in short order the whole movement collapsed, perhaps revealing a primary weakness (low staying power) of revolutions based mainly on symbolism and passion.

Despite its brevity, May 1968 has remained an inspiration for many people who are trying to change the world, and *situ* ideas continue to live in the hearts, minds, and practices of countless activists. In the 1990s a growing number of self-described "culture jammers" became noticeable, especially through the magazine *Adbusters*.

The term *culture jamming* was coined by the band Negativland, and it was transformed into a manifesto by the writer Mark Dery.[2] Kalle Lasn has tried to make it a whole movement, and his book *Culture Jam* is an interesting analysis of the mess we are in. Lasn bases his approach to culture jamming on seven insights he had in the last decade of the twentieth century (by the way, for Lasn "America" includes Canada):

1. America is no longer a country. It's a multitrillion-dollar brand.
2. American culture is no longer created by the people.
3. A free, authentic life is no longer possible in America today.
4. We ourselves have been branded.
5. Our mass media dispense a kind of Huxleyan "soma."
6. American cool is a global pandemic.
7. The Earth can no longer support the lifestyle of the cool-hunting American-style consumer (1999, pp. xii–xvi).

It is clear that he puts consumer culture, and the apparatus that sustains it, at the heart of our current system. It only works, he argues echoing the *situs* and many others today, because we have bought into it. Lasn concludes his book by noting that:

We've had thirty years to think about what the Situationists were talking about, and it's finally starting to make sense. In that interval of time, modern media culture has metastasized. Consumer capitalism has triumphed. We're *in* the spectacle. The spectacle is *in* us. (p. 214, original emphasis)

Near his death, Guy Debord said that the spectacle had become "integrated" by "incessant technological integration of state and economy; generalized secrecy; unanswerable lies; an eternal present" (quoted in Lasn 1999, p. 214, from Debord 1998).

One of the additions Lasn has made to the *situ* analytic is the idea of *memes*. First proposed by the sociobiologist Richard Dawkins (1976), it is a simple, useful idea with profound implications. The concept is straightforward—ideas (or units of information some prefer to say) propagate through culture and humans just as viruses might. They spread, die, mutate, and combine.

A whole intellectual subculture has grown up around memes that some people have used to think deeply about issues such as political change and learning. Others deploy the idea in a pretty crude fashion, and Lasn is a good example of this. He proclaims:

> We build our own meme factory, put out a better product, and beat the corporations at their own game. We identify the macromemes and metamemes—the core ideas without which a sustainable future is unthinkable—and deploy them. (p. 124)

Unfortunately, it isn't that easy. What makes a meme "meta" or "macro" is not clear; it takes more than deployment to propagate them; and finally, just what the hell is a "meme factory" and do we really want more of them? Meme, for Lasn, seems to be clumsy shorthand for recognizing that, although culture seems like a given, it is actually created by us (and the artifacts we choose to invent and make). It is a discourse system and it does indeed have rules and metarules. Still, some of the specific ideas Lasn wants to spread in culture are useful. They include "true cost" (making sure the real price of products to the environment and the workers who make them is known); "demarketing" (the unselling of products, somehow to be accomplished by culture jamming marketing); "the doomsday meme" (to communicate the idea that "The global economy is a doomsday machine that must be stopped . . ."); "no corporate 'I'" (corporations are not people and should not have citizen rights)[3]; and "*media carta*" (everyone has a right to information and access to communication technology) (p. 124).

Lasn also has a particular knack for naming the problems our media-drunk society produces and how they disrupt our mental environment. He has useful discussions about "infotoxins" (p. 24), "information overload" (p. 23), "infoviruses" (p. 30), and "loss of infodiversity" (p. 25) as well as

the "noise" (p. 13), "jolts" (p. 15), "shock" (p. 17), "hype" (p. 18), "unreality" (p. 21), and the "erosion of empathy" (p. 22) we suffer from.

Still, there is something missing. *Adbusters* deploys a sort of "Situationalism for Dummies" approach. Everything is about image. In his introduction, Lasn comments that "cool" could well be "the Huxleyan 'soma' of our time" and that therefore "cynicism is its poisonous, paralytic side effect" (p. xv), but he ends his book by arguing that we are on the verge of a revolution against "American cool" and asking "what could be more cool than that?" (p. 215). What could be more contradictory than that? We need a revolution that aspires to something more than coolness, whatever it means.

Another good example of this sloppy thinking is the attack on the idea of the cyborg that was the centerpiece of the March/April 2001 issue of *Adbusters*. It included a spoof "Cyborg Manifesto" decorated with swastikas. It was "signed" by people as diverse as Stelarc, Howard Bloom, Donna Haraway, Kevin Kelly, Ray Kurzweil, Hans Morevec, and Nicholas Negroponte. The only thing they share is a belief that there are cyborgs and that cyborgization continues. Some celebrate this, others regret it, others want to deal with it, yet all of them try to think about it. But apparently to do so is some sort of fascism, according to *Adbusters*.

In this issue, and following ones, they printed several articles by John Zerzan. Zerzan, a self-described anarchoprimitivist, has crafted an extensive critique of computers, television, all technology, writing, mathematics, and language itself, in his search for a pure place without alienation.[4] His perspective actually has little to do with culture jamming or *Adbusters*, whose love of technology, at least in the form of machines that create and print sophisticated art and design copy, is manifest. Their strange attack on anyone who writes and thinks about cyborgs reveals great internal ambivalence, even confusion, not just about technology but about political change as well. Or perhaps they are just latching on to neoprimitivism as a way of building radical market share?

Naomi Klein is worth quoting about this. Although generally sympathetic, she admits that:

Nowhere is the *Adbuster's* ear for the pitch used to fuller effect than in promotion of adbusting itself, a fact that might explain why culture jamming's truest believers often sound like an odd cross between used-car salesmen and tenured semiotics professors. . . . There is a strong tendency to exaggerate the power of wheatpaste and a damn good joke. (1999, p. 295)

Culture jamming is an important idea but it is limited. There is little that is proactive, that builds a new society, except for the old situationist commitments to novelty and pleasure. Wonderful as those are, they are not enough. A new society, of substance, not spectacle, will have to be built bit by bit as it is prefigured, even lived, for the first time, not just performed.

PREFIGURATION

Art can, art must change the world, for that is its only justification.
—Orlan (2000, p. 1)

Because one of the greatest political issues we face is the progressive cyborgization of humanity (Gray 2001, 1995), art is a major source of our insights about our cyborg society. Even if John Zerzan and *Adbusters* magazine wish it would just go away, cyborgization is here to stay, as are tools and machines. The body art of Stelarc and Orlan (described later) is not only a very political reflection on cyborgization, but also a direct attempt to shape our cyborg future. It is prefigurative art.

To *prefigure* could just mean, as *Webster's Dictionary* has it, "to suggest . . . to picture beforehand . . . to imagine," but that is not the political sense of the term. Instead, the meaning here is "to be an antecedent . . . to foreshadow," also from the dictionary. To prefigure in this way is to model, to work toward, to make the future by living it. The term *prefiguration* has not been used much in this way (or in any way actually) in relation to art, but it is a common idea in politics.

Prefigurative politics is the basis for much of the grass roots organizing today. Influenced strongly by feminism with its slogan "the personal is political," Western activists for the last 30 years or more have stressed that the form of their politics, even their lives, must be consistent with their goals. The debate about prefigurative politics is often framed as "the ends versus the means." Disagreements about the role of violence and nonviolence in social struggles are usually between those who see a direct relationship between means and ends and people with a more instrumentalist view of reality. In any event, most feminists, anarchists, and ecologists practice some form of prefigurative politics, while liberals and Leninists agree with Mao that you "can't make an omelet without breaking eggs." What they really mean is you can't make a revolution without breaking heads but that the revolution somehow won't be taken over by the best head-breakers. History tells us otherwise.

So, in that diffuse but real space that can still be called *counter* culture, people try to live ecologically, relate to each other ethically, govern their communities nonhierarchically, and make political change with as little violence and as much joy as is possible. There isn't necessarily any loss of effectiveness with this approach—witness the movement against corporate globalism that has proved so powerful in Seattle, Zurich, London, Prague, and Geneva—and there is also the benefit of minimizing the hypocrisy that seems inevitable in all politics, especially in those that seek funda-mental change.

Art, as a major part of human culture, is inevitably political, whether that is explicit or not. Formalists and aesthetic romantics won't accept this, but how could it be otherwise? One of the few things Aristotle got right was that community and politics are integral; they are the polis. If art refuses politics, that is political in itself. Every act of representation is inevitably a political act, either reifying or challenging things as they are. One of the best case studies of this is Serge Guibaut's *How New York Stole the Idea of Modern Art*, which demonstrates how abstract expressionism, those boring simplistic geometric paintings and sculptures, is profoundly political in its origins and effects.

David Graeber has an interesting theory about why art is so important to revolutionary politics. He starts by asking "why is it that even when there is next no other constituency for revolutionary politics in a capital-ist society, the one group most likely to be sympathetic . . . consists of artists, musicians, writers and others?" His answer is that they are "involved in . . . non-alienated production." He goes on to conclude:

> Surely there must be a link between the actual experience of first imag-ining things and then bringing them into being, individually or collec-tively, and the ability to envision social alternatives—particularly, the possibility of a society itself premised on less alienated forms of cre-ativity? (Graeber 2002, p. 10)

It seems obvious that all art is prefigurative to some extent. Art may well have started as magic in the service of wish fulfillment: "See, I make the grazing beast with my spear in it so I will kill and we will eat the graz-ing beast." But this belief in the direct efficacy of representation has faded somewhat in the last few thousand years. Art that shows some beautiful possible future might be considered prefigurative as well, although only on an intellectual level; but the vast majority of futuristic art seems more utopian, or dystopian, than truly prefigurative.

It is only recently, with some works of political or environmental performance art, that we see true prefiguration involved in what is "officially" termed art, as with Beulah Gordon's project to make herself an activist monk. Marko, a Slovenian, has done a number of extraordinary projects. As an art project he obtained funding for micro radio stations for Kosovo refugees. He has put together a laboratory to monitor all sorts of border flows, from microwaves to illegals, and facilitate those that are beneficial as a way of deconstructing the border regime. For him, "control of knowledge is the war of the future" and art is a primary battleground. But only for political work. "The trick is not to be a harmless artist." Marko certainly isn't harmless, perhaps in part because his work is so technologically sophisticated. He first learned computers playing with a Sinclair Spectrum in 1982 that was smuggled into Yugoslavia. At that time, "computers were seen as a threat to the socialist state." He continues to work with complex technologies, which have their "own logic" in his view. In particular, he delights in taking military technologies and trying to "change their use" (interview with author, 2000).

The graphic artists of Université Tangente create incredibly complex and accurate cartographies of institutions and other power relationships. Their "European Norms of World-Production" uses dozens of icons to show all the major European corporations, government agencies, and think tanks and how they interlock. They have made similar maps of the "biopolice establishment" and of groups struggling over political control of the Internet (www.universite-tangente.fr.st). Their work is visually fascinating, but it is also politically potent, controlling knowledge so that activists and citizens can use it. But such work is not yet as common as it needs to be, especially in the area of power politics. It has become very influential in the area of body art, where the meaning and future of the human body are explored and contested around several discrete issues.

Cyborgization is a good specific example of this. It is relevant to power politics because it is an integral aspect of postmodern war in the form of man-machine (and other) weapon systems. War itself is also fundamentally about bodies (modified or not), and this prefigurative cyborg body art can help us see how deployed bodies can change laws and culture.

This is not the place to argue that cyborgization represents the next great step in the human-technology relationship that started with *homo faber* (the tool user) and evolved into our culture of cities and machines (civilization). It isn't much of an argument in any event because, thanks to such technosciences as genetic engineering, we are actually on the

verge of producing posthuman species. The real issue is what kinds of cyborgizations we will have, and art such as Orlan's and Stelarc's can play a crucial role in demonstrating, even shaping, our options. Orlan is a French artist undergoing a series of plastic surgeries to remake herself as part classic beauty (as represented by famous artists) and part something else. Stelarc is an Australian famous for dangerous body modifications including a fifth (prosthetic) limb and sending a crawling camera into his intestines that was controlled over the Internet. David Tomas once called his own work "a laboratory for the production and exploration of one kind of quasi-mechanized human body" (1995, p. 255). This also describes the programs of Stelarc and Orlan.

They are directly addressing cyborgization with artistic practices that take prefiguration, politically and artistically, to a whole new level. Looking closely at their work, we can't help but notice their powerful and principled intervention into the fundamental questions of cyborg politics, and we can also discern how their work manifests the necessary, but hidden, relationships between aesthetics, ethics, and politics.

PREFIGURATIVE ETHICS AND EMBODIMENT

Like the Australian artist Stelarc, I believe that the body is obsolete. It can no longer deal with the situation. We mutate at the speed of cockroaches, and yet we are cockroaches with their memories on computer, piloting airplanes, and driving cars which we have developed even though our bodies are not made for their speeds and even though everything is going faster and faster.

—Orlan, 2000, p.12

For everyone as he is himselfe, so he hath a selfe propriety, else could he not be himself. . . .

—Leveller doctrine, 17th century, quoted in Goodall 2000, p. 3

It has been much harder for art to be prefigurative ethically than it has been for it to put forward new aesthetics. But it has not been impossible, as some of the examples given previously demonstrate. The work of Stelarc and Orlan is extraordinary in this regard. Not only do they put forward somewhat different, but fundamentally allied, ethical positions toward the individual, society, and the body but also they are directly involved in actually defining new ethical arrangements around cyborg

medicine specifically and cyborgization in general. It is prefigurative embodiment and ethics through aesthetics. As Stelarc says, "As a body, one no longer looks at art, does not perform as art, but contains art" (Stelarc 1997b, p. 250).

Their prefigurative ethics revolve around several key cyborgian political issues: Whose body is it? Who do the technoscientific cyborgologists work for? What is the relationship between the human and the posthuman? Jane Goodall, a medical doctor, explores some of these issues in terms of Orlan and Stelarc's work in her article "Whose Body? Ethics and Experiment in Performance Art." She makes it clear that Orlan's "aesthetic experiments" are necessarily experiments in ethics as well.

So, whose body is it? Despite references by Stelarc, in his work, to "the" body, not "his" body, it *is his* body. No other bodies are used and nobody else owns the Stelarc body, which is a major point of his art. His choice of words demonstrates his commitment is to the individual's will or personality, not the individual's body, so he proclaims "Evolution by the Individual, for the Individual" (Stelarc 1997a, p. 242, original emphasis). He sees the body as so limited, so obsolete, that to be who he wants to be requires transcending all bodies, including his own. Orlan might see the body as more useful, but she is also claiming her right to her body by seizing the right to remake her body and therefore herself. Both these positions are essentially political. One does not have to like their art or even agree with their critique of the body to appreciate what they are doing. In an age in which our bodies belong more to the experts (of government, of medicine) than ourselves, it is profoundly radical art.

The body is political and the body in art is even more so. It was the second wave of feminism that reestablished the human body as a central philosophical issue in the late twentieth century. In the masculinist Western traditions dominated by Platonism in various forms (pagan, Jewish, atheistic, and Christian), the body was only political as a metaphor—the body politic—not in and of itself. But today the illusion that the human body is not fundamental, that it is basically an epiphenomenon of mind, has been dispelled by feminism politically and analytically (see especially Scarry 1985) and by cyborgian technosciences practically.

Although Orlan and Stelarc both critique the human body for being quite limited, if not actually obsolete unless modified technologically, they both explicitly defend their rights to their own bodies, echoing the Leveller argument that it is their personal property. Goodall asks, in her

article, "Do we have unlimited rights over our own bodies?" and answers with the medical and scientific perspective that bodies are "socialized" and therefore "are subject to regimes of care and discipline" (p. 3).

Yet she does note that "[p]erformance artists contest the regulation of bodies through calculated offenses against body disciplines and codes of propriety" (p. 3). But art can do more than "contest" body regulation and discipline—it can change them as well. Goodall worries that "Almost every aspect of Orlan's work breaches medical protocol" (p. 5). But that is the point—to change medical protocols; to allow us to experiment on ourselves. Even if Orlan's work is "risk without benefit" in medical terms, it is risk with great benefit in political terms. The medical frame is too small and limited to evaluate cyborgian interventions.

As it is now, most cyborgian enhancement work comes out of the military and industry, so to have Stelarc and Orlan carry out their own programs based on their artistic, or even idiosyncratic, desires only broadens the discourse and opens up possibilities. Artists and nonartists are now making themselves into everything from reptiles to Barbie the doll (Asma 2001) in what can only be the beginning of a whole range of human modifications that could well end up producing posthumans who live in the sea or even in space. There is a proliferation of possibilities. This, interestingly enough, is where Goodall ends up, after making her "case for the prosecution" against the work of Stelarc and Orlan. In her conclusion, she admits that they make us "rethink what it means to be an agent, and how the legal, moral, and ethical liabilities of the individual can be encoded" (p. 9).

But it is more than rethinking. Through their actual artistic practices, both Orlan and Stelarc have breached the wall that doctors and scientists have put around medical technologies, and they have shown that we can choose to modify our bodies for our own goals, not just those of technoscience. This is a direct attack on our current notions of what our bodies are, who gets to modify them, and what it means. Jennifer Gonzalez (1995) has written about this, noting important relationships between cyborgian technological developments and the art (and the form of that art) that explore its meanings through the production of, in her words, "a new conceptual and ontological domain" (p. 271).

Gonzalez goes on to look at contemporary cyborgian art and to use it to understand meanings in our cyborgization that are not obvious at first. For example, Robert Longo's *All You Zombies: Truth Before God* is about a stunning hybrid cyborg soldier that communicates incredible

animosity. In this case, Jennifer Gonzalez points out, the great hybrid's anger seems to rage involuntarily "against its own existence" (p. 274). Although mass media stories of cyborgization sometimes touch on cyborg alienation or self-rejection, it really isn't a common idea. It is very much repressed in the real-world medical and military discourses where most actual cyborgs are produced, and it seems eerily similar to the self-hatred that seems behind so many suicidal murder attacks from Columbine to September 11, 2001.

Many of the most meaningful cyborgian art works go beyond even this cyborgian process and actually modify on some level, or use as an object, the human body. The *Bioapparatus* of the Banff Centre (Richards and Tenhaaf 1991) included a range of such explorations. David Tomas (1995), one of the participants, has perhaps gone the furthest theoretically in dehumanizing the body so as to incorporate it into the art. When the body is an art object, it too is cut off from appreciating the art and can only assist prosthetically in generating it. The attention of the art observer-consumer is augmented to the level of intervention, making them artist-citizens. As Mark Dery explains, to understand such work one needs "a politics of posthumanism" (1996, p. 165).

Of course, the big issue for posthumanists is evolution, who is in charge? The best cyborg art directly confronts this question, and answers, "we should be." Cyborgization isn't just about participatory evolution; it demands participatory politics, and it comes to the fore in revolutionary times. As Jennifer Gonzalez reminds us:

> The image of the cyborg has historically recurred at moments of radical social and cultural change. From bestial monstrosities, to unlikely montages of body and machine parts, to electronic implants, imaginary representations of cyborgs take over when traditional bodies fail. In other words, when the current ontological model of human being does not fit a new paradigm, a hybrid model of existence is required to encompass a new, complex and contradictory lived experience. (1995, p. 270)

There has been a clear progression in the work of Stelarc and Orlan from performance art to body art, to carnal art, to what can variously be described as cyborg art or posthuman art. Somewhere along this trajectory, it became prefigurative art as well.

One can argue about labels, but what is undeniable is that we live in an age when change is driven by technoscience; when unifying grand

stories of this God, that nation, high art, and perfect science are not shared universally, even in one geographical/temporal space; and when both the human body and nature itself seem to be under siege.

We have the future of the human body to consider. It cannot, it does not, stay the same. It is being modified continually by militarized technoscience, consumerist manias, and technological art. It is being incredibly threatened by postmodern war. It is changing through conscious and unconscious participatory evolution. These changes are biological, technological, and conceptual. And as the body changes, the very way we think changes. Lisa Moore and Monica Casper once told me that "Anatomy is epistemology." I would amend that to say, "How we think about our anatomy is also epistemology." In both cases, it is clear that we need an open and dynamic epistemology because our bodies, and how we think of them, are changing. This is why Steven Mentor, Heidi Figueroa-Sarriera, and I have proposed our cyborg epistemology: thesis, antithesis, synthesis, prosthesis, and again (Gray et al. 1995).

It is based on the traditional dialectic because the dynamism of the dialectic is worth saving. But it tries to break from the inherent binary structure of only pure action and reaction ad infinitum. Things are more complicated. Reality, like our bodies, is too lumpy, changeable, and contingent for any unified totalizing epistemology; so there is always prosthesis, something from outside. Hopefully, a cyborg epistemology will resist any claims that reality is purely material or ideal or even the tepid dualism of Plato. How do we know? Through our senses, in large part aesthetically, and in our minds, totally. We see, we feel, and we reflect. But there is no closed system or forced march to one future, as Marxist materialists or Hegalian idealists would have it; rather, it is an open and participatory process, like the art of Orlan and Stelarc. Both go to great lengths to involve the public, broadcasting their mortifications and even, in Stelarc's case, giving control of internal probes over to strangers on the Internet. Orlan and Stelarc manifest a cyborg epistemology in their work. Their will, their bodies, technologies, the public, and traditions all react continually together with each other and against themselves, dynamically moving to new starting points.

Other similarities between these two cyborgian artists are striking. Their work is different, their goals seem different, their stance on the body is somewhat different, but they intersect where (1) the canvas is their own body, which meets (2) medical technoscience in (3) sites around the

globe. There, it is (4) enhanced, not rehabilitated, through (5) experimentation. Their approach is that (6) art must change the world, (7) the will triumphs over technology, and (8) art triumphs over science.

One doesn't have to agree with these positions to accept that they are important artists. What are artists for anyway? Are they society's canaries? Its clowns? Its conscience? Its martyrs? For me, artists are all these things. I like funny and serious canaries compelling us to think, prefiguring the future.

Which means prefiguring what, exactly? Cyborgs? Posthumans? Yes, in various forms, but the embodied details are not nearly as important as the process Stelarc and Orlan use. Posthuman cyborgs are coming in any event. Parents are beginning to clamor for smarter babies, taller sons and daughters, cures for inherited diseases, and longer better life. The "market" for posthuman modifications is clearly here, and technoscience is on the verge of delivering some of them. The crucial question is who will decide what is done to whom?There are many experts and leaders who feel that this is not a decision to be made democratically. At best, they say let the market decide; at worst, their criterion is national security. In any event, hard choices have to be made. We can't all have it all.

Will this sea change offer us more choices, so that if we wish, we can proclaim as Orlan does that "I am a she-man and a he-woman?" (Orlan 2000, p. 3). Or will cyborgization strip humanity of its freedom and of its chance to choose its own future, even if that future is to become posthuman? This is a political question, and for some of us a big part of the answer is artistic. This is even more true of war. If we can imagine and create posthumans, why can't we do the same for peace? Real peace is a "new conceptual and ontological domain" as well, to quote again the phrase Jennifer Gonzalez applies to cyborg art (1995, p. 271).

The new is, after all, the future. Fittingly, one of Orlan's favorite slogans is "Remember the Future" (Orlan 2000, p. 6). That is exactly what prefigurative art should do. Maybe it can even help us "remember" a peaceful future.

the possibilities
of citizenship

SUBJECTIVITY

[W]hat used to fill the place of the "subject" pole in the great philo-
sophical traditions has now been reconceptualized in terms of "sys-
tems" that are stable and yet dynamic, self-referential and yet adaptive
... the world of the "object" has given way to the more complex and
nuanced term "environment," that broader context within which the sys-
tem functions, but in a relationship that can no longer be viewed as
organic, linear, or causative.

—Rasch and Wolfe 1995, pp. 5–6

The individual is a system, which means that there is very little pre-
dictability in life, even our own. Identities have always been complex; if that
is recognized, less effort need go into the presentation of an artificial self
in everyday life. We cannot be objects, or even a simple subjects, if open
(democratic) political systems are going to work. Complex citizenship is
required. It has to be an identity that we construct—it can't be given.

Identity has great political import. According to Manuel Castells, it is
"becoming the main, sometimes the only source of meaning" today (1997,
p. 3). This has led to a "fundamental split" with "abstract, universal instru-
mentalism" on one side and "historically rooted, particularistic identities"
on the other. He concludes that "Our societies are increasingly structured
around a bipolar opposition between the Net and the Self."

"Bipolar" is a bit simplistic, but Castells is correct that the long-stand-
ing tensions between individual and community identities are now
mapped over onto technology. This is the embodied paradox of cyborg
subjectivity and citizenship and it is not simple. Castells proposes a
dynamic of alienation:

In this condition of structural schizophrenia between function and meaning, patterns of social communication become increasingly under stress. And when communication breaks down, when it does not exist any longer, even in the form of conflictual communication (as would be the case in social struggles or political opposition), social groups and individuals become alienated from each other, and see the other as a stranger, eventually as a threat. (p. 3)

Is it no surprise, that in times of uncertainty, some people turn to religions and ideologies.

Religious fundamentalism, Christian, Islamic, Jewish, Hindu, and even Buddhist (in what seems to be a contradiction in terms), is probably the most formidable force of personal security and collective mobilization in these troubled years. (p. 3)

The Aum cult drew most of its inspiration from Buddhism and the rest from Isaac Asimov, strangely enough. Political beliefs can take fundamentalist forms as well, and not just fascism and communism. Liberals and conservatives can be fundamentalist and massacre with a clean conscience, especially when their beliefs are linked to religion or nationalism. Even anarchists can be fundamentalist, and that seems as much a contradiction as a Buddhist one. Even those whose ideals are based on rejecting ideology and meaningless symbolism can fall prey to their intoxication. It is so hard to be the author of one's own life and not just a character in a much larger story.

What does it mean to be the subject of our own story instead of the object? Lasn says that is pretty much "as good a working definition of the culture jammers ethos as you'll ever find" (1999, p. 100), but that doesn't really tell us much. It actually seems to have a great deal to do with taking the responsibility that goes along with freedom. How much responsibility we have depends on just how much we are subjects and how much we are objects. Because there are multiple meanings of subject and object, it is not unitary either, except in its embodiment, which is not a trivial exception. One thing is clear, power is central both to the existence, and the exercise, of individuality. As Michel Foucault (1980) explains,

Power is employed and exercised through a net-like organization. And not only do individuals circulate between its threads; they are always in the position of simultaneously undergoing and exercising this power. They are not only its inert or consenting target; they are always also the

elements of its articulation. In other words, individuals are the vehicles of power, not its points of application.

This has profound implications for our understanding of individuality.

> The individual is not to be conceived as a sort of elementary nucleus, a primitive atom, a multiple and inert material on which power comes to fasten or against which it happens to strike, and in so doing subdues or crushes individuals. In fact, it is already one of the prime effects of power that certain bodies, certain gestures, certain discourses, certain desires, come to be identified and constituted as individuals. The individual, that is, is not the vis-à-vis of power; it is, I believe, one of its prime effects. The individual is an effect of power, and at the same time, or precisely to the extent to which it is the effect, it is the element of its articulation. The individual which power has constituted is at the same time its vehicle. (p. 98)

Clearly, the individual can be a locus of both liberating and repressive power and the same can be said for nets. Both are also points of application. Power does subdue and crush individuals and nets as it facilitates them, because power is everywhere—it saturates the nets of existence.

> The chaotic, unpredictable nature of complex dynamics implies that subjectivity is emergent rather than given, distributed rather than located solely in consciousness, emerging from and integrated into a chaotic world rather than occupying a position of mastery and control removed from it. (N. Katherine Hayles 1999, p. 291)

This may sound discouraging, but actually it opens up tremendous opportunities. For one thing, the illusion of mastery has been a terrible problem on many levels, from the intimate politics of the family to international relations, and it remains a problem as military and political leaders keep searching for the Holy Grail called control. Wolfgang Sützl, an Austrian activist and academic, has shown in some of his work how this quest for control and the myth of the strong subject have stood in the way of peace.

He argues that the "weak subject" and the idea of nihilism can "allow a new kind of nonviolent emancipation that requires us to abandon the identification of peace with strength and security" (2001, p. 2). He points out that you have to be a "strong" subject in order to impose on others and

that, in particular, all the fundamentalists try to construct such strong subjects among their believers. This isn't just religious fundamentalism, where the individual becomes one of God's chosen. There is also a secular fundamentalist identity based on the autonomous consumer-citizen. He explains that the "market seems to become a last resort for objective and uncontested truth" and then when one links the free market to the free citizen one has established a logic where "citizenship becomes increasingly synonymous with consumption" (p. 6).[1]

This "free market" citizen-consumer fundamentalism in turn provokes many antimodern fundamentalisms that are based on extreme versions of various religions and a bevy of new cults.

> [I]t appears that the various manifestations of fundamentalism have in common an interest in the strengthening and stabilization of the subject that has been left weak and undefined by the advance of modernization, and that this strengthening is inseparable from the reaffirmation of an authority against which there is no appeal. Fundamentalism either tries to achieve this stabilization through a reversal of modernization or through a strengthening of the notion of history (linear, unitary, globalizing) that very structure that in the end has been responsible for the weakening of the subject itself. (p. 7)

Sützl's work goes on to show that the soldier is the ideal "strong subject," with clear implications for the making of peace, and how art, in the form of radical aesthetization, is integrally linked to emancipation. Finally, he uses Friedrich Nietzsche's concept of the *Ubermensch* to demonstrate what a new, peaceful subjectivity could mean. *Ubermensch* is usually mistranslated as "superman" but it literally means "overman" and bears more relationship to N. Katherine Hayles' posthuman than to a Nazi storm trooper. As Sützl argues, "the Ubermensch seems to display characteristics that Nietzsche referred to as 'good character'" (p. 15). It is worth quoting him on this.

> Nietzsche remarks that when the belief in an objective order of things is no longer present and no single truth available for support, not the most violent man will triumph, but the most moderate one, who is capable of a certain irony vis-à-vis him/herself. In contemporary culture, this may refer to a type of individual that is no longer nostalgic for a solid reality and who is capable of appreciating appearances as such, without the need of classification, exploitation, and the elimination of ambiva-

lence. It is also an individual capable of appreciating difference and plurality. (p. 16)

So our chance to be actors in history and not objects comes down in large part to letting go of illusions of being strong "subjects" and embracing a rich notion of what character is. This is a strange conclusion for a postmodernist, perhaps, but Sützl's analysis shows why it is so. Character, as one might expect, is a complex idea, especially if approached at a postmodern angle. The reality of cyborgization allows us to experiment with character more exuberantly than ever before, and with fewer consequences, with profound implications for citizenship.

HUMANS/CYBORGS/POSTHUMANS

The cyborg citizen is the meeting site of two important but often opposed orders of discourse. On the one hand are those who want to keep humans in their place in the story of the great chain of being. According to this, we can think only in and through the human body as an organic whole; yet our current language for dealing with birth, death, livelihood, and government is dominated by metaphors of system, structure, field, and technology that make it difficult to speak about real human needs. At one pole, small is beautiful, and the human scale is reasserted as a way of rebuilding societies so that real humans could potentially manage them and real democracy would have a chance of flourishing. On the other end are those who believe only in the chain of reason and the long march of the rational human. They see a political landscape of technosciences and bureaucracies, the intricate modern state, the multinational corporation, the complex technologies of energy and waste treatment, as the inevitable form of managing contemporary societies. To them, human scale is an impossible nostalgia, an irresponsible Luddism, a politically naive standpoint.

Cyborgs embody these contradictions. As Haraway (1985, p. 125) points out, cyborg bodies can take pleasure in machine skill and thus have embodied reasons not to demonize it in favor of some mythical organic origin or unity; but they also have "an intimate knowledge of boundaries, their construction and deconstruction" crucial to reconstructing the boundaries and technologies of daily life and the networks of power. If "our bodies are maps of power and identity" then cyborgs offer a new map, a new way to conceive of power and identity, one potentially

more effective in understanding, confronting, and reshaping the actual networks of power in late postmodernity and its mutations.

Indeed, speaking of "the" body, my body, is in some ways a vague thing for a cyborg to say. The cyborg body politic is at times a web, a shifting chain of interrelated bodies, some human-machine, some machine. Although the cyborg is, by definition, one homeostatic system, it is also interconnected to many networks. From one perspective it is just one node in a vast network, and as that net becomes an image of a political body it certainly reconfigures what we mean by political machine and by political community. In an age in which power is multiply enacted and bodily dispersed, the cyborg citizen can claim multiple bodies and multiple communities thanks to its multiple connections. This isn't just a case of linking traditional bodies, getting "bodies" to the demonstration or voting booth, although that happens; it is relearning what a community might feel like, as gender becomes ambiguous (which sex/es am I linked up with?), as persuasion and argument are made more not less available, as information can be amassed from diverse points and concentrated at one location.

As the geography of the body is shifted, so too is the sense of what constitutes a political body or group, and so are the skills and resources that are made available. It is one thing for a progressive company to picture a computer over the caption "political machine," implying that e-mails to your political representatives are the apex of influence; it is another to conceive of oneself intimately connected to machines and other cyborgs, learning the codes of net power, composing and recomposing "prosthetic aesthetics" in the form of teleconferencing, information and argument dispersal, and the accessing of "official" nets for purposes educational and subversive. Cybernetics is all about feedback loops and adjustments; we don't know what social and political potential humans have when they are (arguably) freed from the more insidious interpolations of identity, gender, limited and one-way representation.

This is a political myth, of course, one with plenty of possible dystopian endings as well, from humans going insane inside completely mechanical prostheses to the creation of superhumans, with ambiguous relations to "normals." Andrew Gordon has made a useful analysis of these two tendencies in cyborg science fiction. Following Patricia Warrick, he notices a tendency toward either "closed system models" (dystopian visions of destructive technology based on extrapolations from current trends) or open system models (utopian notions of man-machine symbiosis and evolution) (1982, p. 196). Both visions are being enacted today. Gordon challenges open system models and suggests ways to overcome the

real fears of the closed system stories. This may be the real challenge for 21st century cyborg citizens.

The current forms of the sovereign nation-state and its correlate, the sovereign individual, are hopelessly incapable of confronting the new sources and configurations of power or of limiting the boundary-shifting forms of multinationals. That is why we are in an important period of transition. To what extent will these emergent bodies politically terrify their subjects, tying them to technologies as the lesser half, thrusting implants and software past the boundaries of the organic body, in the psychic and emotional equivalent of the bodily horrors of the industrial revolution? How successful will average citizens be in resisting the most noxious forms this will take, at the level of government, work, even home and sexual life? This will depend on consciously choosing to inhabit this new world, exploring cyborg subjectivity as a form of pleasure and power, building new political bodies and bodies of bodies across the nets, learning the various new boundaries and limitations, learning indeed what might count as action and agency in the age of information.

The cyborg comes after the overstated "death of the subject" and is one answer to the question, "Who comes after the subject?" The cyborg is a meeting place between those unwilling to give up notions of strategic subjectivities and those bent on the liberatory projects that assume the destruction of masterly, coherent selves, whether "achieved (cultural) or innate (biological)" (Haraway 1985, p. 85). And, especially the cyborg can be a place to learn a new conception of agency, what Judith Butler calls "an instituted practice in a field of enabling constraints" (quoted in Haraway 1985, p. 85). Field, network, web—these "inhuman" metaphors, these apparent antitheses to an organic "bodily knowledge" and scale—are not just the arena in which we must bring our bodies and selves to act. They are the new geopolitical territories to be inhabited and contested; they are sites of current and potential imperialism, racism, oppression, multiply gendered games, reasonably sophisticated resistances to aforementioned aggressions, new possibilities of engaging inappropriate/d others and dispersed bodies of community and power. Cyborgs are trapped in patriarchal and late capitalist systems, dependent on institutions while transforming them utterly, involved in the crucial enactment of new forms of agency, and negotiating with and confronting central intelligence through dispersed, diverse bodies of information and communication.

The sites of these negotiations and confrontations are multiple and diverse, and they are all cyborg body politics. James Sheehan (1991, p. 259) declares that "Never before have the conceptual boundaries of humanity

been less secure." He goes on to admit that perhaps "we are now at a point where a persuasive definition of what it means to be a human is impossible." This is true in two very different ways. In one sense, serial killers and soldiers who commit atrocities are often labeled "inhuman," while those they massacre are called subhuman. On the other hand, there are the sophisticated technosoldiers who sit at the center of complex machine-human weapon systems. Many factors have combined to produce these strange dynamics: the love of technology, the institutionalization of innovation, the human hunger for power over others and nature and even death itself.

Cyborg technosciences, especially genetic engineering, seem to promise that eventually humans can be transformed into posthumans. Many writers and scientists have already speculated that such a posthuman will not be bound by human morality and certainly couldn't be judged by human standards of character. Even now on the Internet you find those who attack certain points of view, often humanistic, as "meat thinking." There seems to be an assumption among those who would use such a label that there is a better, higher even, virtual or perhaps "silicon" point of view. Nonetheless, cyborgization does offer us a window for looking at today's tension in high postmodern theory between fragmented subjectivities and embodiment that is directly related to politics.

THE DIGITAL AGORA AND METASPACE POLITICS

In their account of the philosophical debates between Thomas Hobbes and Robert Boyle, *Leviathan and the Air Pump*, Steven Shapin and Simon Schaffer (1985) show that Hobbes and Boyle had very different ideas about the nature of the body politic.

> In the body politic of the Hobbesian philosophical place, the mind was the undisputed master of the eyes and the hands . . . In the body politic of the experimental community, mastery was constitutionally restricted. (p. 338)

For Hobbes, the king (Leviathan's soul-mind) had to be supreme to prevent chaos. For Boyle and his fellows in the Royal Society, the mind was merely, to quote one member, part of a "chain" made up of "links" from "Hands" and "Eyes" to "Memory" and "Reason" and back again in "a continual passage round from one Faculty to another." In other words, the soul

of Hobbes (and Descartes) is replaced by the cybernetic chain of links going round and round—one controlling metaphor replaced by another. To the members of the Royal Society the human was an automaton, as Hobbes and Descartes imagined, but instead of a soul this automaton was animated by a will to knowledge, inflamed by epistemophilia and the promise of freedom.

Shapin and Schaffer remark, "Hobbesian man differed from Boylean man precisely in the latter's possession of free will and in the role of that will in constituting knowledge. Hobbesian philosophy did not seek the foundations of knowledge in witnessed and testified matters of fact: one did not ground philosophy in 'dreams.'" But it was not a dream of total freedom. In contrast to Hobbes's absolutism (Leviathan), the scientists wanted some "middle way" between tyranny and democracy: liberal technocracy. Shapin and Schaffer note that there is

> . . . an intimate and an important relationship between the form of life of experimental natural science and the political forms of liberal and pluralistic societies. (p. 338)

But times change.

> Now we live in a less certain age We regard our scientific knowledge as open and accessible in principle, but the public does not understand it. Scientific journals are in our public libraries, but they are written in a language alien to the citizenry. We say that our laboratories constitute some of our most open professional spaces, yet the public does not enter them. Our society is said to be democratic, but the public cannot call to account what they cannot comprehend. (pp. 343–344)

There is no pure knowledge.

> As we come to recognize the conventional and artifactual status of our forms of knowing, we put ourselves in a position to realize that it is ourselves and not reality that is responsible for what we know. Knowledge, as much as the state, is the product of human actions. Hobbes was right. (pp. 343–344)

Hobbes may well have been right about the social production of knowledge, but his arguments for Leviathan are not convincing. The automaton with a will, where the system reigns supreme under the sign of science, triumphed over the automaton with a soul. Now, however, with

the cybernetic/organic body politic, the citizen is more than a body-as-machine, be it a machine with a soul or a machine with a will; now it is a cyborg citizen, the human body with a political mechanism as prosthesis, or perhaps the other way around. Just as some claimed the subject was disappearing, the body, sweating and farting, dying and breeding, has made its shocking reappearance. Not that it really left, it just wasn't so noticeable there for a while. Now it is cyborgized. It is not so much a matter of being a cyborg technically as it is about accepting the implications of cyborg society politically and psychologically. Some of the most striking: There is no one truth, no one identity, no set culture. We choose to make our nightmares, or our dreams come true. This implies the following.

The notion of the cyborg citizen helps explain postmodern subjectivity. Some contemporary conceptions of identity aren't simply relativistic, leveling, or nihilistic but actually serve as pragmatic rehearsals of the selves we well may have to become in order to contest and inhabit the world we are continually (re)constructing.

The cyborg is not pure, and this is an important ecological insight. Nature is not pure wilderness and the Disneylands are not purely artificial. We will not live in harmony with the earth until we develop a more realistic notion of the ways we create nature as a category and until we have more respect for the complexity of the natural world and can see both a rain forest and a bakery as living organisms and as cybernetic systems that include "natural" and "artificial" elements within the complex feedback and data-manipulation structures that sustain them.

The cyborg metaphor changes possible notions of resistance. Agents of change must move beyond identity politics toward various politics of affinity and association. It is clear that the sovereign nation-state is not the only important body. Transnational nets and local micropolitical systems are also key sites for "empowerment" and for negotiations with power. The decline of state sovereignty, the emergence of hybrids mixing "archaic" formations with new technologies—fundamentalists with AK-47s, Somali youth driving trucks with anti-air weapons (cyborg "technicals")—and the proliferation of body politics all call for the forming of new alliances and new associations (and therefore new cyborg body politics) wherever viable and open networks spread or where temporary autonomous zones can survive.

Cyborg citizens will be more open to heterogeneous genderings and identities based on situations; they will also be more able to expand what we think of as resistance and enact new forms of power based on nets,

information, complex systems, multivocal games and rituals, open sets, and negotiations between entropy and noise as productive and destructive.

The cyborg body politic is "realistic." It is important for figuring current political configurations because the world is interpenetrated by technological development. In the face of this, appeals to holism and natural lifestyles, while important counterbalances, ultimately mystify the extent to which we are dependent on and enmeshed with technology. You can't understand how to deal with contemporary conflicts and dilemmas by appealing to natural, organic people or societies, if there ever were any.

Acknowledging this interpenetration will help us consider how to balance the dual notions of humans as inviolable natural individuals with independent plots and "lifestyles" and humans as resources for social machinery, as cogs in wheels or operators serving the Net. Neither of these notions is accurate because, while we are interpenetrated by technologies that include discourse, humans also make collective and elite decisions that determine the scope and impact of technologies.

Having multiple selves doesn't have to mean being schizophrenic (as opposed to a paranoid insane defense of the fictional mirror self). Rather, it can mean the practical application of cyborg rules of order and operation, a cyborg competence based on how we have already come to grips with a variety of cyborgian elements in daily life.

Cyborg language has to acknowledge both of these because it has to notice what animates technology is our inhabiting of it and what is true about each of us as "cogs" is that society and culture are technologies, no matter how we think we escape into our individual and isolated selves.

Certainly, confusing things can and will happen in a cyborg future. Gender may become less important and new genders might be invented. Less titillating is the possibility that class could become real (embodied) as the cyborg rich live longer, even forever, and become their own race. There might be whole races of cyborgs built around income and position or maybe occupation, such as war. Perhaps cyborg tribes or clans will develop around environments (such as the sea or air) or fascinations. We can hope that it will get so confusing, and subjectivity so clearly constructed, that we will become tolerant of difference. Difference should not make all of the difference, John Brenkman admonishes:

> The body politic has to be reimagined as an arena in which political participation stimulates social change rather than confirming existing relations and institutions. Citizenship has to embrace equality without

demanding homogeneity, in keeping with the diversity of social roles characteristic of modern societies. (1992, p. 20)

He goes on to argue that we must go beyond the simple self-definitions of race, class, and gender and go beyond the abstraction of "positionality" in "determining the socially and politically relevant aspects of identity-formation" because it misses "the crucial difficult and productive tension within every position":

> ... namely, that we are always at one and the same time a member of— (or participant in—) *and* a citizen. Moreover, gender-race-class positionality too easily misses the conflicts that arise *within* every identifiable social group and manifest themselves in *its* political-cultural debates over its identity, its guiding values, its strategies of struggle, its visions of the community's most desired and its most feared destiny. (p. 25, original emphasis)

The cyborg metaphor offers a unique validation of different identities and the social construction of same. Maybe, eventually, we will all realize, as Audre Lorde realized, that we are inevitably multiple selves.

> Each of us had our own needs and pursuits, and many different alliances. Self-preservation warned some of us that we could not afford to settle for one easy definition, one narrow individuation of self. . . . It was a while before we came to realize that our place was the very house of difference rather than the security of any one particular difference . . . and that we could appreciate each other on terms not necessarily our own. (1982, p. 12)

But with all of this said and done, the idea of the cyborg, as body politic or as anything else, is only a tool and only as good as the work it can do and the pleasure it can bring.

There is an arrogance to making these kinds of arguments because they pretend a coherence that is, at the most, only contingent. The sovereignty of any metaphor, including the cyborg body politic, is only illusory, subject as it is to proliferation and hybridization. It should not be prescriptive so much as descriptive and productive of possibilities.

We need metaphors that offer a link between political theorizing and action and that speak to our sense that previous resistance movements have somehow failed to account for the changes we see around us, and they have failed to prepare us for the difficulties of crossing lines of

race, class, and gender, or for the daily wonders produced by contemporary technoscience.

The cyborg body politic is a metaphor within the powerful prosthetic technology called discourse. In cybernetics, a small amount of energy runs the control mechanism; that mechanism is flexible, capable of redesign, and in turn has powerful effects on the large-scale machinery the controls run. So too with discourse, whether it is Hobbes's seventeeth century attempt to resolve the crisis in the nation-state or our current response to the information age and the increasing interdependence of economies—commercial, military, and symbolic. Perhaps we may imagine a nonlinear, noncontinuous shift taking place between Cartesian and cyborgian body-political metaphors, paralleling similar shifts in technological, economic, and political practices. These shifts reflect tensions in the discourse that have material effects on lives and bodies throughout the world.

The cyborg body politic is a myth, not truth; there are other figuring discourses within these sciences and current body politic—discourses of war and mastery, of command and control, of disease and pollution, of liberation, of autonomy, of gender and race and class. Refiguring the body politic is one way to raise questions of how liberatory movements can be more effective, and of what might count as progressive and liberatory given complicated interrelationships of technology, social groupings, discursive practices, and economic models. But also notice the race to rename the emerging spaces of transnational and cyborg bodies by institutions and their representations.

Two examples may serve. Joseph Nye characterizes the New World Order as a dialogue between national and transnational; although the United States maintains hegemony in military affairs, "military prowess is a poor predictor of the outcomes in the economic and transnational layers of current world politics" (Nye 1992–1993, p. 88). Nye imagines an older Newtonian political discourse ("the mechanical balance of states") giving way before postsovereign notions of multiple bodies of power.

Gerald Helman and Steven Ratner suggest the bankruptcy of the sovereign nation-state as an adequate measure of power and a solution to civil war and social collapse. States such as Somalia and Bosnia, they argue, have failed to live up to the stringent standards of national selfhood—they are "failed nation-states." These states should be treated just as the state treats a "failed" individual.

> In domestic systems when the polity confronts persons who are utterly incapable of functioning on their own, the law often provides some

regime whereby the community itself manages the affairs of the victim. Forms of guardianship or trusteeship are a common response to broken families, serious mental or physical illness, or economic destitution. (1992–1993, p. 12)

These positions confront the complexity of world power. Both cite the information revolution and the impact of new technologies that cross borders and redefine territories. Both re-imagine a UN that intervenes in the affairs of nations like Somalia and Bosnia, which has come to pass. Yet both speak unselfconsciously from a position of identity and coherence; if problems are transnational, this does not threaten the First World's sense of identity as nation-states or the major economic powers as some sort of community. Both articles claim that none of the centrifugal forces that threaten nation-state coherence around the globe can affect "our" nation-state. Yet this notion of ideal Western hegemony and self-identity is perhaps at the root of many transnational, boundary-permeating "problems." The proposals of these writers and others are riddled with metaphors not only from cybernetics and information technology but also discourses of politics, addiction, race, and class. The speakers imagine that they are at the center of a potentially coherent body, a "we" who share their concern for U.S. power and security.

But the very forces they begin to unravel and distinguish also riddle the Western nation-states and those of emerging economic blocs; the powerful technologies of cybernetics and communication are shaping their own state, subject to its own confusing centrifugal forces. Neither article questions the role of political bodies such as the World Bank and the International Monetary Fund. Neither article imagines that if the world is more and more transnational and interdependent, the policies and technologies emanating from the First World must have something to do with the impact of policies and technologies in the "failed" or "too slowly developing" countries. The anthropocentric metaphor of developing bodies of parents and children does not map the complex dynamics of proliferating bodies politic.

These articles reflect how politics is affected by new technologies and also the extent to which it still relies on traditional notions of self, self-interest, successful and coherent selves. They are cyborg discourses, yet naively so. These discourses and others like them vie in a field of power and must be contested by other discourses based on other experiences of body, power, and other interfaces with technology. The world is indeed

being Borged and the Death Stars of various Darth Vaders are in production. The world is for sale and the World Trade Organization is in charge. Cybernetic systems kill and determine flows of informatic capital that have material effects on women semiconductor workers in the Philippines, Afghan poppy farmers, and rubber tappers in Brazilian rain forests and, indeed, on us all and the ecosystems that we are part of.

There are other stories, other narratives embedded within cybernetics. We communicate to each other, to friends and activists across the globe, on networks that belie the official organs of news. The notion of community is growing along fiber-optic cables. The same technology that will hardwire a pilot into a computer to fly a jet that rains death from the sky will allow our friend, hit by a speeding truck, to walk again. There is no choice between utopia and dystopia, Good Terminator or evil Terminator—they are both here. We are learning to inhabit this construed ambiguous body (and explore who constructs it) for it is the one we make love in and the one we vote in and the one we put on the line when we really care. We need to practice cyborg family values: good maintenance, technical expertise, pleasures dispersed and multiple, community research and development, improved communication. We need to be cyborg citizens: embodied, connected, and committed.

There can be many types of citizenship, for example, ecological (Curtin 2001) or "flexible" and "transnational" types (Ong 1999). The key component is responsibility (the real basis for freedom) and participation. Citizens have to be part of a polis, a discourse community. Assumptions must be shared with others. The type of citizenship will shape the politics of that community, which is why we need a cyborg citizenship (Gray 2001).

In popular culture, people claim power over their own bodies through piercings and other modifications, as the commodification of the body in medicine, work, and consumer fashion. There are no transcendent meanings in cyborgization, from the mixing of bodies and technologies. There are only transcendent possibilities and horrors. What will determine which we experience? Attention. Will we come to attention artistically and politically or just accept what comes our way, as what we pay attention to?

Citizenship is nurtured first of all in democratic civil society. A global citizenship demands a domain parallel to McWorld's in which communities of cooperation do consciously and for the public good what markets currently do inadvertently on behalf of aggregated private interests. (Barber 1995, p. 277)

Citizenship does come from democratic civil society, but we should remember that the first test for citizenship in the ancient Greek city-states and in the Viking communities was going to war. The citizens were those who went and fought. The commitment, the sacrifice offered, was what gave citizenship its power.

Today citizenship should still require commitment and sacrifice, but not by restoring honor to killing, even though some are taking this approach . The journalist Michael Ignatieff writes in *The Warrior's Honor* about the International Committee of the Red Cross's program to urge soldiers to adopt a warrior ethos. A Red Cross video that was aimed at the former Yugoslavia says, "A Warrior does not kill prisoners. A warrior does not kill children. A warrior does not rape women" (1997, p. 157). He goes on to comment that the Red Cross claims

> There are human and inhuman warriors, just and unjust wars, forms of killing that are necessary and forms that dishonor us all. The Red Cross has become the keeper of these distinction; they are the sentinels between the human and the inhuman. (p. 161)

Near the end of his book, Ignatieff tells of a ceremony at the Geneva airport when the bodies of six Red Cross personnel who had been assassinated in Chechnya on December 17, 1996, were brought from Russia. The director read a message from a field agent that is particularly revealing:

> All our endeavor is based on the belief that, even in the middle of the worst depravities of war, man retains a fundamental minimum of humanity. Events like this can make it very difficult to maintain this belief. But without it we would have to admit that nothing distinguishes man from beast, *and that we will not admit.* (p. 163, original emphasis)

This seems like more denial. It denies that war is serial killing and that it is all too human. It denies the horror of war, what it does to bodies even when it is honorable. According to this logic, the murder of civilians with technology is fine, it is hacking them up in person that is wrong. It is also denial of what it means to be human. Beasts kill for food or for access to food. They do not slaughter for politics or religion or otherwise to mollify inner demons of fear and rage. That is why denial plays such an important role in the dynamics of both postmodern war and domestic serial killing. Both want to erase the body.

> Indeed, one could argue that the erasure of embodiment is a feature common to *both* the liberal humanist subject and the cybernetic posthuman. Identified with the rational mind, the liberal subject *possessed* a body but was not usually represented as *being* a body. (Hayles 1999, p. 4, original emphasis)

What might it mean to be posthuman—not just physiologically, but psychologically and culturally? There is an opportunity to remake ourselves into creatures who are not killers. As N. Katherine Hayles has argued,

> I see the deconstruction of the liberal humanist subject as an opportunity to put back into the picture the flesh that continues to be erased in contemporary discussions about cybernetic subjects. (1999, p. 5)

If the role of flesh in war is recognized, it will lead to understanding how horrible war is, how it is terror and serial killing. Until then, war will continue to produce soldiers such as Commandante Beatriz, a right-wing paramilitary commander in Columbia. She led her group (gang?) into the village of Chengue on January 17th, 2001, where they killed 26 men by bashing in their heads with heavy stones before setting the village on fire. U.S.-trained regular troops of the Colombian military cordoned off the village so that Commandante Beatriz could do her work (Rosenberg 2001, p. 52).

But she isn't an inhuman warrior. She is just one type of human soldier and she depends on the U.S. military radar operators, the U.S. civilian crop duster pilots, the Colombian commandos, and all the other postmodern soldiers. Her war is made possible by the Columbian political elite, the U.S. taxpayers who fund much of the war, and drug users of the world.

Had enough of humanity? Perhaps in the construction of posthumanities we can do better. Yes, we might do worse and allow the production of horrific posthuman soldiers, genetically engineered and cyborged for obedience, without conscience or fear. But, as with cyborgs in general, the idea and the reality of the posthuman offer us an opportunity to do better than the human. It is worth a try.

reasons for hope

EPISTEMOLOGICAL CONCLUSIONS

After years of U.S. missiles flying into outward shores,
a decade after 100,000 Iraqis cruise missile'd to death
under Father George
The war has now come home, where it's apparent to all
what a senseless random murderer
is the one-eyed giant Terror
how it eats its innocent victims screaming alive, feet flailing
how it breaks the strongest of backs, rips flesh wide open
how it tosses arms East, legs South, skull & genitals
North and West
how it forces hardened athletes to dive head first 99 floors
to a concrete death softer than its iron teeth
how it leaves no paperwork behind to comfort the living
how it answers pleading mothers & weeping babes
with a knife to the belly, glass shards to throat
how it burns a skyline of fresh bones to fragile white ash
<div align="right">

—Eliot Katz, New York City, September 2001
(from "When the Skyline Crumbles")
</div>

What do we really know of September 11, 2001? A New York poet can tell us some things, and our own hearts, others. News reports, psychological analyses, and political theories all have their place. But we have to start with understanding our very basis for knowing; our first problem is always epistemological. How do we know what we know? In many respects this is a political question. Consider the rise of fundamentalist movements

and states that combine the simplest of epistemologies with the most sophisticated WMD. It is no coincidence that fundamentalist worldviews often embrace apocalypse. The frightening thing is that now they might obtain the technical means to bring it about. A modest epistemology based on what we know of the limits of information is a counter to fundamentalism. Politically this often takes the form of multiculturalism: not the caricature conservatives promulgate that claims multiculturalism as pure cultural relativism, but rather the realization that no one culture, no one point of view, no one belief system contains all truth. And often, knowing some truths precludes knowing others. This is the way we "construct" truth: not out of whole cloth, but out of our choices (conscious or not) about what, and how, we want to know.

Epistemology is not a problem that can be solved and then forgotten. It is an "ongoing commitment," as William Rasch and Gary Wolfe argue,

> Like pragmatism and deconstruction, systems theory insists on the social and historical contingency of all knowledge and on the impossibility of thinking unity, origin, or ground. But unlike pragmatism, it believes that the recognition of contingency requires an ongoing commitment to, rather than evasion of (as Cornel West puts it) epistemology. (1995, p. 11)

Rasch and Wolfe defend systems theory because, "unlike deconstruction," in their view, it provides a "coherent means of describing all systems . . . " (p. 11). This also means that it is reflexive. It can describe itself, as every good theory should. They conclude by arguing that systems theory is not "ontologically grounded along the lines of traditional dichotomies" as with Kantian idealism, Cartesian materialism, and Marxism (pp. 11–12). Similar concerns led to the cyborg epistemology: thesis, antithesis, synthesis, prosthesis, and again, discussed earlier.[1]

We need to use a more sophisticated epistemology than those that are limited to the most simple logical steps and human senses. Reality is bigger than that and more alive. It is even more dynamic than the dialectic (thesis, antithesis, synthesis) based on simple dualities. Most dualities are not helpful. Peace is not just antiwar. The so-called artificial is also part of the natural world. Systems, whether organic or machinic, use the same principles and today more and more systems are combinations of the evolved and the made.

Since World War II many military leaders (Lord Mountbatten, Gen. Eisenhower, dozens of Cold War I generals—see Generals 1984) and mil-

itary historians (John Keegan, Gwynne Dyer, Martin Van Creveld) have argued that war as we know it is over. Yet, it obviously has not gone away. Out of this paradox, how are we to predict the future (or possible futures), of war and of peace?

The safest way to predict the future is merely to extrapolate from the present. But that fails to anticipate the truly new. Besides, with contemporary war it is clear that things cannot go on as they have in the past because of the quantitative changes in military technology, especially WMD. So, in terms of the chances for real peace, extrapolation has to be leavened with common sense and with a rich qualitative understanding of military history, human culture, and the realities of international relations.

Extrapolation offers us little comfort. If the war system continues as it is, we face apocalypse. Even though the crisis in war is clear to all the experts, the responses remain the same. The U.S. panel charged with studying security in the twenty-first century came up with the same old recommendations: nuclear capability for deterrence, conventional forces for major wars, rapidly deployable forces for smaller conflicts, better homeland security (especially against terroristic uses of weapons of mass destruction), and units trained for peacekeeping and humanitarian missions. None of this is new, not even training peacekeepers, which some commentators, such as the German politician Ulrich Beck, call "the new military humanism" (Jelinek 2000).

Noam Chomsky (2000) dissects this strange formula. He shows that the U.S.-NATO operations against Serbia in 1999 violated international norms and, less convincingly, he argues that the military intervention made things much worse. His scathing critique of the tendency of great powers to throw out international law when it suits them is important. His defense of the sovereignty of nation-states such as Yugoslavia is much less compelling and is a bit disappointing, coming from an anarchist.

Chomsky seems mesmerized by the continuities with the past—the same old institutions ignoring international law—while he doesn't see what was profoundly different about the Kosovo intervention as opposed to Vietnam, for example. International law has been formulated by the very nation-states that are at the root of most modern and postmodern conflict. International laws are flouted by the same entities whenever it serves their purpose. So, disregarding international law is not new, nor should it shock us, nor should we make a fetish of international laws that protect those who threaten peace. Chomsky underestimates the new legitimacy of the criminalization of war, the importance of the cultural and

technological globalization of humanity, and the changes within war's discourse that validate peacekeeping as a military operation and that make peacemaking the only legitimizing rationale for war.

He does point out that the only effective way to prevent horrors such as the ethnic cleansing of Yugoslavia is to be proactive for peace. The military failures of interventions such as in Kosovo and Somalia demonstrate this conclusively. But he is wrong to see the "new military humanism" as the same old imperialism of the great powers. No, it is hypocrisy and it is violent but it also marks a real crisis in war as we know it.

Change doesn't come at us in a straightforward dialectical march: thesis, antithesis, producing a new synthesis. Change, as any close reading of history shows, is much more complicated. New information theory now gives us a few tools to understand why history is nonlinear, as Manuel DeLanda has argued (1997). The key insight is that *we cannot have perfect information.* Anything as complex as human culture is not perfectly predictable. All complex systems defy rationalization. That doesn't mean that we cannot thoughtfully notice what is happening and what likely possibilities come out of today. The most basic element of information flow is feedback loops, both positive and negative. Certain dynamics reinforce themselves, such as a nuclear arms race where each escalation leads to another one. Other processes are the opposite, such as the utilization of inferior technologies, strategies, or tactics in war. Such behavior is extinguished in more ways than one.

Thanks to complexity theory, we know that great changes are possible, often starting with small acts. This is not the butterfly effect whereby one small event out of millions has profound consequences. Rather, it is water falling on stone. Eventually, the stone washes away or suddenly shatters. Much of biology and culture seems to be some form of punctuated equilibrium. In the case of culture it is often perceptual changes that lead to revolutionary breaks. Slavoj Zizek describes such a "tipping point:"

> Recall the processes of collapse of a political regime—say, the collapse of the Communist regimes in Eastern Europe. At a certain moment, people all of a sudden became aware that the game was over, that the Communists had lost. The break was purely symbolic, nothing changed "in reality"—and, nonetheless, from that moment on the final collapse of the regime was just a question of days. (2001, p. 26)

Perceptual changes are not easy. They start with a set of principles and with a full awareness of what forces are shaping political realities, as they

did with Charter 77 in Czechoslovakia and Solidarity in Poland. Among the best guides are common sense and hard work. Common sense tells us that we often lie to ourselves and that politicians lie to everyone, that the rich want to get richer, that there is no free lunch (especially when the environment is on the table), and that violence doesn't stop violence in the long run, but it might in the short term. There is more, of course, but you see the point. Common sense isn't the same as cynicism, but it certainly isn't naive. Common sense has to learn from history and that means that we have to look closely at what is new and what isn't.

The crucial dynamics for understanding war today and how we might end it are: (1) the relentless spread of globalization (corporate and democratic), (2) the expansion of citizenship, (3) the continued proliferation of technoscientific extravagancies, and (4) the realization that the environment isn't infinite. Several of these principles offer us hope for reconstructing international relations into a peaceful system, especially globalization (if it can be carried out democratically and not as a project of unrestrained capitalism) and the expansion of citizenship. The spread of technologically sophisticated nongovernmental organizations that struggle for universal human rights is a key aspect of any hope for an international order that isn't based on violence. The proliferation of horrible weapons has to be a spur to mobilize people to make the changes necessary to bring about real peace.

On a smaller scale we have to bear in mind that war can never be virtual, nor can it be won by technology, not even airpower (Associated Press 1999a). Despite the obvious dangers to humanity's future, war is continuing. Colombia, Pakistan/India, China/Taiwan, Indonesia, Burma, Chechnya and the rest of the former Soviet empire, and much of Africa are all sites of real and potential wars. According to the United Nations Children's Fund (UNICEF), in the 10 years since the Convention on the Rights of the Child was adopted by the UN General Assembly in 1990, two million children died in armed conflict (*Time* 2000, p. 23). This shows that the current international system is failing disastrously.

On the bright side, few justifications remain for war, and peace movements push for the end of ancient conflicts such as those in Northern Ireland and the Middle East. Nation-state sovereignty continues to decline in the midst of spasms of nationalism. Nation-states aren't the only cause of war, certainly; empires and tribes seem just as capable of violence. But our current international system is based on nation-states and their decline opens up a real opportunity, actually it is a necessity, to demilitarize politics.

Many international institutions, nongovernmental organizations, and individuals are working for this demilitarization, which has become a major constraint on organized political violence, even if it hasn't stopped it. Which raises the most important question about war: Can it be abolished? Yes, but only if we all take part. For example, Charles Piller and Prof. Yamamoto advocate not just international treaties to prevent the spread of bioweapons but also a ban on secret research, a ban on defensive research, and putting all genetic research in civilian control (1988, pp. 235–236). In 1999 the eminent physicist Sir Joseph Rotblat called for all scientists and engineers to take the student Pugwash oath that pledges to "work for a better world" and not to use "education for any purpose intended to harm human beings or the environment." Of course, the Hippocratic oath did not keep many German and Japanese doctors from horrible crimes in World War II, but such oaths are an important start. They are especially important for spreading the realization that what technoscience does is the responsibility of those who make it possible, not just political leaders.

As postmodern militarization has seeped into every aspect of contemporary life, there must be a countermobilization against war. It has to look at the underlying causes of war and address them and not just focus on the latest battle when it explodes on TV screens. For years, the people of Kosovo organized nonviolently for their rights and were pretty much ignored. Only when fighting broke out did the world turn its attention to the region, but by then it was too late.

War is certainly not a natural drive. Most people never fight in war and most cultures are not at war most of the time. But aggression is a natural part of the human psyche and when combined with our current culture, with its compelling masculinist and nationalist stories, war becomes very powerful indeed. But it is too dangerous to allow. Even those who believe war is inevitable believe it must be ended.

One leading advocate of the "war is natural" school, Professor Marvin Harris of the University of Florida, concluded, after strenuously arguing that the few societies without war "shouldn't lead researchers into naively believing that they can abolish war" and deriding anthropologists for believing that "if we can only talk to these people and convince them, they will stop war," that "we can and must abolish war if humanity is going to have any future at all" (McDonald 1999).

When even those who—mistakenly in my opinion—believe war is natural say it must be abolished, it is clear that something must be and can

be done, and it isn't too late, despite war's triumphs. In 1994 a group of intellectuals posted a notice in *The New York Times*:

> IN MEMORIUM— Our commitments, principles, and moral values. Died: Bosnia, 1994, on the occasion of the 1,000th day of the siege of Sarajevo.

I wept for Sarajevo at that time, that brave, beautiful attempt to keep tolerance and humanism alive in the face of insane ancient prejudices, modern weaponry, and postmodern politics. But it was too early to give up. Since then we have had massacres in a dozen more places, from Indonesia to Central Africa, and it is still too early to give up. We have nuclear escalation between India and Pakistan, destabilizing defense systems under development in the United States, and the spread of weapons of mass destruction around the globe, and it is still too early to give up. We have had 9/11, Afghanistan, and preemptive war in Iraq, and it is still too early to give up. Because there is a worldwide movement for peace, there is a worldwide realization that our environment is in danger and there is a worldwide understanding that human rights should be universal, and that war is no longer an acceptable way of solving political differences. Now we just have to change the international political order. It won't be easy, but as it is necessary, it is a commitment we must make.

Manuel Castells explains the relationship between his epistemology and his commitments clearly. After affirming his belief in "rationality" (but not worshiping it), "meaningful social action," and in the liberatory power of identity, he summarizes his other epistemological assumptions. The first is that "all the major trends . . . are related" and that "we can make sense of their interrelationship (1997, p. 4). He later adds,

> [O]bserving, analyzing, and theorizing is a way of helping to build a different, better world. Not by providing the answers, that will be specific to each society and found by social actors themselves, but by raising some relevant questions. (pp. 14–15)

The questions raised come out of epistemological assumptions.

> The theoretical perspective underlying this approach postulates that societies are organized around human processes structured by historically determined relationships of *production, experience,* and *power.* (p. 215, original emphasis)

This analysis is based, in turn, on other epistemological conclusions.

> This approach stems from my conviction that we have entered a truly multicultural interdependent world, that can only be understood, and changed, from a plural perspective that brings together cultural identity, global networking, and multidimensional politics. (pp. 28–29)

I actually agree with Castells's framework, although I use different words in stating it. It is good not to get too infatuated with one's own ways of saying things because the function of all this theory isn't just to understand the world; it is to change it.

PREDICTIONS

> The twenty-first century will not be a dark age. Neither will it deliver to most people the bounties promised by the most extraordinary technological revolution in history. Rather, it may well be characterized by informed bewilderment. (Manuel Castells 1998, p. 378)

Analysis such as this has to be judged on its usefulness. It is a pragmatic aesthetics that includes the prefigurative effects of predictions themselves, but not in a linear way. To see possible horrors is one of the best ways to avoid them. There are many ways to judge an intellectual argument or story, but for results few criteria beat useful predictions. Certainly they are messy in the real world, especially in human culture, but that makes them all the more necessary. Here is a prediction by Manuel Castells, probably written in the mid-1990s:

> There is . . . an explosion of fundamentalist movements that take up the Qur'an, the Bible, or any holy text, to interpret it and use it, as a banner of their despair and a weapon of their rage. Fundamentalisms of different kinds and from different sources will represent the most daring, uncompromising challenge to one-sided domination of informational, global capitalism. Their potential access to weapons of mass extermination casts a giant shadow on the optimistic prospects of the Information Age. (1998, p. 375)

There is certainly much truth in this, but I don't agree with it all. We need a real third option. Not the Third Way of Clinton or Blair (another flavor of neoliberalism) but something more like the Third Force of the

Vietnamese Buddhists and Western radicals of the 1960s who rejected both the puppet regime of South Vietnam and the dictatorship of the communist North. We need to break the Jihad vs. McWorld dialectic.

I do accept another of Castells's predictions that

> . . . nation-states will survive, but not so their sovereignty. They will band together in multilateral networks with a variable geometry of commitments, responsibilities, alliances, and subordinations. (1998, p. 375)

I would add that without sovereignty, the nation-state as we know it will be no more, but some nation-states will survive, especially empires such as the United States, China, and Russia.

So what are some of the things we can predict? Waxing fundamentalisms are likely, because the threat of postmodernity, culturally and politically, will only increase over time, fueling the anxieties that drive some people to embrace simple certainties. But built into any absolute view of the world are contradictions that cannot be overcome in the long run, including the proliferation of enemies both internal (women, gays, dissenters, heretics) and external (everyone not enlightened), ambivalence toward important technologies of war and media that need training and enthusiasm to be truly mastered, and the relentless critique of real-world events (the reality principle), which eventually overruns any simple epistemology, despite the most rigorous denial.

For capitalism and neoliberalism, the paradoxes are integral, and they go far beyond what the Marxists dreamt. Even with information to add value virtually, the economy depends on human work and living nature. It cannot grow infinitely, and yet this is the task it has set for itself. It cannot mine authenticity infinitely, yet this is the process it is embarked upon. President Bush can declare, as he did at the World Trade Meeting in China on October 17, 2001, that the war with the "terrorists" is a war for free markets: "We will defeat them by expanding and encouraging world trade." But most thinking people know that if the United States is truly at war with those who sponsor terrorism, it is at war with itself.

Consider the School of the Americas (SOA) As a headline in *The Guardian*, one of the preeminent newspapers in Britain, sums it up: "The U.S. has been training terrorists at a camp in Georgia for years—and it's still at it" (Monbiot 2001). The school changed its name because of criticism for its role in fostering terrorism, but the change was "basically cosmetic," according to Senator Paul Coverdell (R), one of the school's congressional patrons (p. 2).

In 55 years of operation, graduates of the school have been involved in an incredible array of terrorist acts in Latin America. Not only have the officers who ran death squads in Honduras (Battalion 3-16), Mexico (the 1994 Ocosingo massacre), El Salvador (Roberto D'Aubusson), Guatemala (the heads of D-2 military intelligence and 40 percent of the cabinet ministers who served the military dictators), Chile (commanders of all three concentration camps under the Fascist dictatorship and the head of the secret police), and many other countries studied there, so have such notorious dictators as Roberto Viola (Argentina), Leopoldo Galtieri (Argentina), Manuel Noriega (Panama), Omar Torrijo (Panama), Juan Velasco Alvarado (Peru), and Guillermo Rodriguez (Ecuador). In El Salvador, the killers of Archbishop Oscar Romero, and 19 of the 26 soldiers who killed the Jesuit priests in 1989 studied at the school.

More recently it was two SOA graduates who killed Colombia's peace commissioner, Alex Lopera, in 1999. Another Columbian SOA graduate was convicted in February 2001 of taking part in the torture and killing of 30 peasants. A Guatemalan graduate was convicted of the murder of Bishop Juan Gerardi in 1998. Testimony by graduates, copies of training manuals, and common sense all link the SOA (now called Whisc) directly to terrorism. This is the same evidence the United States uses to tie bin Laden and Al Qaeda to similar horrors. Do the rules of evidence not apply to the United States?

Even when the U.S. Congress forbade the executive branch from promulgating a terrorist war against Nicaragua in the 1980s, it was illegally carried out anyway by Oliver North and others. Ironically, one of the ways this was done was to get money from rich Arabs to finance the contras who blew up peasant cooperatives and targeted teachers and health workers for rape and murder. Among the contributors, a construction tycoon named Osama bin Laden (Monaghan 2001).

So, when Graham Fuller, the former vice chairman of the National Intelligence Council at the CIA, says the problem is "hypocrisy," he knows what he is talking about (2001). He adds,

> In fact, the vast majority of Muslims or even Islamist political parties do not challenge most American values, but query whether the United States is constant to its own values, especially the spread of democracy.

The United States, he adds, doesn't seem to promote democracy in the Middle East. He concludes that, "There is no war over values; it is about the American failure to share with others those beliefs that helped to make this

country great." Perhaps. However, U.S. history is a tale about not only the pursuit of liberty and justice for all, but also the conquest of North America through the destruction of the Indian nations, slavery, and the economic domination of much of the world. It would seem that the SOA is also a reflection of certain "American values."

But if the West, especially the United States, is hypocritical and confused, the fundamentalists of the world labor under even greater disadvantages. Their hubris surpasses that of even the most arrogant chief executive officer (CEO). The Islamists plan to conquer the world and avenge "the tragedy of Al Andalus"! They think they can restore the Islamic conquest of Spain. The caliphate won't ever return, but the more success they do have, the greater the likelihood of Armageddon.

The misogyny, the absolute hatred of women, of the Islamist (and in general fundamentalism) is a trap. It may be an inevitable one because of their fearful reaction to the liberal feminism that globalization brings to traditional patriarchical cultures. Still, they will never have support from most of the Western Left because of the centrality of feminism. They'll never get most Muslim women to sign on either; that's for certain.

Antilife extremism is the final problem. "There is no fun in Islam," proclaimed Iran's Ayatollah Khomeini (Wright 2000, p. 77). It isn't just that they encourage all young people to give their lives to the jihad, but they want all of society to give up living and dedicate their lives to the afterlife. Most people aren't suited to an existence of monkish dedication, even if they believe in it. To try to force people to it just won't work.

The Left has its own weaknesses. One of them is its own tendency toward moral superiority. I am sure that most people who attend leftist rallies do so with a great deal of ambivalence. At one of the first protests against the aggressive U.S. response to September 11, the crowd was being harangued, as usual, with various stupid chants. The response was tepid, until, to the call of "What do we want?" someone in the crowd responded, "A pony!" The crowd roared. Yes, that person also wanted peace; that was why he or she was there getting yelled at. But a pony, now there is a wonderful heartfelt desire as well. Maybe we can have peace and a pony?

The Left has always had an infatuation with binary thinking. A war is always wrong or right. One side is good, the other bad. You are the enemy of my enemy so you are my friend. Do you have to be for or against every battle? Every war? Think about the Gulf War, Somalia, Haiti, Bosnia, Afghanistan 2001, Rwanda. Would it have been bad if foreign troops had stopped the machete-killing of a million people in Africa?

I have to confess, I was not totally against any of these wars. I was not for them either. I think about how wars can be prevented, how they can be avoided, how they can be ended, and I agitate for those outcomes. But at any particular point in time we have to deal with what we have. Once years of bad policy produced Saddam Hussein and he invaded Kuwait, then what? Of course, the United States should not have done a million things that led up to that, but should he have been allowed to take over Kuwait?

If Afghanistan is ruled by Islamists who subjugate women to an extra-ordinary degree, who massacre those of different tribes and beliefs, who sponsor terrorists whose direct goal is the Islamization of the world, and whose tactics are basically mass, spree, and serial killing, then what? Embargo and starve a quarter of a million women and children to death as we did in Iraq? John Le Carré has summarized the reality succinctly:

> It's a horrible, necessary, humiliating police action to redress the failure of our intelligence services and our blind political stupidity in arming and exploiting Islamic fanatics to fight the Soviet invader, then aban-doning them to a devastated, leaderless country. As a result, it's our miserable duty to seek out and punish a bunch of modern-medieval reli-gious zealots who will gain mythic stature from the very death we pro-pose to dish out to them. (2001, p. 17)

The ray of hope in all this, he continues, is that "the conscience of the West" may have been reawakened. If it has, perhaps "a new sort of politi-cal morality has . . . been born." Let us hope he is right.

It just isn't accurate to take the position of those on the Left who are always *for* whoever is against the United States or who, even more com-monly, take the "both sides are equally evil" approach. Seldom are both sides equally evil. World War II comes to mind. There are different levels of evil. Much as I oppose empires, such as the old European ones and the new North American system, I still cannot help but notice that Stalinist Communism was significantly more evil. It was more dictatorial, more damaging to the environment, and more dangerous than the liberal empires. The Nazis were still another order more horrible, if that can even be comprehended.

We have to look at and think about each war with as much sophisti-cation as we can. In general, war is a last resort and it always represents a terrible failure. But sometimes, in today's world, it is the best we can do. That is why we need a better world.

The humanitarian and democratic impulses in human culture are profoundly strong, and they live in many imperfect institutions and human bodies. When these correspond with powerful corporate and/or imperialistic impulses, they can lead to military operations that are not automatically wrong. We need to go beyond the Left, not least because of its failed theories. One way to go beyond old generalized theories is to be more specific.

The best way to contemplate possible forms of future war is through scenarios, the little narratives that are widely used by military practitioners to think through various possible forms wars might take so as to prepare for them. These story-telling exercises draw on the long history of war gaming (going back further than chess) and can be on tactical, strategic, or geostrategic levels. They can look to the near future or further on into what might be considered science fiction. Some of those "far out" fantasies will be discussed subsequently. But there is a good chance that the distant future of war will actually be decided in the next few decades, so that is where we shall begin.

On September 28, 2001, 17 days after 9/11, students and faculty from New York University gathered to create some possible scenarios for the war on terror over the next four years. Their efforts are remarkably similar to many exercises since, and they nicely lay out the main possibilities (Kleiner 2003). Now that we are more than halfway through their predictive framework we can analyze their results and draw some conclusions about the assumptions behind the different scenarios.

Their five most likely futures:

- *An Empire Stretched Too Thin*: U.S. caught in never-ending quagmire.
- *International McCarthyism*: U.S. wins and becomes a social control–oriented corporate state.
- *Black Market World*: War leads to fragmentation, "gated nations," a war between rich and poor nations, and increased reliance on underground economies.
- *Gloom and Boom*: Pakistan turns radical Islamist, leading to nuclear attacks and Chernobyls everywhere.
- *Blooming World*: The only optimistic future of the five, in which the war's imperatives change the culture for the better.

Major elements of the first three scenarios have already come to pass: U.S. invasions of Iraq and Afghanistan, guerrilla war, U.S. alienation of allies, rise of corporate power, loss of civil liberties in the United States and Europe. Other elements from them, especially more successful attacks on

the United States, have yet to materialize. What is most interesting is that the only positive scenario and the worst scenario have proven to have very little predictive power so far. This highlights the fact that the situation remains incredibly uncertain, a hallmark of postmodern war.

Of course, none of these exact scenarios will come to pass. And none of them need to. A much better world is indeed possible, but only if the rules of politics, international and local, are fundamentally changed.

SHAPING THE FUTURE

Nothing is gained without loss.
—Paul Virilio 1999, p. 54

A student of mine wrote me soon after September 11, 2001, that he was struck by his similar feelings when reading two very different book series and while experiencing the events we were all living through.

I replied:

It is insightful for you to see deep similarities between the reading you're doing and the events of September. Both *Masks of the Gods* and the *Illuminati Trilogy* argue, and demonstrate, that our cultural world is almost totally created by intersubjectivity, by the intersection of all that we all believe. The physical reality plays a part, but within the range of what is possible, within the vast sweep of human cultures and subcultures working today, there is basically a bounded infinity. The complex mythologies of humans, the worldview of the suicide pilots of September 11, the beliefs of the wacko conspirators in the Illuminati tale, our own lives, all seem equally plausible or implausible. It is a clue, a very important clue, that we can shape reality to a much greater extent than we think we can.

One of the most important ways we shape the world is with technologies, if we consciously choose them and don't ignore obvious, albeit unintended consequences. Jessica Mathews is optimistic:

A world that is more adaptable and in which power is more diffused could mean more peace, justice, and capacity to manage the burgeoning list of humankind's interconnected problems. (1997, p. 63)

She goes on to make a sophisticated case that improving technology could produce stronger NGOs and weaker governments and that this is all

for the better. She admits, however, that the situation could be much worse, with problems outrunning solutions, a fractured world of tribes, nations, and nation-states forced into more and more undemocratic global decision making.

Another way to shape the future is with what we write and what we say. Elitists claim that intellectuals determine the very way we sense the world but it is more complicated than that, especially in an open society. Gunter Ropohl has a nice summary:

> Sense domination will not work insofar as the individual crisis of sense can be overcome. This is the very point where the philosophical task appears. In the face of the multiplication of information through science and technology, philosophy again has to assist in constituting sense. It has to assist—which means that philosophy is not entitled to constitute sense on behalf of individuals. Technological sense domination must not be overcome through philosophical sense domination. In an open society, philosophy has to confine itself to elaborating the categories of sense constitution and to instructing people about the possibilities for constituting their own personal sense. (1986, p. 73)

Actually, isn't this what everyone does in how they live—constitute sense? Epistemology is always under reconsideration and reconstruction, so is history. Sybille Kramer-Friedrich reminds us,

> Human memory exists only in the capacity for being constantly reconstructed. What is reconstructed is determined less by established meanings of past information than by the present problem and action context which sheds its light on the past. As a result, the meaning of "what was" constantly changes. This re-organization of information collected in the past by the re-constructing activity of consciousnesses according to a current information situation is an important distinction between computer information storage and human memory. The historical process of the receiving subject means, then, that information gathered in the past is liable to a constant alteration and transformation in meaning. (1986, p. 28)

It makes sense (constructs useful meaning) only if we reconstruct it carefully, not wed to old binaries.

It is time to go beyond left and right. As an anarchist-feminist I am especially sympathetic to the Left, but I have to agree with Kalle Lasn that the Left has become "tired, self-satisfied, and dogmatic" (1999, p. 119).[2]

Once, when I was the teaching assistant in Donna Haraway's "Science and Politics" class at the University of California, Santa Cruz, she let me give a lecture. I tried to communicate how limited the left-right schema was by taking a box and covering it with paper. On it I created three different axes: attitude toward government, attitude toward nature, and the traditional left vs. right. Finally, you could show exactly where ecological Marxists fall and why they aren't like ecofeminists exactly. Still, many more axes would be needed to give a full model of how complex political identities are. You'd want a gender grid, a technophilia to neoprimitivist arc, a race identity to multiculturalism scale, and probably others.

The world is not simple. Yes, the Islamist terrorists are motivated by U.S. policies. There would not be a worldwide anti-U.S. terror network without U.S. support for Israel, U.S. troops in Saudi Arabia, and U.S. support for various dictators from the Shah of Iran to Saddam Hussein, and now there is the U.S. conquest of Iraq. But the horror of September 11, 2001, has other fundamental causes as well. Of the millions of Muslims, and others, who disagree with U.S. Middle East policy, why have only a handful dedicated themselves to suicidal mass murder?

Few remember that the Columbine student-killers had planned first to kill 500 of their fellows and then hijack a jet to New York City and crash it there. Back in 1999, District Attorney Dave Thomas said, "I suppose when you first hear it, you think that it's some horrible fantasy. But we now know that at least the first portion of these planned activities were, in fact, carried out" (Associated Press 1999c).

We now know that such horrible fantasies can become real. So what did the Columbine killers and the Al Queda suicide hijackers have in common? They are young, male, middle and upper class, and angry. They hunger for power and even more for meaning. It is a common desire.

On October 12, 2001, the news broadcasts carried the text of some of the propaganda messages that were being broadcast at the Taliban. One of them was "Resistance is futile." Did the CIA or Defense Intelligence Agency (DIA) authors of this bit of rhetoric know they were directly quoting the evil Borg from the *Star Trek* universe? Did they realize how stupid such a proclamation is to the Afghan people, who have never been permanently conquered? They know, in fact, that in the long run, "Resistance is fertile," it is the very reason there is an Afghanistan. It is oppression that is futile in the long run. That includes the oppressions we allow into our own consciousness, the oppressions of absolute systems of perfect belief.

As Manuel Castells said, and I repeat this quotation from Chapter 2,

> The most fundamental political liberation is for people to free them-
> selves from uncritical adherence to theoretical or ideological schemes, to
> construct their practice on the basis of their experience, while using
> whatever information or analysis is available to them, from a variety of
> sources. (1998, p. 379)

This is why we need new ways of thinking, new ideas such as "pre-
ventive democracy" and "transnational citizenship" (Barber 2003).
Activists don't just need computer technology, they need "to be directly
involved in designing and applying IT for their own uses" (Latham 2003,
p. 1). We need participatory security and real democracy. Two students I
worked with at Goddard, Pauline and Robert, had studied for years at the
noncredit Institute for Designing New Societies, where participants think
of themselves as social designers working with other people to construct
the society they collectively choose. Another student, Alex, describes social
change as "cultural reengineering to overcome economic conditioning"
and uses art for "mythopoetic transformations of society." These conceits
help free us from the old habits of left-right, top-down, instrumentalist
reason and individual heroics that have framed so much of politics for the
last 500 years. What was necessary and progressive at the birth of moder-
nity today threatens to produce fundamentalist apocalypse now that
modernity is coming to an end.

What is the minimum we need? Tolerance, pluralism, acceptance,
compassion, love? Is it true that "all you need is love," as the Beatles sang?
I'm afraid we need much more than that. It is necessary but not sufficient.
We also need understanding, and that doesn't come easily. It comes from
hard thinking and hard living.

One of my students, a brilliant young artist named Juliet Gagnon, was
in Amsterdam on September 11, and she wrote about what it was like to
watch it unfold on television, among friends and kind strangers, but so far
from home. Her reflections on the people who threw themselves from the
towers gave me chills.

> There were people falling from the sky. To be so afraid that you would
> either jump so you don't burn to death or because somewhere in you, you
> believe there's a chance you could fly, that your weight could fall softly to
> the ground, that you might feel your child again, your lover, eat a pastrami

sandwich, wrap your hand 'round a coffee cup, lay in bed with either the rain on your roof leaking in ruining your stuff or the sun in the morning on your blanket warming you from the outside in. That you could fly.

We have to remember that we can't fly physically, at least not without technical help, which is all the more reason we have to learn to fly conceptually. To go beyond the simple truths about peace that we have been relying upon. And we need freedom to do this. Freedom within world views, such as Islam,[3] and freedom from unitary world views, be they market driven or religious. If we don't have the freedom to come up with powerful ideas to create a society of justice and peace, our society will be based on unthinking reactions to events. Akbar Ahmed and Lawrence Rosen, in a beautiful article on their work to preserve the intellectual legacy of Mohammed Ali Jinnah, one of the founders of Pakistan who was committed to "human rights, women's rights, minority rights, and the rule of law" (2001, p. B11), quote the president of the American University of Beirut, Malcolm Kerr, who was assassinated in his office in 1984:

> If ideas are not available to shape events, then by default events will shape ideas, in keeping with their own unplanned and, perhaps, grotesque course. (p. B11)

This work, and all my work, is in this spirit.

Years ago, my youngest son used to play soldiers in our yard at the edge of the lilac bushes right off the back steps. The last time he played I picked up all the soldiers I could find and put them in his little bucket. Still, every year, sometimes in the fall, sometimes in the spring, a new crop of little 1- and 2-inch bodies appear, most of them in remarkably good condition, shooting their rifles, throwing hand grenades, urging their comrades on. However, some are a bit chewed up. Our German shepherd, Odysseus, spends a great deal of time in the back yard and, while not particularly mouthy, he does explore a fair amount of the world with his impressive canines and expressive lips.

The eternal return of these plastic warriors gave me pause in the fall of 2001. It seemed depressingly like the battlefields of Vietnam, which continue to offer up bodies of Frenchmen and Americans and Chinese and, most of all, Vietnamese from years and years of war. Even the killing ground of the Great War—and how quaint a title that seems today, although we have to remember that it represents millions dead—offers up corpses still.

The ancients used to say that old battlefields were particularly fertile fields. I don't think that is the case any more. Most of the corpses are removed but always some pieces remain, along with fragments of metal and slivers of plastic that will long outlast any flesh. Even explosives, decades old, can lie hidden only to go off when cut by a plow or jostled by the play of children.

This is all, unfortunately, very much like the postmodern war system. Old wars leave corpses and plastic and metal and explosives lurking not just in our landscapes, but in our cultures, our minds, and our hearts. And the fields of battle are certainly no longer fertile. How many ways can it be said? War is killing us. War is going to destroy us. It will take our liberties and our honor and our loved ones and our planet and our very lives if we are not careful.

The discerning reader will have noticed a strong shift to the personal voice starting in the last few chapters and growing much stronger here. It is disconcerting that so many books on contemporary politics that I admire end with the same sort of heartfelt personal pleas, often in fraught, frightened, blustering tones. I really find this move distasteful but feel compelled, nonetheless, to add my warnings and plaintive (if not shrill) pleadings to the chorus. This is the age of Cassandras. We live in interesting (horrible and decisive) times, a cusp in human history if there ever was one.

Bringing the postmodern war system to an end, stopping the second Cold War before it morphs into a third Cold War or apocalyptic World War III is surely possible. But it will take understanding as much as action, it will take faith as much as reason, it will take forgiveness as much as judgment, it will take respect much more than disdain. It will take tolerance. It will take sacrifice. It will take love. Can it be simpler?

notes

INTRODUCTION

1. If Americans (meaning U.S. citizens) want to understand why some in the world "hate us so much," they might reflect on why they believe September 11, 2001, was so extraordinarily horrible as compared with so many other dates in recent history when thousands have died, killed in U.S.-supported dictatorships (such as Saddam's Iraq until 1991), U.S.-supported coups, U.S. armed wars, U.S. corporate disasters, and tragedies authored by other countries or by nature's cruel hand. Even September 11 isn't a tragic day that belongs only to the United States. It is the day in 1973 when a U.S.-supported coup overthrew the elected government of Chile, leading to many more than 3,000 deaths. It is also a day of many other personal and political tragedies. Diane Nelson writes insightfully about the murder of her friend and colleague, the Guatemalan anthropologist Myrna Mack Chang, in 1990 on September 11, by a Guatemalan soldier, on orders from the U.S.-trained and supported military command.

 > These are the people who knew Myrna with terrible intimacy. They surveilled her, listened to her phone calls, read her mail, followed her research carefully (better than most dissertation advisors!), watched her child at play, knew her friends, lover, family—all the networks in which she was a node. They knew what she hoped for, dreamed of, perhaps better than her closest friends. When they stabbed her 27 times on September 11th, they sought to remove her from all that, to disrupt all the *relations* she made, all the knowledge she produced, all the questions she raised, all the de-familiarizing she did, all the networks and dreams of change. Her work led them to classify her as a terrorist and in turn, they tried to use her body as an instrument of terror, sending a message to everyone in her long skeins of relationality that "you are not safe," "resistance is futile," and "there is no alternative."
 >
 > —Nelson 2003, p. 206, emphasis in original

2. The term "Islamist," although not widely used in the United States, is common in the rest of the world and in the professional literature. It refers to radical, fundamentalist, and extremist Muslims who put their religion at the center of their politics. It is

used throughout this book to differentiate this minority perspective from the majority of Muslim/Islamic faithful (See Bodansky 1999, p. ix, note). "Islamist terrorist" differentiates those nonstate terrorists from nonstate Christian fundamentalist terrorists, Hindu fundamentalist terrorists, Jewish extremist terrorists (Zionists and Orthodox/fundamentalists), Fascist, Communist, Maoist, Trotskyist, and even anarchist terrorists. State terror is called war except where specifically distinguished.

3. In 1976 the cultural theorist Raymond Williams published a collection of little essays on 110 keywords. The latest edition has added a few words such as "ecology" but retains the virtues, and limitations, of the original.

4. All etymological information and quotations not attributed to other sources are from the 1989 printing of the *Compact Edition of the Oxford English Dictionary*, Oxford University Press, 1971, or Eric Partridge, *Origins*, Macmillan, 1979.

5. The logic chopping of Hume and others is useful in understanding that what might seem obvious is not so. But if a philosophy fails to show causality exists, or morality for that matter, then it is a failure of the philosophy, not a proof positive of an unconnected and meaningless world.

6. Postmodernity makes sense because our age is still embroiled with the successes and failures of modernity and the importance of bricolage, the information society, and the proliferation of narrativeds, all aspects of postmodernity, are so clear.

7. But, unlike current Republicans and Democrats, who officially hate all government except for the military, the police, and the spy agencies, these early pragmatic anarchists were against maintaining a giant security apparatus, which actually seems to make sense because what is the threat of government to our liberties: food stamps or secret police? What the politicians are really against is any government aid for those without political power, because corporate welfare is now a fundamental part of neoliberal democracy. In Europe, *libertarian* means *anarchist*. In the United States, there is a small political movement that calls itself Libertarian and argues that businesses must be unregulated by society for freedom to exist. (See Gray 2001, Chapter 3 for a critique of this reasoning.) Most Libertarians are just Republicans in their policies and hypocrisies, but some sincerely want to limit government, naively believing corporations don't foster government because it suits their needs.

CHAPTER 1

1. After I reached this conclusion I read in Yosef Bodansky's book, *Bin Laden,* that Prof. Mark Jurgensmeyer of the University of Hawaii had already described the growing U.S.-Bin Laden conflict as part of "a new Cold War between the religious Third World and the secular West" (Quoted in Bodansky, 1999, pg. xvii).

2. Not that this is the real issue. But, in terms of official reasons for the conflict, justice seems to be a theme that continually reappears in many different guises from both "sides" and from many outside the dichotomy. For example, activists opposed to capitalism and fundamentalism consider themselves part of a "global justice movement." "Peace and Justice" is a long-standing radical slogan going back at least to the early 1970s.

3. Most North Americans and Europeans do not realize to what extent Third World countries are disrupted by the world economy. Old economic relationships are

destroyed as traditional cultures undergo forced modernization. Industrialization often becomes militarization, and massive international debts are accumulated to finance the process and the continued control by military and civilian kleptocracies.

4. The justices of the second Cold War initially seem somewhat different from those of the first. The "infinite justice" that the United States called for with its (now rejected) name for the response to the September 11, 2001, attacks is very much about revenge. "Whether we bring our enemies to justice or bring justice to our enemies, justice will be done," President George W. Bush proclaimed in his speech of September 20, 2001. But behind this avenging angel idea we hear many protestations that it is the "freedom" of the West that the fundamentalists most fear. Meanwhile, Osama bin Laden and others call for "God's justice," but on closer examination they spend more time decrying the systematic underdevelopment of the Third World, even the parts awash in oil, and the economic and cultural domination of the First World over the rest.

5. Mary Kaldor is too kind when she says, "President Bush is perhaps right" to call this a new war (2001, p. 15). Her work on "new wars" makes it clear that these basically nonstate, criminal conflicts, such as the Diamond Wars in Africa, are only revived in this era, and what happened on September 11 was not the start of the first new war by any means. Her new wars of networks, of criminals, of fundamentalists against civilians, are part of postmodern war.

6. A few days later, Rumsfeld did mention that the current situation was like the Cold War in some ways, but it is not an idea he returned to.

7. Looking back in history, we see various religious struggles (not all over): Moslem-Christian, Catholic-Protestant, Hindu-Moslem, and even some more "traditional," such as the French and Indian Wars. Today we have the drug wars, very similar in many of their operational aspects to this Cold War, and they are actually linked directly to both Cold Wars through the importance of drug production and smuggling for financing state and nonstate TerrorWar in the golden triangle of Southeast Asia, the bloody mountains of Colombia, and the poppy fields of Afghanistan.

8. Back in 1975, the Egyptian Islamist ideologue Wail Uthman wrote in *The Party of God in Struggle with the Party of Satan* that the leaders of the party of Satan were people such as President Sadat and other Muslims. "The party of Satan is that group of people who pretend to believe in Islam but in reality are Islam's first enemies" (quoted in Bodansky 1999, p. 5).

9. McWorld didn't produce these results so much as it hasn't prevented them from coming into being in specific parts of the global economy. Wealth and health are produced by human work, which uses nature and information to be more effective. Unless governments, religions, or other frameworks get in the way, this is what people do. The McWorld system actually diverts tremendous amounts of human labor, natural resources, and innovative ingenuity into war, dross, and profits.

10. Yosef Bodansky goes even further, citing Napoleon's invasion of Egypt (1789) and including the Crimean War and the Russian conquest of Central Asia as key points in the decline of the core Islamic nations, the "Hub of Islam," as he calls it, that culminated in the fall of the Ottoman Empire (1999, p. xii).

11. It is disquieting that Afghanistan is in the middle of the world's latest major oil rush. Although it doesn't have significant reserves, several of its neighbors do, and it is situated in a key location for pipelines and other developments. Ahmed Rashid's *Taliban*, published in 2000, discusses the Caspian oil rush and its impact on

Afghanistan in great detail. Michael Klare (2001a) gives great weight to the role of resources in current wars and offers a detailed analysis of oil and the current conflict (2001b), pointing especially to the Carter doctrine of 1979 that claims the United States would consider any threat to the oil of the Persian Gulf as "an assault on the vital interests" of the country (p. 12). In this light, the Gulf Wars, U.S. hostility to Iran, and U.S. fears for Saudi Arabian stability all make perfect sense.

12. In actuality, the lack of morality in much U.S. foreign policy is not just based on the principles of realpolitik but also is determined by what interests "politik" serves. In all too many cases, those interests are corporate.

CHAPTER 2

1. For a discussion of the Clausewitz-Foucault dialogue on war and politics see Gray 1997, pp. 258–259.
2. The "institutionalization of innovation" comes from Martin Van Creveld (1989). "Moore's Law" is the prediction that computing power will increase geometrically. Originally Gordon Moore predicted that it would be in 18-month cycles but it is closer to 12-month cycles now (Moore 1965). Many experts believe storage capacity is doubling every 12 months as well, and network capacity doubles every 9 months (Denning 2003, p. 34).
3. The criticisms of President Reagan's Strategic Defense Initiative are now seen as relevant to a whole range of new military technologies, as will be evident in other parts of this book. The applicability of the Church-Turing Thesis (that even an infinite computer will be incomplete or with paradoxes—or both) was only one of a number of critiques of the SDI computing systems. The problems raised fell into three basic areas: (1) the limitations of computers, (2) the limitations of ballistic missile defense, and (3) systems effects. These are covered at length in Floyd 1985; Ladd 1987; Nelson and Redell 1986; Ornstein, Smith, and Suchman 1984; Ornstein and Suchman 1985; Parnas 1985; Parnas 1987; Parnas et al 1988; Pullum 1987; and Smith 1979.

CHAPTER 3

1. This is not just the characterization long put forward by the Left to explain Indian Wars, the Monroe Doctrine, 1848, 1898, and many small expeditions before or since in Latin America, the superpower status (and colonies) won in WWI and WWII, the interventions in Korea, Vietnam, and other places since then, especially the Middle East which the Carter doctrine added to the U.S. sphere of influence. Now the idea of empire is embraced by right-wing think tanks, government officials, and a growing segment of the public.
2. As the result of several legal rulings, business corporations enjoy many of the constitutional protections of citizens in the United States. This led to a court case (still in litigation in 2004) in which Nike argues that lying to its customers is exercising "free speech." There is a significant amount of criticism of this "corporate citizen" conceit,

including my own call for the abolition of the fiction in my Cyborg Bill of Rights (2001).

3. A situation that doesn't please everyone. Peter Gloz complains that

> The second [crucial] worldwide development has been a loss of power by individual nations—that is, their political bureaucracies have lost out to central banks, banks operating internationally, transnational finance markets, and multinational corporations. There is a name for this: *the collapse of a central pillar of nationhood, the Lebanonization of the economic function of the modern industrial state.* (1986, pp. 331–332, original emphasis)

4. It is not as if states, or nations for that matter, are "natural" in the way eating and dying are natural. They are inventions. Nation-states may be on the way out, but one of the surprises of the last 50 years is that nationalism is thriving.

5. Such as the international associations of scientists, anarchists, lawyers, therapists, prostitutes, and many other self-selected groups of various levels of importance. Improved worldwide communication and travel will make such contacts, and individual relationships across borders and other boundaries, more politically important year after year. Such cybernetic inputs as faxes from Tiananmen Square and e-mails from besieged Sarajevo and bombed Baghdad already play an important political roll in shifting the relative importance of various political bodies.

6. A contentious term, but I would agree with Kaldor and others that it is more useful than not. We also have to think about "uncivil" society, the often legal (or even in power) subcommunities based on injustice, theft, and coercion.

CHAPTER 4

1. Mircea Eliade (1962) was one of the first to write at length on metallurgy and war, noting in particular the social constraints put on metalworking because of its violent potential. The ancients felt, as do I, that no technology is innocent of its consequences.

2. Sybille Kramer-Friedrich remarks, "classical information theory is not really about information." She argues that computers do not actually process information and that information as we use the term is more mythical than real. She goes on to point out that, because information theory as it is commonly used "functions as an ideology," we should ask, "What social processes does such an interpretation support?" Her answer is significant:

> At the very least, the following analogy is suggested: Just as the value of all goods and services in a capitalist society can be measured only by means of a labor-money exchange rate which abstracts from inherent meanings 1 is governed by technology, so something similar happens with information. All the special meanings of signs are put aside when measured against the ability to be coded—that is, exchanged. (1986, p. 17)

3. He did this by mathematizing an old Greek philosophical conundrum and putting it into mathematics. What happens when you meet someone who always lies and they tell you something and add, "I'm lying"? If they are lying about lying then. . . . Well,

you get the picture. It seems likely that such systems always are incomplete and have paradoxes, but that remains to be proven.

4. Ropohl defines *sense* carefully. It is "not caused by mere facts, but grows out of the total situation in which the individual mind finds itself." Sense is held only in individual minds, at least so far, because sense is needed to navigate in real life. It "mediates between objectivity and subjectivity." This is because

> Sense is the mode in which the world is *given* to the human mind, *and* it is the scheme which the mind has to *construct* in order to provide orientation and identity within the absurd variety of the world. (1986, p. 71, original emphasis)

5. Ropohl again,

> The constitution of sense, however, is not just an individual performance. On the contrary, it may be that the main traits of personal sense patterns originate in societal mechanism, and that personal sense is rather a variation of "the social construction of reality." (1986, p. 71)

6. You can have a simple robot that only looks for electricity. That's all it cares about. It trundles around looking for electric sockets and plugs itself in when it is successful. You program the little beastie with a number of possible search strategies and then, as it uses them, it focuses more and more of its own energy on the search patterns that are the more successful. Gradually, it learns. The patterns it has chosen are transplanted into the inherited memory of the next generation of little robots.

7. One of the principles of situationism is the *dérive*, the "drift," which they appropriated from the Dadaists. This "locomotion without a goal" leads to an understanding of what you want. As Lasn explains,

> As a *dériviste*, you float through the city, open to whatever you come in contact with, thus exposing yourself to the whole spectrum of feelings you encounter by chance in everyday life. Openness is key. You embrace whatever you love, and in the process, you discover what it is you hate. (1999, pp. 102–103, original emphasis)

This life would replace the artificial categories of "work and entertainment."

8. In years of anarchist organizing, strongly influenced by Quaker-pacifist consensus processes and feminist group dynamics, I have come to accept a number of other principles that harmonize with complexity theory: the personal is political, leadership not leaders, synthesis is stronger than unitary analysis, those who do the work should decide, and means *are* ends. These principles also map over well onto emergent systems, which should not be surprising because anarchists and feminists, fostering a new way of doing things politically that is nonhierarchical and nonauthoritarian, are trying to bring into being a new type of political-social system.

CHAPTER 5

1 I was a member of a Love & Rage affinity group and wrote about the Diablo action as a network event in 1981 (http://www.routledge-ny.com/CyborgCitizen/papers.html).

2. I helped start the California Group to Establish Trust Between the U.S. and U.S.S.R. to speak out in support of Russians and others jailed for working for peace in the

Soviet Union. In 1989, in Moscow, I got to meet many of these activists, including friends and family of Siberian woodcutters jailed for years for calling for peace between the two empires.

3. PGA was formally established at a later *encuentro* in Barcelona in 1998, by anarchists from Europe and "a Gandhian socialist peasant league in India, the Argentinean teachers' union, indigenous groups such as the Maori of New Zealand and Kuna of Ecuador, the Brazilian landless peasants' movement" and others, including the Canadian Postal Workers Union, which facilitated communications until the Internet filled the void (Graeber 2001, p. 12).

4. Civil disobedience (CD) specifically means consciously violating immoral laws and accepting the consequences. Symbolic sit-ins and other orchestrated nonviolent protests are often considered CD. Direct action (DA) can be nonviolent or not. DA is doing directly what the protesters think should be done, from riding subways for free to disrupting nuclear testing. A particularly thorny issue is property destruction, which many activists consider isn't necessarily violent; property doesn't hurt or bleed. And if it is property that is part of a violence system, such as weapons, then how can destroying it be violent? This is the theory behind ploughshares actions, in which people attack weapon systems. Unsurprisingly, many ploughshares activists are Christians, including a significant number of priests and nuns. But it is an ecumenical movement, including Buddhists, pagans, Jews, Moslems, atheists, and agnostics.

5. Anthony Collings discusses this issue in his article, "Datelines and Firing Lines" (2001). He points out that, in the 1990s, 458 journalists died in the line of duty. At the end of 1999 "at least 87 were in prison because of their work" (p. B19). One of the bright spots is the use of the Internet to bypass censorship and to campaign for persecuted journalists, and he gives as examples Ying Chan, a Chinese-American charged with criminal libel in Taiwan for exposing illegal contributions to the Clinton campaign (B18), a "Belarussian publisher whose newspaper was shut down" moving to the Web, and a Serbian radio station that switched to "email and an Internet audio Web site to disseminate the news after the government prevented it from broadcasting." Still, when Nigerian reporters prepared to "enter cyberspace, police got word of their plan and torched their office, destroying their computers" (B19).

6. Of course, most soldiers don't think the way the military officers who attended the Martial Ecologies conference do. They were chosen by some extraordinary Israelis searching for new thinking on a very old war. But that such soldiers exist is important nonetheless.

7. The Internet Corporation for Assigned Names and Numbers controls all virtual real estate by the simple act of naming, or not naming, domains. See http://www.cpsr.org for updates on the struggle over governance of the Internet.

8. A good illustration of this is Web projects that reach the larger world directly. Examples can be found in *Community Technology Review* (www.comtechreview.org), which covers many initiatives that mobilize technology in the service of community, such as Privaterra, which links computer professionals with human rights workers worldwide (http://privaterra.cpsr.org), and the Association for Progressive Communications (www.apc.org/english/betinho/). Perhaps more confrontational is the Organizers Collaborative (www.organizenow.net), which is creating a Web-based social change network. Labor.net.org links together grassroots labor activists around the world, the Kosovo Project uses the Internet to build community and expose

human rights abuses in that tormented land, Wired For Peace fosters virtual diplomacy in Northeast Asia, and there are countless other examples. A good overview is in *Activists Beyond Borders* by Margaret Keck and Kathryn Sikkink (1998).

9. Just as disconcerting is the sad reality that new technologies in general can certainly be mobilized to foster evil as well as good. Rafael Rohozinski reports how in Rwanda the military confiscated cell phones and other communication equipment from human rights workers to cut their communications while using intercepts from their network to direct massacres of refugees and organizing sophisticated press conferences to spin what news there was their way. The then Minister of Defense (now President) Paul Kagame bragged that Rwanda had "used information and communication warfare better than anyone" (2003, p. 220). Rohozinski goes on to conclude that "the development community's unreflective assumptions about the 'neutral, liberal, and positive' potential of ICTs in conflict zones are both fallible and potentially dangerous" (p. 223).

10. To CAE, "The idea of community is . . . the liberal equivalent to the conservative 'family values'—neither exists in contemporary culture and both are grounded in political fantasy" (pp. 74–75). Although I don't agree with this, they have a point. Many who oppose the status quo seem to think in slogans and homilies, not experience or principles. But in the case of community and family, these are real human patterns whose values are in contestation. It is a dangerous illusion to take individualism to the point of atomization. Politics comes out of the polis; without the potential for real community at least on some scale, politics would not be worth the trouble.

CHAPTER 6

1. The key situationist texts are in *The Situationist International Anthology*, edited by Ken Knabb (1981), with the exception of two longer works, now out in nice new editions: Raul Vaneigem's *The Revolution of Everyday Life* (1994) and Guy Debord's *The Society of the Spectacle* (1994). The influence of the situs on contemporary activists is huge. There are specific groups such as the Perpendiculaires in France, loose networks such as the culture jammers, discussed subsequently, and many other anarchist, ecologist, feminist, and even Marxist groups that have drawn on them.

2. Dery's 1993 booklet "Culture Jamming: Hacking, Slashing, and Sniping in the Empire of Signs" was published by the Open Magazine Pamphlet Series. Klein (1999, p. 282) says that, "For Dery, culture jamming is anything essentially that mixes art, media, parody, and the outsider stance."

3. This is a crucial issue in the United States and other Western countries. See my "Cyborg Bill of Rights" for example, in *Cyborg Citizen* (2001). Lasn has a fine discussion of the history of the idiocy of giving corporations human rights on pp. 67–69.

4. It is worth noting that for the neoprimitivist program to be implemented billions of humans would have to die. Without technology the carrying capacity of Earth in terms of humans couldn't be more than a billion and would probably be significantly less. Perhaps neoprimitivism is a legitimate political position to advocate in a postapocalyptic world, but until then it is fundamentally genocidal.

CHAPTER 7

1. And one of the most powerful of the "secular fundamentalist" genres turns out to be information and communication technologies (ICTs). As Sützl explains,

 > The market fundamentalism and the new scientific traditionalism are made possible by the accelerated development of information and communication technologies. Consequently, the latter seem to become another fundamentalist value of modern culture. There is no problem, it seems, to which ICTs do not offer a solution, and no politician can allow him or herself to be anything else than thoroughly optimistic about the social and economic impact of informatization. Information and communication technologies have become the gospel of the present age, spread by missionaries across the globe. (2001, p. 6)

CHAPTER 8

1. One of the main points is that it isn't a closed system; prosthesis (modifications of the binary dialectical dance) impinges constantly. See Gray, Mentor, Figueroa-Sarriera 1995 and Gray 2001 for a more elaborate discussion.

2. He argues in the same chapter that feminism has become a "special interest 'victim' group" (p. 118), and he has the typical North American prejudice against theorizing, which he calls "academics" (pp. 115–116). Neither of these straw-man arguments do him credit. Maybe if he paid more attention to scholarship, he wouldn't claim that the 1950s were a heroic time for the Left (p. 118) in the West when in actuality they were dominated by Stalinism and that the 1950s were actually "pretty good" in general and people were "fairly happy" (p. 59). A strange thing to say about an era in which colonialism was fighting for its life with U.S. help; a time of unbridled self-satisfied consumerism, racism, and sexism with millions of woman taking legal drugs; with marital rape and child abuse as "family affairs"; and McCarthyism as the politics of the day. The 1960s came about because the 1950s were so bad. Such nostalgia for the era of compulsory normalcy is quite strange in a self-proclaimed cultural revolutionary.

3. Akbar Ahmed and Lawrence Rosen point out that Islam treasures scholarship. The prophet Muhammad even said, "The death of a scholar is the death of the universe" (quoted on p. B12, 2001). They ask, "How is one to achieve the Islamic ideal of knowledge if one is not free to inquire, probe, and appraise the world?" (p. B12). In Islam, there is a growing movement of religious thinkers who go even further, who argue, as the Iranian Shiite theologian Abdul Karim Soroush says, "In order to be a true believer, one must be free" (Wright 2000, p. 41). For if you aren't free not to believe, your belief is not really your own. He adds, "Cling to freedom, because among God's favorite creations, freedom is the most beautiful and delicate. Tolerate the thorn for the sake of the beauty of the flower" (Wright 2000, p. 32).

bibliography

A

Afshari, Reza (2001) *Human Rights in Iran: The Abuse of Cultural Relativism*, State College: University of Pennsylvania Press.

Ahmed, Akbar and Lawrence Rosen (2001) "Islam, Academe, and Freedom of the Mind," *The Chronicle of Higher Education*, November 2, pp. B11–B12.

Alibek, Ken (1999) *Biohazard*, New York: Random House.

Armstrong, David (2002) "Dick Cheney's Song of America: Drafting a Plan for Global Dominance," *Harper's Magazine*, October, pp. 76–83.

Arquilla, John and David Ronfeldt (1993) "Cyberwar Is Coming!" *Journal of Comparative Strategy* 12, no. 2, pp. 141–165.

_____ (1997) *In Athena's Camp: Preparing for Conflict in the Information Age*, Santa Monica, CA: Rand.

Asma, Stephen T. (2001) "A Portrait of the Artist as a Work in Progress," *The Chronicle of Higher Education*, January 19, pp. B17–B18.

Associated Press (2003) "Meth is 'Chemical Weapon'?" *Great Falls Tribune*, September 15, p. A2.

_____ (2001) "Handheld Computers Give Sailors a High-Tech Lifeline," *Great Falls Tribune*, February 25, p. 2A.

_____ (2000a) "NATO Troops Use Tear Gas to Avert Kosovo Clash," *Great Falls Tribune*, February 22, p. 4A.

_____ (2000b) "Hefty Prison Sentence Ordered for War Crimes," *Great Falls Tribune*, July 3, p. 3A.

_____ (1999a) "Even Air Force Cautious over Air War Policy," *Great Falls Tribune*, July 3, p. 3A.

_____ (1999b) "Campaign Against Yugoslavia Included Mysterious Cyber-Aspect," *Great Falls Tribune*, October 8, p. 4A.

_____ (1999c) "Teen Gunmen Plotted to Kill 500, Hijack Jet," *Milwaukee Journal Sentinel*, April 27, p. 1.

B

Barber, Benjamin (1995) *Jihad vs. McWorld: How Globalism and Tribalism Are Reshaping the World*, New York: Ballantine.

_____ (2001) "Scholars and the Truth of Power," *The Chronicle of Higher Education*, August 10, pp. B7–B10.

_____ (2003) *Fear's Empire: War, Terrorism and Democracy*, New York: Norton.

Barnhart, Robert K., ed. (1988) *The Barnhart Dictionary of Etymology*, New York: H. W. Wilson Co.

Baumard, Philippe (2000) "From Inertia Warfare to Cognitive Warfare: Economics of Force in Cognitive Arenas," Martial Ecologies: Towards a New Strategic Discourse Conference, Tel Aviv and Caesarea, Israel.

Berdal, Mats (1993) *Whither UN Peacekeeping?* London: Brassy's.

Berland, Jody (2000) "The Memory of Matter," *N*, Lloyd Gibson and Mark Little, ed., London: Locus+, pp. 57–65.

Bernstein, Barton J. (1987) "Churchill's Secret Biological Weapons," *Bulletin of the Atomic Scientists* 43, January/February, pp. 46–50.

Bey, Hakim (1996) "The Net and the Web," in *CyberReader*, Victor Vitanza, ed., Boston: Allyn & Bacon, pp. 366–371.

_____ (1998) "The Information War," in *Virtual Futures*, Joan Broadhurst Dixon and Eric J. Cassidy, ed., New York: Routledge, pp. 3–10 and (1995) in *CTheory* (www.ctheory.com).

Bodansky, Yosef (1999) *Bin Laden: The Man Who Declared War on America*, New York: Forum/Random House.

Boot, Max (2003) "The New American Way of War," *Foreign Affairs*, vol. 82, no. 4, July/August, pp. 41–59.

Borgmann, Albert (1999) *Holding on to Reality: The Nature of Information at the Turn of the Millennium*, Chicago: University of Chicago Press.

Boutet, Danielle (1996) "A Challenge to Art Discourses," *Parallélogramme*, vol. 20, no. 4, pp. 40–46.

Bowden, Mark (1999) *Black Hawk Down: A Story of Modern War*, New York: Penguin.

Bowdish, Lt. Cmdr. Randall (1995) "The Revolution in Military Affairs: The Sixth Generation," *Military Review*, November-December, pp. 26–33.

Boyd, Andrew (2003) "The Web Rewires the Movement," *The Nation*, August 4, pp. 13–18.

Brenkman, John (1992) "Multiculturalism and Criticism," unpublished ms., pp. 20, 26.

Bunker, Robert (1994) "The Transition to Fourth Epoch War," *Marine Corps Gazette*, September, pp. 23–32.

Byford, Grenville (2002) "The Wrong War," *Foreign Affairs*, vol. 81, no. 4, July/August, pp. 34–43.

C

Carr, Caleb (2000) *Killing Time*, New York: Random House.

Carré, John Le (2001) "A War We Cannot Win," *The Nation*, vol. 273, no. 16, November 19, pp. 15–17.

Castells, Manuel (1996) *The Rise of the Network Society*, vol. 1 of *The Information Age: Economy, Society and Culture*, Oxford: Blackwell.

_____ (1997) *The Power of Identity*, vol. 2 of *The Information Age: Economy, Society and Culture*, Oxford: Blackwell.

_____ (1998) *End of Millennium*, vol. 3 *of The Information Age: Economy, Society and Culture*, Oxford: Blackwell.

Cebrowski, Vice-Admiral Arthur K. and John J. Gartska (1998) "Network-Centric Warfare: Its Origin and Future," *U.S. Naval Institute Proceedings* 123, no. 1, January, pp. 28–35.

Chaliand, Gérard (1978) *Revolution in the Third World*, Diana Johnson, trans., New York: Penguin.

Cheney, Dick (1992) *Defense Planning Guidance for the 1994–1999 Fiscal Years*, Washington, DC: Dept. of Defense.

_____ (1993) *Defense Strategy for the 1990s*, Washington, DC: Dept. of Defense.

Chomsky, Noam (2000) *The New Military Humanism: Lessons from Kosovo*, Vancouver: New Star Books.

Clark, Wesley (2003) *Winning Modern Wars*, New York: Public Affairs.

Collings, Anthony (2001) "Datelines and Firing Lines," *The Chronicle of Higher Education*, June 22, pp. B18–B20.

CrimethInc. Workers' Collective (2001) *Days of War, Nights of Love: Crimethink for Beginners*, Atlanta: Free Press.

Critical Arts Ensemble (2001) *Digital Resistance: Explorations in Tactical Media*, New York: Autonomedia.

Curtin, Deane W. (2001) *Chinnagounder's Challenge: The Question of Ecological Citizenship*, Bloomington: Indiana University Press.

D

Davies, Owen (1987) "Robotic Warriors Clash in Cyberwars," *Omni*, January, pp. 76–88.

Dawkins, Richard (1976) *The Selfish Gene*, Oxford: Oxford University Press.

Debord, Guy (1994) *Society of the Spectacle*, New York: Zone Books.

_____ (1998) *Comments on the Society of the Spectacle*, London: Verso.

DeLanda, Manuel (1991) *War in the Age of Intelligent Machines*, Cambridge, MA: Zone Books.

Denning, Dorothy E. (2003) "Cyber-Security as an Emergent Infrastructure," in *Bombs and Bandwidth*, R. Latham, ed., New York and London: The New Press, pp. 26–48.

Der Derian, James (1991) "Cyberwar, Video Games, and the New World Order," Second Annual Cyberspace Conference, Santa Cruz, California.

_____ (1999) "A Virtual Theory of Global Politics, Mimetic War and the Spectral State," *Angelaki*, September.

_____ (2000) "Virtuous War: The Techno-Ethical Imperative in Late Modern Warfare," Martial Ecologies: Towards a New Strategic Discourse Conference, Tel Aviv and Caesarea, Israel.

_____ (2001) *Virtuous War: Mapping the Military-Industrial-Media-Entertainment Network*, Boulder, CO: Westview.

Dery, Mark (1996) *Escape Velocity*, New York: Grove Press.

Donovan, Col. James (1970) *Militarism U.S.A.*, New York: Scribner's.

Dyer, Gwynne (1985) *War*, New York: Crown Publications.

E

Edwards, Paul (1986) "Artificial Intelligence and High Technology War: The Perspective of the Formal Machine," Working Paper no. 6, Silicon Valley Research Group, University of California at Santa Cruz.

———— (1996) *The Closed World: Computers and the Politics of Discourse in Cold War America*, Cambridge, MA: MIT Press.

Eliade, Mircea (1962) *The Forge and the Crucible*, New York: Harper & Row.

Ellsberg, Daniel (1972) *Papers on the War*, New York: Simon & Schuster.

Engelhardt, Tom (2003) "Introduction to Fragments of the Future," November 26, http://www.alternet.org/story.html?StoryID=17267, pp. 1–2.

Enloe, Cynthia (1982) *Does Khaki Become You? The Militarisation of Women's Lives*, London: Pluto Press.

Estava, Gustavo and Madhu Suri Prakash (1998) *Grassroots Post-Modernism: Remaking the Soil of Cultures*, London: Palgrave.

Everard, Jerry (2000) *Virtual States: The Internet and the Boundaries of the Nation-State*, New York: Routledge.

F

Featherstone, Simon (1995) *War Poetry*, London: Routledge.

Feuerverger, Grace (2001) *Oasis of Dreams: Teaching and Learning Peace in a Jewish-Palestinian Village in Israel*, New York: Routledge.

Floyd, Christine (1985) "The Responsible Use of Computers: Where Do We Draw the Line?" *CPSR Newsletter*, June 1, pp. 4–7.

Foghelin, Jan (2000) "The War Which You Do Not Want to Fight: On Asymmetric Warfare," Martial Ecologies: Towards a New Strategic Discourse Conference, Tel Aviv and Caesarea, Israel.

Foucault, Michel (1977) *Discipline and Punish: The Birth of the Prison*, Alan Sheridan, trans., New York: Vintage.

———— (1980) *Power/Knowledge*, Colin Gordon, ed., New York: Pantheon.

Fuller, Graham E. (2001) "Hypocrisy Is the Issue, Not Values," *Great Falls Tribune*, October 10, p. 6A.

G

Generals for Peace (1984) *Generals for Peace and Disarmament*, New York: Universe Books.

Gentry, John, Lt. Col., ret. (1998) "Knowledge-Based 'Warfare': Lessons from Bosnia," *American Intelligence Journal*, 18, October, pp. 73–80.

———— (2002–03) "Doomed to Fail: America's Blind Faith in Military Technology," *Parameters*, Winter, pp. 88–103.

Gibson, James (1986) *The Perfect War: Technowar in Vietnam*, Boston: Atlantic Monthly Press.

Gloz, Peter (1986) "Forward to Europe: A Declaration for a New European Left," *Dissent*, Summer, pp. 327–339.

Goetz, Thomas (2003) "Open Source Everywhere," *Wired*, November, pp. 158–167, 208.

Golding, Susan (1999) "A Bit(e) of the Other: An Interview with Sue Golding," by Joanna Zylinska, *Parallax*, vol. 5, no. 4, pp. 145–155.

Gonzalez, Jennifer (1995) "Envisioning Cyborg Bodies: Notes from Current Research," in *The Cyborg Handbook*, Chris Hables Gray et al., ed., New York and London: Routledge, pp. 267–280.

Goodall, Jane (2000) "Whose Body? Ethics and Experiment in Performance Art," http://www.cofa.unsw.edu.au/research/stanford/artmed/papers/goodall.html

Gordon, Andrew (1982) "Human, More or Less: Man-Machine Communion in Samuel Delaney's *Nova* and Other Science Fiction Stories," in *Mechanical God*, Westport, CT: Greenwood Press, pp. 189–199.

Gordon, Richard (1989) "Modern States" (Course syllabus, University of California at Santa Cruz).

Graeber, David (2001) "The Globalization Movement," *Items and Issues*, vol. 2, no. 3-4, Winter, pp. 12–14.

_____ (2002) "The New Anarchists," *New Left Review*, 13, January-February, pp. 61–73. http://www.newleftreview.net/NLR24704.shtml, pp. 1–10

Graicer, Ofra (2000) "Littorals—Systemic Meditation on Spatial Subversions," Martial Ecologies: Towards a New Strategic Discourse Conference, Tel Aviv and Caesarea, Israel.

Gray, Chris Hables (1988) "Gender and Postmodern War," Conference of the University of California Council of Women's Programs "Athena Meets Prometheus: Gender, Science, and Technology," Davis, California.

_____ ed. (1995) *The Cyborg Handbook*, New York and London: Routledge.

_____ (1997) *Postmodern War: The New Politics of Conflict*, New York: Guilford, London: Routledge.

_____ (2001) *Cyborg Citizen: Politics in the Postmodern Age*, New York and London: Routledge.

Gray, Chris Hables, Heidi Figueroa-Sarriera, and Steven Mentor (1995) "Cyborgology: Constructing the Knowledge of Cybernetic Organisms," in *The Cyborg Handbook*, Chris Hables Gray, Heidi Figueroa-Sarriera, and Steven Mentor, ed., New York and London: Routledge, pp. 1–16.

Gray, Colin (2002) "Thinking Asymmetrically in Times of Terror," *Parameters*, Spring, pp. 5–14.

Greenberger, Robert and Karby Leggett (2003) "President's Dream: Changing Not Just Regime but a Region," *Wall Street Journal*, March 21, pp. A1, A16.

Guibaut, Serge (1983) *How New York Stole the Idea of Modern Art: Abstract Expressionism, Freedom, and the Cold War*, Arthur Goldhammer, trans., Chicago and London: University of Chicago Press.

H

Hall, Pam (1994) *The Coil—A History in Four Parts 1988–1993*, Memorial University of Newfoundland Art Gallery, St. John's, Canada.

Haraway, Donna (1985) "A Manifesto for Cyborgs: Science, Technology, and Socialist Feminism in the 1980s," *Socialist Review*, no. 80, pp. 65–107.

_____ (1988) "Situated Knowledges: The Science Question in Feminism and the Privilege of Partial Perspective," *Feminist Studies* 14, no. 2, Fall, pp. 575–599.

_____ (1991) Personal communication.

189

_____ (1995) "Cyborgs and Symbionts: Living Together in the New World Order," in *The Cyborg Handbook*, Chris Hables Gray, Steven Mentor, and Heidi Figueroa-Sarriera, ed., New York: Routledge, pp. xi–xx.

Hardt, Michael and Antonio Negri (2001) *Empire*, Cambridge, MA: Harvard University Press.

Hayles, N. Katherine (1999) *How We Became Posthuman: Virtual Bodies in Cybernetics, Literature, and Informatics*, Chicago: University of Chicago Press.

Hayward, Clarissa Rile (2000) *De-Facing Power*, Cambridge, England: Cambridge University Press.

Helman, Gerald and Steven R. Ratner (1992-93) "Saving Failed States," *Foreign Policy*, no. 89, Winter, p. 12.

Helprin, Mark (1998) "Revolution or Dissolution," *Forbes*, vol. 161, no. 4, February 23, pp. 86–102.

Henck, Nicholas (2002) *Broadening the Struggle & Winning the Media War*, Montreal: Kersplededeb Distribution.

Herman, Edward (1982) *The Real Terror Network*, Boston: South End Press.

Hersh, Seymour (2003) "Moving Targets," *New Yorker*, December 15.

Hobbes, Thomas (1965) *Leviathan or The Matter, Forme, & Power of a Common-Wealth Ecclesiastical and Civill*, London: Penguin, first published in 1651.

Huntington, Samuel (1993) "The Clash of Civilizations," *Foreign Affairs*, vol. 72, no. 3, Summer, pp. 22–49.

_____ (1997) "The Erosion of American National Interests," *Foreign Affairs*, vol. 76, no. 5, September/October, pp. 28–49.

I

Ignatieff, Michael (1997) *The Warrior's Honor: Ethnic War and the Modern Conscience*, New York: Owl Books.

_____ (2001) *The Rights Revolution*, New York: House of Anasi.

Juergensmeyer, Mark (1993) *The New Cold War? Religious Nationalism Confronts the Secular State*, Berkeley: University of California Press.

J

Jameson, Fredric (1984) "Postmodernism, or On the Cultural Logic of Late Capitalism," *New Left Review*, no. 146, July-August, pp. 53–92.

Jelinek, Pauline (2000) "Panel: U.S. Needs New Security Plan," *Great Falls Tribune*, April 20, p. 7A.

Johnson, Chalmers (2003) "The War Business," *Harpers*, November, pp. 53–58.

_____ (2000) *Blowback: The Costs and Consequences of American Empire*, New York: Metropolitan Books.

Johnson, Steven (2001) *Emergence: The Connected Lives of Ants, Brains, Cities and Software*, New York: Scribner.

Joxe, Alain (2002) *Empire of Disorder*, Ames Hodges, trans., New York: Semiotext(e).

K

Kaldor, Mary (1987) "The Imaginary War," in *Prospectives for a Habitable Planet*, B. Smith and E.P. Thompson, ed., New York: Penguin.

_____ (1999) *New and Old Wars: Organized Violence in a Global Era*, Palo Alto, CA: Stanford University Press.

_____ (2000) "New Wars in the Global Era," Martial Ecologies: Towards a New Strategic Discourse Conference, Tel Aviv and Caesarea, Israel.

_____ (2001) "Wanted: Global Politics," *The Nation*, vol. 273, no. 14, pp. 15–18.

Katz, Eliot (2001) "When the Skyline Crumbles," unpublished ms.

Keck, Margaret E. and Kathryn Sikkink (1998) *Activists Beyond Borders: Advocacy Networks in International Politics*, Ithaca, NY: Cornell University Press.

Keegan, John (2003) *Intelligence in War*, New York: Knopf.

Keenan, Thomas (2001) "'Looking Like Flames and Falling Like Stars': Kosovo, the First Internet War," http://www.bard.edu/hrp/keenan/kosovo.htm

Kelly, Kevin, (1994) *Out of Control: The New Biology of Machines, Social Systems, and the Economic World*, New York: Addison-Wesley.

Kennedy, Paul (1987) *The Rise and Fall of the Great Powers*, New York: Random House.

Klare, Michael (1972) *War Without End: America Planning for the Next Vietnams*, New York: Knopf.

Klare, Michael T. (2001a) "The Geopolitics of War," *The Nation*, vol. 273, no. 14, pp. 11–15.

_____ (2001b) *Resource Wars: The New Landscape of Global Conflict*, New York: Metropolitan Books.

Klein, Naomi (1999) *No Logo: Money, Marketing, and the Growing Anti-Corporate Movement*, New York: Picador.

_____ (2003) "A Deadly Franchise," *The Guardian*, August 28, pp. 1–3. http://www.guardian.co.uk/comment/story/0,3604,1080572,00.html

Kleiner, Art (2003) "Scenarios for the New War," http://stage.itp.nyu.edu/scenario/WTCsenarios.html#alternatives

Knabb, Ken (1981) *The Situationist International Anthology*, Berkeley: Bureau of Public Secrets.

Kokopeli, Bruce and George Lakey (1978) "Leadership for Change," *Win Magazine*, vol. 14, no. 37, November 2, pp. 4–14.

Kozloff, Max (1975) "Editorial," *Artforum*, December, p. 7.

Kramer-Friedrich, Sybille (1986) "Information Measurement and Information Technology: A Myth of the Twentieth Century," in *Philosophy and Technology II*, Carl Mitcham and Alois Huning, ed., Greenwich, CT: JAI Press, pp. 17–28.

Krepinevich, Andrew (1994) "Calvary to Computer: The Pattern of Military Revolutions," *National Interest*, Fall; reprinted in *Foreign Policy*, Winter, 1998, pp. 82–83.

Krugman, Paul (2003) "Thanks for the M.R.E.'s," *New York Times*, August 12, p. A21.

L

Ladd, John (1987) "Computers at War: Philosophical Reflections on Ends and Means," in *Computers in Battle*, D. Bellin and G. Chapman, ed., Harcourt Brace Jovanovich, pp. 286–312.

Laqueur, Walter (1999) *The New Terrorism: Fanaticism and the Arms of Mass Destruction,* New York and Oxford: Oxford University Press.

Lasn, Kalle (1999) *Culture Jam,* New York: Quill/HarperCollins.

Latham, Robert (2003) "Introduction," in *Bombs and Bandwidth,* R. Latham, ed., New York and London: The New Press, pp. 1–21.

Lenoir, Timothy (2003) "Programming Theaters of War: Gamemakers as Soldiers," in *Bombs and Bandwidth,* R. Latham, ed., New York and London: The New Press, pp. 175–198.

Levinson, Paul (1997) *The Soft Edge: A Natural History and Future of the Information Revolution,* New York: Routledge.

Lewis, Paul (1992) "A Short History of United Nations Peacekeeping," *MHQ: The Quarterly Journal of Military History,* vol. 5, no. 1, Autumn, pp. 33–47.

Liang, Qiao and Wang Xiangsui (1999) *Unrestricted Warfare,* Foreign Broadcast Information Service, trans., Beijing: People's Liberation Army.

Linenthal, Edward (2001) "The Predicament of Aftermath: 19 April 1995 and 11 September 2001," *OAH Newsletter.* html://www.oah.org/pubs/nl/2001nov/linenthal.html

Lorde, Audre (1982) *Zami: A New Spelling of My Name,* Trumansburg, NY: Crossing Press, p. 12.

Los Angeles Times staff (2002) "Political Manuals More Useful than Dictionary in Defining 'Terrorism'," *Great Falls Tribune,* July 6, p. 2A.

Luttwak, Edward (2000) "The Challenge of 'Post-Heroic' War," Martial Ecologies: Towards a New Strategic Discourse Conference, Tel Aviv and Caesarea, Israel.

M

Madden, Mike (2001) "Civil Liberties Vulnerable in 'War'," *Great Falls Tribune,* September 16, p. 5A.

Mansfield, Susan (1982) *The Gestalt of War: An Inquiry into Its Origin and Meaning as a Social Institution,* New York: Dial Press.

Maret, Susan (2002) "The Channel of Public Papers: A Rhizomic Inquiry," unpublished Ph.D. dissertation, The Union Institute and University.

Mariya, Kanan (1998) *Republic of Fear: The Politics of Modern Iraq,* updated ed., Berkeley: University of California Press.

Martinez, Elizabeth and Arnoldo Garcia (2001) E-mail letter, August 8.

Marvin, Carolyn (1988) *When Old Technologies Were New: Thinking About Electric Communication in the Late Nineteenth Century,* Oxford: Oxford University Press.

Matthews, Jessica (1997) "Power Shift," *Foreign Affairs,* vol. 76, no. 1, January/February, pp. 50–66.

May, Rollo (1972) *Power and Innocence: A Search for the Sources of Violence,* New York: Norton.

McDermott, Jeremy (1999) "Columbia's Rebels Ready for Y2K," BBC World Service, December 23. http://news.bbc.co.uk/hi/english/world/americas/newsaid_576000/576212.stm

McDonald, Kim A. (1999) "Anthropologists Debate Whether, and How, War Can Be Wiped Out," *The Chronicle of Higher Education,* December 3, p. A21.

McRae, Ron (1984) *Mind Wars: The True Story of Secret Government Research in the Military Potential of Psychic Weapons,* New York: St. Martin's Press.

Melman, Seymour (1974) *The Permanent War Economy: American Capitalism in Decline*, New York: Simon & Schuster.

Monaghan, Peter (2001) "Verbatim: Interview with Matilde Zimmerman, Author of *Sandinista*," *The Chronicle of Higher Education*, November 16, p. A16.

Monbiot, George (2001) "Backyard Terrorism: The U.S. Has Been Training Terrorists at a Camp in Georgia for Years—and It's Still At It," *The Guardian*, October 29, pp. 1–2.

Moore, Gordon (1965) "Cramming More Components onto Integrated Circuits," *Electronics*, vol. 38, no. 8, April 19, pp. 114–117.

Moraes, Lisa de (2001) "Wall-to-Wall Coverage Close to Setting a Record," *Washington Post*, September 14, p. C07.

Moran, Michael (1998) "Bin Laden Comes Home to Roost: His CIA Ties Are Only the Beginning of a Woeful Story," MSNBC, August 24.

Moravcsik, Andrew (2003) "Striking a New Transatlantic Bargain," *Foreign Affairs*, vol. 82, no. 4, July/August, pp. 74–89.

Mumford, Lewis (1964) "Authoritarian and Democratic Technics," *Technology and Culture*, no. 5, pp. 1–8.

_____ (1970) *The Myth of the Machine*, vol. 1: *Technics and Human Development*; vol. 2: *The Pentagon of Power*, New York: Harcourt Brace Jovanovich.

N

Nef, John (1963) *War and Human Progress*, New York: Norton.

Negri, Antonio (2003) "Negri on Empire," Interview by Ida Dominijanni, Arianea Bove and Erik Empson, trans., http://www.generation_online

Nelson, Diane (2002) "Relating to Terror: Gender, Anthropology, Law, and Some September Elevenths," *Duke Journal of Gender Law and Policy*, vol. 9, Summer, pp. 195–210.

Nelson, Greg and David Redell (1986) "The Star Wars Computer System," *Abacus* 3, no. 1, Winter, pp. 8–22.

Nye, Joseph, Jr. (1992-93) "What New World Order?" *Foreign Affairs*, vol. 72, no. 5, p. 88.

_____ (2003) "U.S. Power and Strategy After Iraq," *Foreign Affairs*, vol. 82, no. 4, July/August, pp. 60–73.

O

O'Hanlon, Michael (1998) "Can High Technology Bring U.S. Troops Home?" *Foreign Policy*, Winter, pp. 72–84.

Ong, Aihwa (1999) *Flexible Citizenship: The Cultural Logics of Transnationality*, Chapel Hill, NC: Duke University Press.

Orlan (2000) "'I Do Not Want to Look Like . . .': Orlan on Becoming Orlan," Heidi Reitmeier, trans., http://www.cicv.fr/creation_artistique/online/orlan/women/women .html

Ornstein, Severo, Brian C. Smith, and Lucy Suchman (1984) "Strategic Computing," *Bulletin of the Atomic Scientists*, December, pp. 17–24.

Ornstein, Severo and Lucy Suchman (1985) "Reliability and Responsibility," *Abacus* 3, no. 1, Fall, pp. 57–61, 68.

Oxford University Press editors (1971) *The Compact Edition of the Oxford English Dictionary*, Oxford: Oxford University Press.

P

Parnas, David (1985) "Software Aspects of Strategic Defense Systems," *American Scientist*, September-October, pp. 37–46.

_____ (1987) "Computers in Weapons: The Limits of Confidence," in *Computers in Battle*, D. Bellin and G. Chapman, ed., New York: Harcourt Brace Jovanovich, pp. 202–232.

Parnas, David and the National Test Bed Study Group (1988) "The SDI's National Test Bed: An Appraisal," CPSR, Inc., Report no. WS-100-5, May.

Partridge, Eric (1979) *Origins*, New York: Macmillan.

Paschell, Rod (1992) "Tactical Exercises: The Impartial Buffer," *MHQ: The Quarterly Journal of Military History*, vol. 5, no. 1, Autumn, pp. 52–53.

Peraica, Ana (2000) "Project De/Light Me! Proposal," unpublished ms.

Perry, Dan (2000) "After Five Years, U.S. Military Writes End to Mission in Haiti," *Boston Globe*, January 21, p. A4.

Picasso, Pablo (1945) "Conversation on Guernica," in *Theories of Modern Art*, Herschel B. Chipp, ed., Berkeley and Los Angeles: University of California Press, 1969, pp. 487–489.

Piller, Charles and Keith R. Yamamoto (1988) *Gene Wars: Military Control over the New Genetic Technologies*, New York: Beech Tree Books/Morrow.

Pitts, Joe (2003) "Post 9/11's Decline of Civil Rights Isn't Unique to America," *Great Falls Tribune*, August 23, p. A6.

Pohl, Fredric (1981) *Cool War*, New York: Ballantine.

Possony, Stefan and Pournelle, Jerry (1970) *The Strategy of Technology*, Cambridge: University Press of Cambridge.

Postman, Neil (1992), *Technopoly: The Surrender of Culture to Technology*, New York: Knopf.

Pullum, Geoffrey (1987) "Natural Language Interfaces and Strategic Computing," *AI and Society* 1, no. 1, pp. 47–58.

R

Rasch, William and Gary Wolfe (1995) "Introduction: The Politics of Systems and Environments," *Cultural Critique*, Spring, pp. 5–13.

Rashid, Ahmed (2000) *Taliban: Militant Islam, Oil & Fundamentalism in Central Asia*, New Haven, CT: Yale University Press.

Rasmussen, Mikkel (2000) "'War Is Never Civilised' Civilisation, Civil Society and the Kosovo War," Copenhagen: Dansk Udenrigspolitsk Institut (DUPI) Working Papers.

_____ (2001) "The Acme of Skill: Clausewitz, Sun Tzu and the Revolutions in Military Affairs," Copenhagen: DUPI, report no. 12, p. 1.

Rawson, Hugh and Margaret Miner (1986) *The New International Dictionary of Quotations*, Signet.

Richards, Catherine and Nell Tenhaaf, ed. (1991) *Bioapparatus*, Banff, Canada: Banff Centre for the Arts.

Rifkin, Jeremy (2000) *The Age of Access: The New Culture of Hypercapitalism*, New York: Tarcher/Putnam.

_____ (1987) *Time Wars: The Primary Conflict in Human History*, New York: Henry Holt.

Robinson, Geoffrey (2000) *Crimes Against Humanity: The Struggle for Global Justice*, New York: New Press.

Rohde, David (1999) "Perfidy and Treachery," in *Crimes of War*, Roy Gutman and David Rieff, ed., New York: Norton, pp. 270–271. http://www.crimesofwar.org

Rohozinski, Rafal (2003) "Bullets to Bytes: Reflections on ICTs and 'Local' Conflict," in *Bombs and Bandwidth*, R. Latham, ed., New York and London: The New Press, pp. 215–234.

Ropohl, Gunter (1986) "Information Does Not Make Sense or: The Relevance Gap in Information Technology and Its Social Dangers," in *Philosophy and Technology II*, Carl Mitcham and Alois Huning, ed., Greenwich, CT: JAI Press, pp. 63–75.

Rosenberg, Tina (2001) "The Great Cocaine Quagmire: Can Bush Resist Expanding Clinton's Colombian Drug War?" *Rolling Stone*, no. 866, April 12, pp. 51–54.

Rotblat, Joseph (1999) "A Hippocratic Oath for Scientists," *Science*, vol. 286, no. 5444, p. 1475.

Rothkopf, David J. (1998) "Cyberpolitik: The Changing Nature of Power in the Information Age," *Journal of International Affairs*, vol. 51, no. 2, Spring, pp. 325–359.

Rumsfeld, Donald (2002) *Defense Planning Guidance for the 2004–2009 Fiscal Years*, Washington, DC: Dept. of Defense.

Rumsfeld, Donald et al. (2001) Report of the Commission to Assess United States National Security Space Management and Organization, Washington, DC: Dept. of Defense.

Rushdie, Salman (2001) "Contrary to What We're Told, This *Is* About Islam," *Great Falls Tribune*, November 4, p. 10A.

S

Sale, Kirkpatrick (1995) "Setting Limits on Technology," *The Nation*, June 5, pp. 785–788.

Sandler, Irving (1996) *Art of the Postmodern Era: From the Late 1960s to the Early 1990s*, New York: Harper Collins.

Scarry, Elaine (1985) *The Body in Pain: The Making and Unmaking of the World*, New York: Oxford University Press.

Schell, Jonathan (2003) "The World's Other Superpower," *The Nation*, April 14, pp. 11–12.

Scott, William B. (1996) "USSC Prepares for Future Combat Missions in Space," *Aviation Week & Space Technology*, August 5.

Serrano, Maria and Silvia Lopez (2003) "Positions, Situations, Short-Circuits: La Eskalera Karakola, A Deliberate Space," 5th European Feminist Research Conference, Lund University, Sweden.

Shapin, Steven and Simon Schaffer (1985) *Leviathan and the Air Pump: Hobbes, Boyle, and the Experimental Life*, Princeton, NJ: Princeton University Press.

Shawcross, William (2000) *Deliver Us from Evil: Peacekeepers, Warlords and a World of Endless Conflict*, New York: Simon & Schuster.

Sheehan, James J. (1991) "Coda," in *The Boundaries of Humanity: Humans, Animals, Machines*, James J. Sheehan and Morton Sosna, ed., Berkeley: University of California Press, pp. 259–265.

Sherry, Michael (1987) *The Rise of American Air Power: The Creation of Armageddon*, New Haven, CT: Yale University Press.

Sklar, Holly, ed. (1980) *Trilateralism*, Boston: South End Press.

Slaughter, Anne-Marie (1997) "The Real New World Order," *Foreign Affairs*, vol. 76, no. 5, September-October, pp. 183–197.

Smith, Anthony D. (1986) *The Ethnic Origins of Nations*, Oxford: Blackwell.

Smith, Brian Cantrell (1979) "The Limits of Correctness in Computers," from the Center for the Study of Language and Information (Palo Alto: Stanford University, 1979), report no. CSLI-85-36; also in Charles Dunlop and Rob Kling, ed., *Computerization and Controversy*, New York: Academic Press, 1985.

Solnit, Rebecca (2003) "Fragments of the Future: The FTAA in Miami," Alternet.org, November 26, pp. 1–7. http://www.alternet.org/story.html?StoryID=17267

Starhawk (2001) "Only Poetry Can Address Grief Moving Forward after 9/11." http://www.starhawk.org/activism/movingforward.html

Stelarc (1997a) "From Psycho to Cyber Strategies: Prosthetics, Robotics and Remote Existence," *Cultural Values*, October, vol. 1, no. 2, pp. 241–249.

_____ (1997b) "Hollow Body/Host Space/Stomach Sculpture," *Cultural Values*, October, vol. 1, no. 2, pp. 250–251.

Sterling, Bruce (1993) "SimWar," *Wired Magazine*, May, pp. 52–56.

Sützl, Wolfgang (2001) "The Weak Subject: Peace and Nihilism Reconsidered," unpublished ms.

Szafranski, Col. Richard (1995) "A Theory of Information War: Preparing for 2020," *Airpower Journal* IX, no. 1, Spring, pp. 18–27.

T

Tenner, Edward (1996) *Why Things Bite Back: Technology and the Revenge of Unintended Consequences*, New York: Knopf.

Terry, Jennifer and Melodie Calvert, ed. (1997) *Processed Lives: Gender and Technology in Everyday Life*, New York: Routledge.

Thacker, Eugene (2000) "Biowar & Infowar: The Technoscientific Enhancements of National Security," *N*, Lloyd Gibson and Mark Little, ed., London: Locus+, pp. 46–55.

Thomas, Daniel C. (2001) *The Helsinki Effect: International Norms, Human Rights, and the Demise of Communism*, Princeton, NJ: Princeton University Press.

Thomas, Lt. Col. Timothy L. (2001) "29 IT Requirements for 'Policekeeping'," *Military Review*, September/October. http://www.leavenworth.army.mil/milrev/English/Sept.Oct01/thomas.htm.

Tiles, Mary and Hans Oberdiek (1995) *Living in a Technological Culture: Human Tools and Human Values*, New York: Routledge.

Time (2000) "Notebook," January 24, pp. 18–23.

Toffler, Alvin and Heidi Toffler (1993) *War and Anti-War*, New York: Warner Books.

Tomas, David (1995) "Art, Psychasthenic Assimilation, and the Cybernetic Automaton," in *The Cyborg Handbook*, Chris Hables Gray et al., ed., New York and London: Routledge, pp. 255–266.

Trux, Jon (1991) "Desert Storm: A Space-Age War," *New Scientist* 27, July, pp. 30–34.

U

United Nations Commission on Global Governance (1995) *Report of the Commission,* United Nations.

U.S. Army (1982) *AirLand Battle, 2000,* August, Washington, DC: U.S. Dept. of Defense.

U.S. Dept. of Defense, Joint Chiefs of Staff (1995) "Joint Doctrine for Command and Control Warfare," Joint Pub. 3-13.1, Washington, DC: Author.

_____ (1986) "Joint Low-Intensity Conflict Project Final Report," August 1, Washington, DC: U.S. Dept. of Defense.

V

Van Creveld, Martin (1989) *Technology and War: From 2000 B.C. to the Present,* New York: Free Press.

Vaneigem, Raul (1994) *The Revolution of Everyday Life,* Seattle: Rebel Press/Left Bank Books.

Virilio, Paul (1990) *War and Cinema: The Logistics of Perception,* P. A. Camiller, trans., London: Verso.

_____ (1999) *Politics of the Very Worst,* interview by Philippe Petit, M. Cavaliere, trans., New York: Semiotext(e).

Virilio, Paul and Sylvere Lotringer (1983), *Pure War,* M. Polizotti, trans., New York: Semiotext(e).

W

Ward, Colin (1992) (originally 1973) *Anarchy in Action,* London: Freedom Press.

Washington Post (2003) "U.S. turning to Saddam's Agents," *Great Falls Tribune,* August 24, p. A2.

Weart, Spencer R. (1998) *Never at War: Why Democracies Will Not Fight One Another,* New Haven, CT: Yale University Press.

Webster, Frank (1995) *Theories of the Information Society,* London: Routledge.

Whittaker, David J., ed. (2001) *The Terrorism Reader,* New York: Routledge.

Wieja, John (2001) "Interview with Bruce Robbins," unpublished ms.

Wilhelm, Anthony G. (2000) *Democracy in the Digital Age: Challenges to Political Life in Cyberspace,* New York: Routledge.

Williams, Raymond (1977) *Keywords: A Vocabulary of Culture and Society,* Oxford: Oxford University Press.

Wilson, Michael (1998) "National Security and Infrastructural Warfare," Gerfried Stocker and Christine Scopf, ed., *Infowar,* New York: Springer, pp. 119–129.

Winner, Langdon (1986) *The Whale and the Reactor: A Search for Limits in an Age of High Technology,* Chicago: University of Chicago Press.

Wright, Robin (2000) *The Last Great Revolution: Turmoil and Transformation in Iran,* New York: Vintage.

XYZ

Zerzan, John and Theresa Kintz (2002) *Running on Empty: The Pathology of Civilization*, Eugene, Oregon: Feral House.

Žižek, Slavoj (2001) "The Desert of the Real," *In These Times*, vol. 25, no. 24, October 29, pp. 25–27.

Zulaika, Joseba and William A. Douglass (1997) *Terror and Taboo: The Follies, Fables, and Faces of Terrorism*, New York: Routledge.

Index

911, *see* September 11, 2001
1984, 86

A

Abokoi, 40
Activists Beyond Borders, 182n
Acton, Lord, xvi
Adbusters
 attacking cyborgologists, 127, 128
 "Cyborg Manifesto," 127, 128
affinity groups, 99, 105, *see also* Love & Rage
Afghanistan War, 14, 170
Afshari, Reza, 66
agency, xv–xvi
Age of Access, 56
Ahmed, Akbar and Lawrence Rosen, 172, 183n
AirLand Battle, 24
Al Qaeda, xi, 6, 8, 18, 19, 164, 170
Alibek, Ken, 30
alienation, 137–138
All You Zombies, 133–134
American, *see* United States
American Friends Service Committee, 98
anarchism/anarchists, 111
 and civil society, 89–90
 defined, xix
 information theory, 84, 85
 liberty, xix
 organizing, 180n
 power, 86
 practices, 99–100
 theory and complexity, 84, 85, 180n
anarcho-primitivist, 127, *see also* neoprimi-
 tivist
Anarchy in Action, 84
Andrews, Bruce, 119

anthrax
 2001 attack, 32
 accident in Siberia, 31
 British, 120–22
 death by, 30
 history, 31
 symptoms, 30
anti-nuclear movement, 99–100
apocalypse, *see* war, apocalyptic
Argentina's Dirty War, 13
Aristide, Bertrand, 23
Aristotle is wrong, xii–xiii
Armageddon, 91
Armstrong, David, 8
Arquilla, John, 38
Arquilla, John and David Ronfeldt, 24, 25, 39
art
 changes metarules, 119–120
 culture, 119–120, 129
 cyborg
 prefiguration, 130
 technologies, 133–134
 hard to define, 119
 makes meaning, 11–120
 revolutionary politics, 129, 131–133
Art and Revolution, 101
Art of War, xvi
Ashy, Gen. Joseph, 34
Asma, Stephen, 133
Assam, Sheikh, 52
Associated Press, 13, 39, 40, 103, 159, 170
Association for Progressive Communications,
 58, 181n
asymmetrical, 42–45
 globalization, 44–45
 warfare, 25
 world system, 51

199